Rebecca Stone-Miller

W9-BMX-941

Art of the Andes
from Chavín to Inca

180 illustrations, 35 in color

Thames & Hudson world of art

First published in paperback in the United States of America in 1995 by Thames & Hudson Inc., 500 Fifth Avenue, New York, New York 10110

thamesandhudsonusa.com

Second edition 2002

Library of Congress Catalog Card Number 2002101747
ISBN 0-500-20363-6

Printed and bound in Slovenia by Mladinska Knjiga Tiskarna

Frontispiece: This tall Chancay Black-and-White-style ceramic female effigy displays elaborate body and facial painting. Originally she wore an actual cotton dress, an imprint of which was left on her torso. Late Intermediate Period.

REBECCA STONE-MILLER was born Rebecca Rollins Stone in
Manchester, New Hampshire, and educated at the universities of
Michigan, Ann Arbor and Yale. She received her PhD in History of Art
from Yale in 1987 and now holds the post of Associate Professor of
Art History and Faculty Curator of Art of the Ancient Americas at
Emory University in Atlanta, Georgia. Professor Stone-Miller has
conducted extensive research and published articles on Andean art
and architecture, particularly textiles and ceramics. She has curated
numerous exhibitions on ancient American art of various cultures at
Emory's Michael C. Carlos Museum and the Museum of Fine Arts,
Boston. One of them resulted in her book, *To Weave for the Sun:
Ancient Andean Textiles* (Museum of Fine Arts, Boston, 1992;
Thames & Hudson, London 1994). She has also written *Seeing with
New Eyes: Highlights of the Michael C. Carlos Museum Collection of
Art of the Ancient Americas* (published by the Carlos Museum and
distributed by University of Washington Press, 2002).

Thames & Hudson world of art

This famous series provides the widest available
range of illustrated books on art in all its aspects.

If you would like to receive a complete list
of titles in print please write to:

THAMES & HUDSON
181A High Holborn
London WC1V 7QX

In the United States please write to:

THAMES & HUDSON INC.
500 Fifth Avenue
New York, New York 10110

Printed in Slovenia

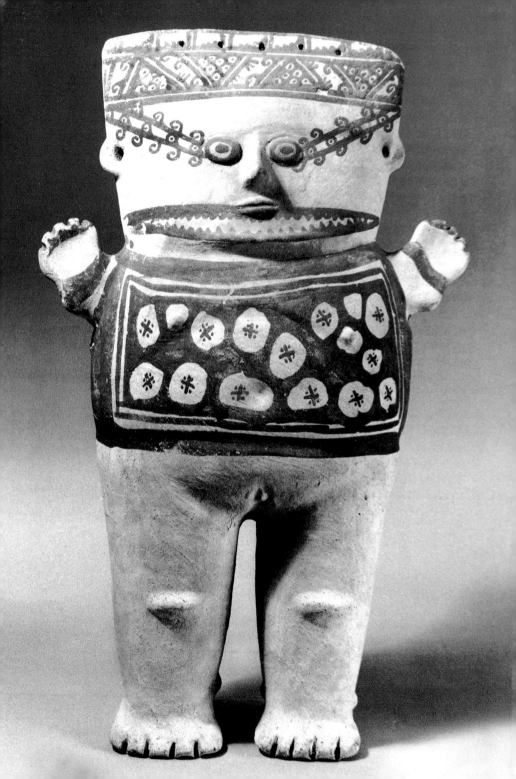

Contents

7 Preface

9 Chapter 1
 Introduction

17 Chapter 2
 Early and Chavín Art

48 Chapter 3
 Paracas and Nasca

82 Chapter 4
 Moche Art and Architecture

118 Chapter 5
 Tiwanaku and Wari Imperial Styles

153 Chapter 6
 Late Intermediate Period Styles

180 Chapter 7
 Inca Art and Architecture

219 Select Bibliography
221 Sources of Illustrations
223 Index

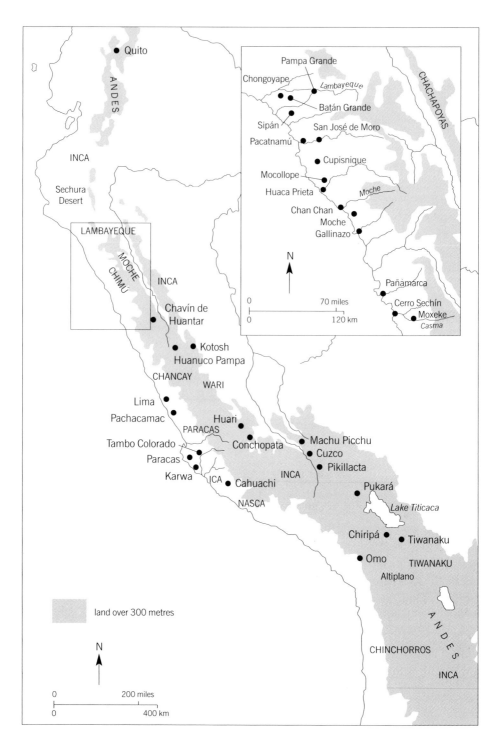

Quito

ANDES

INCA

Sechura
Desert

LAMBAYEQUE

MOCHE
CHIMÚ

INCA

Chavín de
Huantar

Kotosh
Huanuco Pampa

CHANCAY

WARI

Lima

Pachacamac

Huari

PARACAS

Tambo Colorado

Conchopata

Paracas

Karwa

ICA

Cahuachi

INCA

NASCA

Machu Picchu

Cuzco

Pikillacta

Pukará

Lake Titicaca

Chiripá

Tiwanaku

Omo

TIWANAKU

Altiplano

CHINCHORROS

ANDES

INCA

Inset map:

Pampa Grande

Chongoyape

Lambayeque

Batán Grande

Sipán

San José de Moro

Pacatnamú

Cupisnique

Mocollope

Huaca Prieta

Moche

Chan Chan

Moche

Gallinazo

CHACHAPOYAS

Pañamarca

N

0 70 miles

Cerro Sechín

Moxeke

0 120 km

Casma

land over 300 metres

N

0 200 miles

0 400 km

6

Preface

1. Map of the Central Andes, with sites mentioned in the text.

This book intends to introduce briefly the history of Andean art and architecture to the general reader, whether student or traveler. The aesthetic achievements of this important cradle of civilization have been sadly neglected until recently; this necessarily limited study may begin to redress this lack. Drawing on the research of my colleagues in Art History and Archaeology, I have attempted to highlight the major, representative art styles over a vast stretch of time. Obviously this has meant that some cultures are not considered at all, and others only cursorily. For those whose interest is piqued, further readings are suggested in the Select Bibliography.

The twelve millennia during which the Central Andes have been inhabited are subdivided by specialists into a system of periods whose names are intended to be neutral, although they are not in fact completely so. All the dates are generalized and approximate until the Late Horizon and the Spanish invasion. The earliest and longest period is known as the Lithic (10,000–3000 BC), and covers from the first known remains to the first major geologic stabilization. Next comes a period, typically known as the Pre-Ceramic (3000–1800 BC), that spans the end of the more rudimentary Lithic to the advent of fired clay objects. Because textile arts dominate this important time, here the name 'Cotton Pre-Ceramic' will be used, as it is in some publications. From 1800 to 1000 BC is known as the Initial Period, setting the stage for the first unifying cult style of the Early Horizon (1000–200 BC). 'Horizons' feature widespread similarities in the art and culture of various areas that may be associated with the power of a cult, state, or empire. These alternate with 'Intermediate Periods' in which regional diversity is seen as more characteristic. Thus, the Early Horizon, dominated by the Chavín aesthetic message, is followed by the Early Intermediate Period (200 BC–AD 500) in which the Paracas, Nasca, Moche, and other peoples flourished in their respective segments of the coast. The Middle Horizon (AD 500–900) unified to a degree much of the Central Andes under two closely related states, the Wari and Tiwanaku. The Late Intermediate Period (AD 900–1400) then saw several peoples, the Chimú, Chancay, and

7

Ica, among others, gain ascendancy. Finally, the Late Horizon, unequivocally dominated by the mighty Incas until toppled by the Spanish, took up the final century (c. 1438–1534). Although scholars have recently called into question the oversimplification of the Horizon scheme – more research revealing the diversity within Horizons and the unities within Intermediate Periods – it remains a useful overall structure for introductory purposes.

I would like to thank Mary Ellen Miller for her constant encouragement over the years. Richard Burger, Colin McEwan, Izumi Shimada, Joanne Pillsbury, Jeffrey Quilter, Adriana von Hagen, Brian Bauer, William Isbell, and Warren Church supplied most useful comments; naturally any errors remain my own. I also appreciate the efficient, expert staff of Thames & Hudson who guided this second edition, like the first, with alacrity. Emory University generously gave support to this project in the form of Summer Faculty Development awards. For her assistance this time around, I thank Laura Brannen. My family, Doug, Dylan, and Rhiannon, has been a source of constant joy and inspiration. I re-dedicate this edition to my parents, Al and Grace Stone, with love.

TIME SCALE	PERIODS/ HORIZONS	COASTAL PERU			HIGHLAND PERU			TITICACA REGION		
		North Coast	Central Coast	South Coast	North	Central	South	Moquegua	Arica	Titicaca-Altiplano
1500	LATE HORIZON	INCA	INCA	INCA	INCA	INCA	INCA	INCA	INCA	INCA
1250	LATE INTER-MEDIATE PERIOD	CHIMÚ	CHANCAY							
1000		LAMBAY-EQUE		ICA						
750	MIDDLE HORIZON		WARI			WARI	WARI			
500		MOCHE	Pachacamac					TIWANAKU		TIWANAKU
250	EARLY INTER-MEDIATE PERIOD			NASCA	RECUAY					
AD		GALLINAZO				HUARPA				
BC		SALINAR								PUKARÁ
500	EARLY HORIZON	CUPISNIQUE		PARACAS	CHAVÍN					
1000	INITIAL PERIOD	Caballo Muerto Cerro Sechín	Garagay							
2000	COTTON PRE-CERAMIC	Huaca Prieta	Huaca la Florida El Paraíso		Kotosh				CHINCHORROS	
4000										
6000	LITHIC PERIOD									
8000					Guitarrero					
10,000										

Chapter 1: Introduction

The varied cultures of the South American Andes created some of the most transcendent art the world has ever known. In a formidable and demanding environment, the ancient peoples not only survived and prospered, but spent precious time and energy on aesthetic endeavors, from elaborate rituals to vast cities, from delicate goldwork to sumptuous textiles. Highlights of these many accomplishments will be introduced in this art historical overview of the Central Andes. We will be concerned specifically with the related cultures that existed in the area between Quito and Santiago, the territorial span of roughly 3400 miles (5500 km) ultimately ruled by the Inca empire in the early sixteenth century. Cultural and artistic traditions differ substantially in both the Northern Andes of Ecuador and Colombia and the Southern Andes of Chile. Thus, the countries of Peru and Bolivia constitute the main focus here; but modern political boundaries rarely correspond to indigenous cultural zones, hence the more neutral 'Central Andes.' 146

Andean art has been preserved from before 8000 BC; however, sophisticated art forms date from around 2500 BC and later. Our primary concern here will be the time of large-scale organized aesthetic systems, the three millennia between 1500 BC and AD 1550, encompassing the Chavín through the neo-Inca styles. Brief consideration of the important precursors to the Chavín and post-invasion continuations of the Incas will expand these time boundaries somewhat at either end.

Andean environments and art
Given the environmental extremes, it is astonishing that humans have lived for so long, much less thrived, in the Central Andes. Western South America contains the world's driest coastal desert, its longest and second-highest mountain chain, and one of its largest and densest tropical jungles. None of these three zones offers a satisfactory balance of water and land for agriculture, hence the indigenous populations have had to develop social organizations in which travel, reciprocity, diversification, and control are paramount. These concerns naturally are found in the art, since it inherently expresses the fundamental 2, 3

9

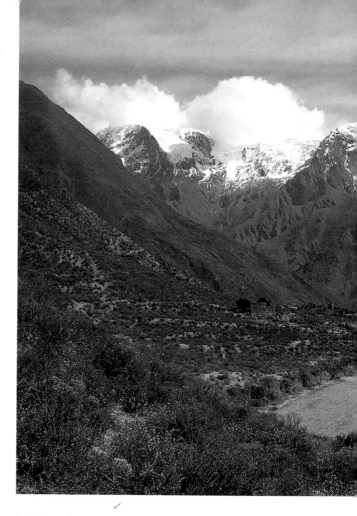

2. View of the Andes between mountains. The longest mountain chain in the world, the Andes are second only to the Himalayas in altitude. Yet people have survived and thrived in this rugged environment for thousands of years.

beliefs and practices of its creators. This juxtaposition of environments has had other important effects on culture and art as well. The sea abruptly gives way to the desert, which in turn swiftly rises to the Andes, which then steeply descend into the jungle. This dramatic environment has provided these traditions with a series of extraordinarily sharp contrasts to resolve; dualistic, complementary relationships seem to pervade the politics, religion, and art of the Central Andes.

The desert sand dunes, some of which have never recorded a drop of rain, plunge into the Pacific Ocean where the Humboldt Current's deep, cold waters harbor the world's richest fishing grounds for anchovies and many other marine species. From the teeming sea to the barren wasteland of the coast, abundance contrasts with paucity; such contrasts can be strongly felt in many

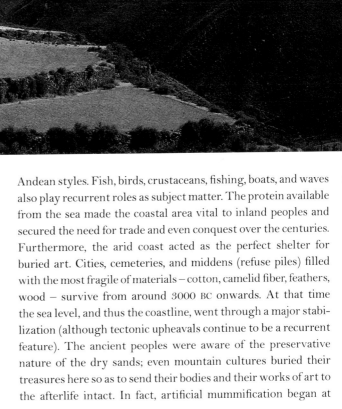

Andean styles. Fish, birds, crustaceans, fishing, boats, and waves
also play recurrent roles as subject matter. The protein available
from the sea made the coastal area vital to inland peoples and
secured the need for trade and even conquest over the centuries.
Furthermore, the arid coast acted as the perfect shelter for
buried art. Cities, cemeteries, and middens (refuse piles) filled
with the most fragile of materials – cotton, camelid fiber, feathers,
wood – survive from around 3000 BC onwards. At that time
the sea level, and thus the coastline, went through a major stabi-
lization (although tectonic upheavals continue to be a recurrent
feature). The ancient peoples were aware of the preservative
nature of the dry sands; even mountain cultures buried their
treasures here so as to send their bodies and their works of art to
the afterlife intact. In fact, artificial mummification began at

Chinchorros in northern Chile centuries before the more famous Egyptians began a similar tradition in the Old World.

The desert coast is segmented by east–west streams, thirty of which link their high Andean glacial sources to the ocean. However, the streams' relatively low water volume often does not suffice to irrigate the sands very far beyond their banks. The ultimate effect of the coastal environment was to isolate and regionalize early coastal cultures into small units corresponding to one or two valleys. Nevertheless, largely through major hydraulic projects, the Nasca, Moche, and Chimú states managed to unify increasingly large coastal areas. But it was the imperial Wari and later the Incas who organized on such a scale that the complementary environments of coast and highlands together could provide sustenance for all. Yet not even the mighty Incas could prevent the periodic upheaval brought by the so-called El Niño, a massive environmental inversion that still plagues the coast today. Unusually warm water currents bring on torrential rains, producing flooding and erosion that 'rearranges' the coast every generation or so. El Niños are partly responsible for the ruined state of ancient coastal capitals such as Moche and Chan Chan. This is one of the many ways in which the Andean environment challenges human existence, its unpredictability lending a sense of anxiety and concomitant desire for control and order.

With peaks as high as Mt Aconcagua at 22,830 ft (6960 m), the Andes rank second only to the Himalayas in altitude and physical challenge, while surpassing them by three times in length, stretching 4660 miles (7500 km). Although the mountains are the source for the coastal rivers, there is an extremely low water volume in the highland streams. Given the precipitous mountainsides, only proportionately minute areas of arable land can be exploited. The combination of extreme altitude and consequent strength of the sun's ultraviolet rays means searing day heat and as much as fifty-degree temperature drops at night. Few foodstuffs grow, from only dry grasses on the high plains (*altiplano*) up to 15,750 ft (4800 m), to potatoes up to 13,750 ft (4200 m), to maize (corn) up to 11,100 ft (3400 m), and coca – a stimulant and appetite suppressant – up to 4000 ft (1200 m).

Because the highlands consist of a series of agricultural zones according to altitude, the adaptive strategy named by John Murra 'verticality' was developed. In order to obtain all the necessary foods and materials, people from different altitudes physically traverse the resource zones and trade with one another

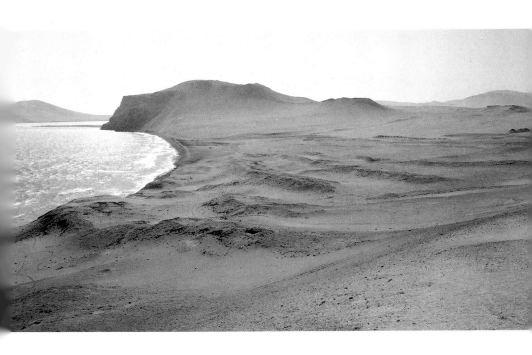

3. View of the Andean desert coast, Independence Bay, Paracas Peninsula, showing how the dunes plunge into the sea. Ancient peoples understood the preservative qualities of the world's driest coastal desert and buried people and works of art in the sands for millennia.

in a system of strict reciprocity, often claiming a kin relationship in order to cement the levels of their inclined world. The highlanders were more reliant on different resource zones for obtaining certain essential foodstuffs and artistic materials than the coastal peoples. Hence it was often the mountain peoples who generated the large-scale, unifying religious-political movements across ecological zones, joining both coast and jungle. Highland art reflects an understandable preoccupation with survival. On the practical level, highlanders have always relied on the New World camelids – llamas, alpacas, guanacos, and vicuñas – for protein, fuel, and all-important fiber. Camelids' silky hair, spun and woven into cloth, provided vital protection from the elements. These animals were crucial to the transportation of objects and people over the rugged terrain, and figure prominently in highland, and even some coastal, iconography. Verticality is also expressed more abstractly, ranging from a strong topographic emphasis in architecture to recurrent stepped patterning in the visual arts.

Although the Amazonian jungle was never formally unified with coast or highlands, it was unquestionably involved at the level of inspiration, symbolism, and trade in 'exotic' materials. The riverine lowlands were often conceived of as an origin place, certainly as a focus of abundance and fertility. Shamanic practice

4

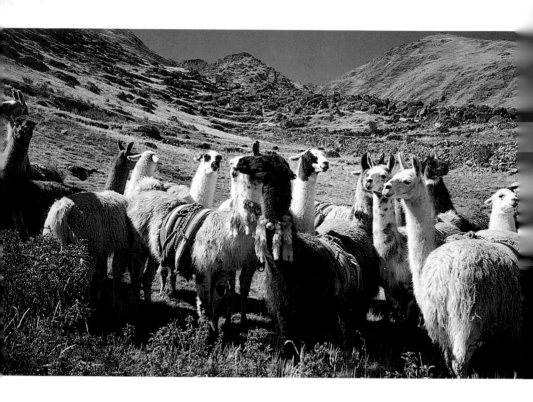

4. Herd of llamas, one of the four species of camelids in the Americas (along with alpacas, vicuñas, and guanacos). Llamas carry loads of up to one hundred pounds (note the saddlebags) over the rough Andean terrain.

has long been centered in this area, which harbors many hallucinogenic plants. Animals such as the fearsome cayman and the agile monkey are found in works of art far removed from jungle habitats. The eastern lowlands functioned as an important source of highly prized aesthetic products, such as feathers and dyes. However, the rainforest remained too remote for fullscale conquest by the Andeans.

Even the most marginal of environments have their advantages for art and society (such as the dry desert providing optimal preservation). The very harshness and incompatibility of the different zones seem to have challenged the ancient peoples to forge strong social organizations. Such social networks gave artists support and prominence, as well as providing them with diverse materials, images, and ideas. Yet alongside emphases on control, standardization, and collective thinking, Andean cultures also seem to have developed a social climate of artistic virtuosity, perhaps out of the same determined spirit that allowed them to build empires on dry dunes and high peaks. The interplay between creativity and constraint is one of the most interesting features of the art and architecture of the Andes.

Andean culture and worldview

Attitudes toward the natural world, creativity, and control, among other patterns of thought, form what anthropologists call a worldview. Andean worldviews, although by no means the same for 3000 years, seem to have shared many features. We know most about the Incas and often use them to understand earlier peoples. Four of the most important features of the Andean worldview – collectivity, reciprocity, transformation, and essence – help contextualize the diverse arts of the Andes.

Collective, 'corporate,' thinking meant that the group took precedence over the individual, the whole over its parts. The adaptive necessity of favoring 'the common good' in such a difficult environment is quite obvious. Within the group individuals are not necessarily equal; in fact, Andean cultures tended to be quite hierarchical and power unevenly distributed. In an extreme version of a pyramidal power structure in which the few control the many, the Incas – who numbered around 100,000 – made over ten million people their subjects.

Collectivity manifests itself in art as a general de-emphasis on portraiture, historical detail, and narrative. The particular features, physical location, or actions of a specific person are rarely important (the Moche being the primary exception). Rather, Andean arts tend to focus on a person's role, explore continuous patterning, and feature supernatural imagery. Individual artists are not known, at least by name, although increasingly their particular styles or hands are being distinguished. Yet anonymity does not mean that all Andean art is somehow generic; styles and iconographic programs are distinctive and varied, individual works of art dynamic and idiosyncratic. Even so, the individual artist is not a focus, rather the image takes precedence. A stress on abstract form makes Andean art highly sophisticated, but precisely in the direction away from specific appearances.

Reciprocity is a feature of a corporate worldview: one part is countered by and connected to another. This holds true on the social side, such as in the vertically-organized trade between altitude zones and in the state's obligations to provide for its members and vice versa. Reciprocal or dualistic thinking may have found inspiration or validation in the appearance of the Southern Hemisphere sky, in which star-to-star constellations are joined by dark, starless areas which seem to form animal shapes as well. The Incas and their descendants see a balance between a dark llama in the sky, complete with two stars for eyes,

and those same animals down below. Andean art as a whole has an emphasis on opposites interlocked, on pairs, doubling, and mirror-images of all kinds. Inca architecture sculpts the earth in 149-5 oppositions of light and shadow, Chancay textiles dovetail identical birds, and double-headed creatures abound. The double reading (a single motif with more than one possible identification and hence multiple, sometimes opposite, interpretations) particularly characterizes Chavín art but this subtle, intriguing tendency is also found in many other Andean styles.

Chavín art brings us naturally to the fundamental issue of transformation. Andeans, and indeed all ancient Americans, believed in a universe of transformations from one plane of existence and state of being to another. Life and death were not seen as separate categories, but merely aspects of constant natural cycling. The world, though orderly, was viewed as being in a state of flux: seasons changing back and forth from dry to wet; planets appearing, moving across the heavens, and disappearing again; human history progressing yet constantly repeating itself. Cyclical thinking was (and is) key to the Andean worldview, and dynamic circular compositions can be found throughout the artistic tradition. Art often served to unite different planes and capture transformations, such as those of the shamans (like priests) who metamorphized from humans to 24-26 animals to supernaturals. Such a dynamic worldview created interesting artistic challenges, such as how to show two things as one or existences beyond terrestrial space.

The concept that ties together all these tenets of worldview is that of 'essence over appearance.' Andean art favored the symbolic reality, the inner core, over outward appearance. This guided metallurgists to allow precious alloys to gild themselves, sculptors to emphasize interiors, and weavers to explore illegibility but stay true to their subject. Essence explains how the Nasca Lines are too large to be seen; it is not necessarily 60, 61 important that an image be visible for its essence to be conveyed. Andean art could de-emphasize the human audience because it was usually created for its own sake, the supernatural realm, the afterlife, and/or ritual efficacy. Thus, a sacred image may be placed in the dark or made nearly impossible to comprehend. Interestingly, humans are not necessarily central in the Central Andean worldview and the art they themselves created.

Chapter 2: Early and Chavín Art

The Andes have been occupied for at least 10,000 years, as we know from objects securely dated as far back as 8600 BC. The first major style to be disseminated widely was that of the Chavín beginning around 400 BC. However, many important artistic traditions and stylistic components existed well before the Chavín 'synthesis,' most notably fiber arts as a central medium and composite beings (two as one) as an iconographic staple. Monumental architecture and sculpture were widespread, as was jaguar, snake, and bird imagery. These Lithic, Cotton Pre-Ceramic, and Initial Periods will be characterized briefly to set the stage for the later styles.

The Lithic Period (10,000–3000 BC)
Ten-thousand-year-old fiberwork from Guitarrero Cave, the earliest so far from South America, and the later sophisticated textiles from Huaca Prieta, demonstrate an unusual sequence: in the Andes textiles preceded fired ceramics by thousands of years. It is only around 1800 BC that hardened clay becomes an important practical and aesthetic material. While the basket fragments, cords, and simple cloths in a dry highland cave appear undistinguished, they mark the beginning of the longest continuous textile record in the world. At Guitarrero Cave – chosen for its strategic location near mountain passes, abundant flora, fauna, and water – plant fibers were twisted, looped, and knotted to make useful containers. Although there were no patterns in these first baskets, the cords are uniform and techniques well executed, suggesting even these were not the very first attempts at fiberwork. By about 5500 BC a stone scraper tool was carefully wrapped in a piece of animal hide and tied with a cord, thus inaugurating a longstanding pan-American practice of protecting, sanctifying, even vivifying objects by wrapping them in fiber.

 An extension of this propensity, the world's earliest artificial mummification was invented in the northern Chilean Chinchorros area around 5000 BC, predating Egyptian practices by over 500 years. The deceased were allowed to decompose, then their bones reassembled and held in place by ropes and canes, the

6, 7

5

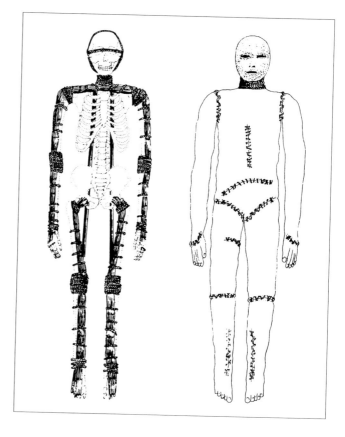

5. The world's first artificial mummification was invented on the north coast of Chile at Chinchorros. The body was reinforced with canes to keep the bones in place and the skin was stuffed, then clay features were restored to the face. Lithic Period.

insides replaced by fiber stuffing and encased in a form-imitating sewn casement, complete with delineated fingernails and a clay death mask. The resulting aestheticized body-sculpture, truly a multi-media construction, was often kept aboveground as an ongoing member of the family. Andean interest in the preserved human body continued through Inca times, when royal mummies (*mallquis*) were likewise treated as if alive.

There is something of a gap in the artistic record during the later Lithic Period, largely because the last melting glaciers caused the sea to cover most of the western South American coast *c.* 3000 BC. Thus, much was likely submerged and lost to posterity.

The Cotton Pre-Ceramic Period (3000–1800 BC)
After the environmental stabilization *c.* 3000 BC, Cotton Pre-Ceramic sites such as Huaca Prieta demonstrate that enormous strides had been taken in the development of the fiber arts. Fish-

nets, found in abundance, are quite impressive: one is estimated at over 98 ft (30 m) long. The coastal openwork tradition established by functional nets and bags remained in aestheticized form from this time onward. The midden at Huaca Prieta, a modest fishing village, also contained the remains of thousands of used and discarded twined cotton cloths. When painstakingly reconstructed, they were found to contain some of the most graphically complex images ever twisted in thread. Twining is a non-loom technique, somewhat like macramé, in which the vertical warp threads are diverted slightly to the left and right and held in position by twisted horizontal weft threads. Different colored warps trade places on the front and back faces of the cloth to form polychrome patterns with characteristic zigzag contours. Despite the relatively simple technique, the resulting compositions are far from simplistic. Profile-headed raptors, double-headed birds, crabs that transform into snakes, and other fantastical and convoluted images abound. These are not the first attempts of weavers to add pattern to cloth, but rather represent the height of pre-loom fiber art virtuosity.

The Huaca Prieta textiles bear further comment, as evidence of extremely early Andean concerns with visualization, multiple readings, and composite beings. The photographic reconstruction of one piece shows the outspread wings and characteristic hooked beak of a raptor with a coiled snake in/on its belly. The embedded snake shows how the artist has presented different

6. A reconstruction of a twined textile from Huaca Prieta illustrating a raptor with a snake in its stomach. Over 9000 cloth fragments were excavated from this North Coast site. Cotton Pre-Ceramic.

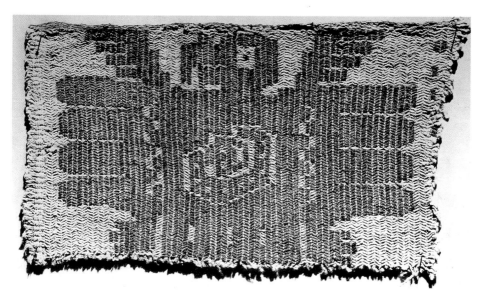

19

7. A drawing of a Huaca Prieta twined composition featuring crabs that transform into snakes. Such sophisticated imagery was accomplished in this non-loom technique c.2500 BC. Cotton Pre-Ceramic.

layers of reality simultaneously. The essential relationship of predator and prey is thereby succinctly communicated. The horizontal orientation of the zigzag contours betrays that the image was positioned *sideways* as the textile was being twined, thus underscoring the artist's power to visualize the final design. Presumably the twiner worked in this direction intentionally – it would have been considerably easier to work on an upright figure – probably so that the more dynamic zigzags could convey the movement of beating wings in flight. This piece is an excellent example of the typical Andean transcendence of technical limitations and denial of efficiency; aesthetic ends justified difficult and circuitous means.

Huaca Prieta compositions also feature more complex 'multiple readings' in which one image turns into a completely different one: a crab, its large pincers and spidery legs jutting out, becomes a large, triangular-headed, poisonous snake. The entire crab-snake image is rotated so that the dual image is itself reversed and doubled. Such spectacular convolution betrays extraordinary preplanning, especially considering how threads recross within and between cloth faces in this technique. The characteristic twining zigzags are exploited in this case to convey scuttering crab and slithering snake movement. Here two separate species unite in a composite being; perhaps the crab represents the sea and the snake the complementary realm of land; or possibly the aggressiveness of both, magnified by their pairing, transfer to the cloth's owner. The Huaca Prieta textiles may have held important ritual functions; however, they were recovered from a giant refuse heap 40 ft (12 m) deep. Evidently even such intricate examples as these were not saved for high status burial offerings (as in later times). In fact, social status differences in art and other material goods are not marked for about another thousand years.

Besides textiles, Cotton Pre-Ceramic sites have yielded small numbers of carved gourds, simple bone and shell jewelry, bits of copper sheet metal, wooden earplugs and carved bowls, mirrors (one decorated with a double bird motif), feathers, and unbaked clay figurines (mostly female). These establish several Andean artistic forms that remain important: large elaborate earrings, primarily for men; mosaic mirrors; featherwork; and female effigies. Other longstanding practices begun during this period include the taking of human heads (evident at the site of Asia), the sacrificial burning of cloth as an offering (at Aspero), and the central importance of long-distance trade (of gourds, the

highly-prized orange spondylus [spiny oyster] shells from the north, and tropical bird feathers from the east). Well before extensive agriculture, fired ceramics, cities, or social stratification, Andeans were exchanging a great variety of aesthetic products.

Cotton Pre-Ceramic monumental architecture, the oldest in the Americas by over a millennium, rivals portable art achievements. Artificial mounds, series of superimposed temples, large plazas, and sunken circular courtyards were combined at Caral, Asia, Aspero, Salinas de Chao, El Paraíso, La Galgada, and Kotosh. The newly reevaluated Supe Valley city of Caral, now dated as the earliest in South America, beginning around 2600 BC, had six stone platform mounds up to six stories tall. Several thousand people lived in each center, communally building and rebuilding them over time. Richard Burger calls this early public architecture 'the reification of human labor' because it consumed so much community time: workers at El Paraíso, the largest, moved an estimated 100,000 tons of stone to construct its nine enormous complexes. Constant rebuilding – there are least seven layers of buried temples at Kotosh – also served to cyclical- 8, 9ly validate the community. Large plazas, found in later Andean city planning, allowed the populace to participate in open-air rituals. Later, restricted access to adjacent temples was established, as at Chavín de Huantar, but the communal ceremonial role remained strong. Andean architecture conveys corporate messages by enclosing outdoor space for public rituals, as elsewhere in the ancient Americas. The huge works of public architecture also served to impress, and perhaps intimidate, neighboring groups.

The highland site of Kotosh, first constructed c. 2450 BC, has typical Cotton Pre-Ceramic features: mounds topped with freestanding, small, masonry temples; painted, mud-plastered interior walls often punctuated with niches and embellished with mud reliefs; plus centrally-located fire pits for the ritual burning of offerings. Earlier temple levels were carefully protected (layers of sand shielded the Kotosh reliefs), and built over; archaeologists have called this 'temple entombment.' (Not only reserved for temples, many works of Andean art were similarly anthropomorphized; for instance, sculptures were dressed, ritually killed, and buried with or without their human counterparts.) Since sacred buildings represented the spiritual world, the collectivity, and were considered animate like everything else, they required proper treatment at their 'death.' Rather than

underscore an individual's achievement by starting a new building campaign in a new location, Andean worldview dictated the reuse of a sanctified spot, the acknowledgment of the ancestors as an extension of the present builders, and respect for the building itself as a living representation of the group through time.

Kotosh consists of two mounds, the larger of which includes in its lower layers the Temple of the Crossed Hands, in which two adobe reliefs were sculpted below niches flanking a large central double trapezoidal niche. The duality of the mounds and of the reliefs, each emphasizing two arms, seems consciously repetitive; it may signal the pervasive Andean interest in complementarity, or even the moiety social organization (a group divided into two interdependent though unequal halves), a pattern that continues to this day. One pair of crossed arms is smaller than the other and Seiichi Izumi proposed that they symbolize a female and a male. The much-later Incas used the term *karihuarmi* to denote the fundamental principle of male-female complementarity. Clay figurines, found in niches elsewhere at Kotosh and other Cotton Pre-Ceramic sites, betray a concern with human fertility, a preoccupation in early societies. It is certainly tempting to envision sculpted human heads in the niches above the arm reliefs. With or without actual heads, the reliefs literally humanize the temple, whose entombment becomes even more understandable. The reliefs, although technically and artistically rudimentary, do depict five digits and clearly show the superposition of arms, revealing an interest in

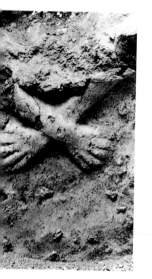

8, 9. Interior view of the Temple of the Crossed Hands at Kotosh. Adobe reliefs below two of the niches personalize this room and were carefully protected with sand when the temple was originally buried. Cotton Pre-Ceramic.

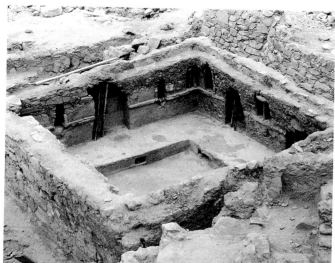

22

anatomical accuracy. While these choices in themselves may not seem extraordinary, they are by no means centrally important in other Andean art styles which, for example, rarely concern themselves with the correct number of fingers in a hand.

118

The Initial Period (1800–800 BC)
During the Initial Period Andean peoples began to farm intensively and live increasingly sedentary existences. They built larger settlements with more elaborate religious architecture, wove textiles more efficiently on looms, and fired clay (previously considered too weighty and impractical; but now receptacles were needed in which to boil agricultural products). Transhumance, herders' seasonal migration, maintained an important role in the mountains. Along the coast, fishing continued to supplement inland growing of cotton, maize, chili peppers, and beans. However, in all areas larger groups of people coexisted, their combined labor producing portable art and public monuments on a massive scale. During this period many components of the synthetic Chavín style, from building layout to sculptural imagery, were set down; in fact, only recently have scholars determined that most of what was thought to be Chavín is actually dated much earlier.

Initial Period architecture features two distinctive systems, one coastal in origin and the other highland, which then intermingle, particularly on the North-Central Coast. U-shaped structures, often with flanking mounds that embrace enormous plazas, characterize the coast for over 1000 years and even spread into the highlands to reappear at Chavín de Huantar centuries later. In the highlands, however, over fifty civic-ceremonial centers featured a different choice: sunken circular courts

10

11

10. Reconstruction drawing of the U-shaped Huaca la Florida, Rimac Valley, dated c. 2000 BC. Its arrangement of long mounds flanking a taller one typifies early coastal architecture. Initial Period.

often combined with rectangular platforms, themselves topped 1▮ with sunken rectangular plazas. Combinations of these features continue in the later Initial Period and Early Horizon.

The artistic choices involved in both templates reveal fundamental Andean values. U-shaped structures, such as those at Huaca la Florida that consumed an estimated 6.7 million work- 1C days to construct, are designed to capture centralized ritual space near the temple. Thus, group cohesion through religious celebration is reified. However, while its axial and centralized form leads participants into its core, they proceed in increasingly smaller numbers, often through elevated or enclosed spaces and finally up a restricted staircase to the most sacred area. This hierarchical tendency to cordon off specialized, exclusive space reminds us that group rituals and corporate thinking are not to be confused with egalitarianism. Furthermore, the two arms of U-shaped configurations are usually slightly different, which at least suggests the importance of complementary parts, perhaps with the central building as mediator. These uneven halves may again signal the presence of the moiety system. The subdivided group could array itself along opposite mounds and repre- sentatives, or finally priests, proceed to the more rarified portions of the complex, the message of the building being that religious intervention mediated social distinctions. Thus, dual symbolism of cohesion and constriction were successfully united in this spatial arrangement.

The highland pattern of sunken courts, circular on ground 1▮ level and rectangular on elevated platforms, can also be inter-

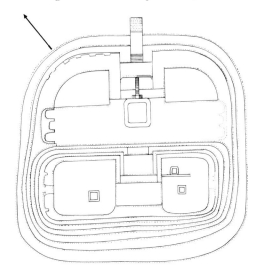

11. Plan of the main structure at Moxeke; sunken courtyards atop platforms characterize early Andean highland architecture. Huge adobe sculptures faced outward to announce elite power to those below. Initial Period.

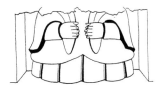
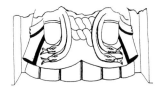
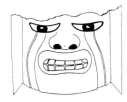

12. Now semi-fragmentary, three of the large adobe sculptures on the top of Moxeke (see ill. 11) feature a caped figure, a shamanic being emanating snakes, and a head.

13. A huge sculpture of a feline head at the Huaca de los Reyes mound of Caballo Muerto on the North Coast. The adobe, probably originally painted, has not entirely survived the past three millennia or more since it was modeled. Initial Period.

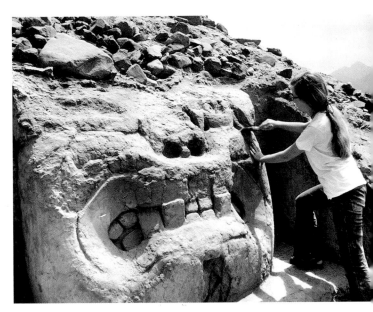

preted socially. Round courts seem to mark off intimate, more egalitarian space for gatherings, as in the kivas of the American Southwest. Circles do not favor any one direction, nor is any part differentially elevated, so all participants are at least potentially equal. These courts would seem to function as meeting places, possibly for kin groups. On the other hand, the tall platforms with maze-like buildings, such as at Moxeke, are dwarfing in scale, set apart and literally above. The tiered shape, most probably representing a sacred mountain, soars 98 ft (30 m) in height and covers 540 by 560 ft (165 by 170 m) at its base. The wide stair interrupted by a platform continues as a narrower one that splits at the top, again emphasizing issues of duality, procession, and access. The upper platform's rectangular spaces seem more suited to direct attention toward leaders holding court.

Recent archaeological excavations have uncovered copper and gold foil on the platform at Mina Perdida, south of Lima on the coast. Dated to between 1450 and 1150 BC, these tiny remnants

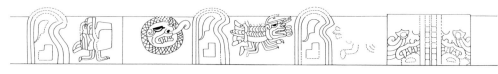

14. Originally brightly painted, the adobe friezes at Garagay depict shamanic transformation from human to insect. Initial Period.

represent the earliest known metallurgy in the Central Andes, and set the stage for the elaborate Chavín pieces of the Early Horizon. Significantly, some of the foils are actually gilded copper and so also represent the beginning of an Andean commitment to this combinatory technique (later especially exploited by the Moche). In addition, the foils seem to have been refuse thrown from the summit of the tall structure where ceremonies took place, making an early association between high-status metals and lofty ritual activity. Likewise, Mina Perdida provides a rare glimpse into the early ritual use of fiber human effigies, as a jointed, thread-wrapped gourd dressed in a cotton mantle was found buried face down on the main mound's back terrace. Condor markings on the effigy's face suggest shamanic transformation may have been enacted with this unusual item.

It is on these platforms and around their plazas that elaborate, colorful monumental sculpture, painted reliefs, and wall murals were placed during the Initial Period. At Moxeke, embellishment took the form of nearly 13-ft-wide (4-m) painted adobe sculptures. Two are skillfully modeled, extremely high-relief, standing, now headless figures and one represents a colossal head. While their exact identities remain unclear, the lower bodies' fluted edge may represent severed torsos and the head may be decapitated, by analogy with the gruesome images from Cerro Sechín. Snakes may signal the spiritual role of the center figure, as they are highly characteristic of shamanic visions. Originally painted in pink, blue, and white, with incisions filled in black (one figure apparently painted entirely in black, possibly symbolic of death), these great sculptures would have boldly advertised the might of the Moxeke elites.

Other coastal sites, such as Huaca de los Reyes at Caballo Muerto, had similarly impressive clay statuary with the new configuration of features that was to be highly influential to the Chavín: eyes with pendant irises, wide feline noses, fangs in drawn-back lips, and pronounced facial lines. Probably brightly painted, as were reliefs at Garagay on the Central Coast, these transformational images of often anthropomorphized feline, reptilian, arachnid, and other animals were widespread on all media at this time.

Garagay's friezes on the atrium of its Middle Temple feature a fanged face in a cross-hatched spider web, an insect with a human head, and facing fanged faces. The first has a pronounced volute from the nose, either the representation of the arachnid's pedipalp or the mucus secretions characteristic of hallucinogen snuffing, or both. Thus, shamanic transformation from human to insect is shown in various guises. Spider behavior can be used to predict the weather; in fact, certain Inca diviners employed spiders for foretelling the future.

Each Initial Period site has its own character, but nevertheless combines threatening with spiritual imagery, especially apparent at Cerro Sechín in the North Highlands. An impressive 15–17 revetment wall surrounds an inner room complex with alternating 10-ft-tall (3-m) upright stones and stacks of smaller slabs. Well over 300 slabs depict dismembered bodies, severed torsos, decapitated heads, and even abstracted vertebral columns, interspersed with upright figures in special hats holding implements.

15, 16, 17. Cerro Sechín's walled temple (*below*) is faced with over 300 reliefs depicting many dead figures, shown as decapitated (*bottom left*) and dismembered (*bottom right*). Interpretations vary from a bloody massacre to a symbolic shamanic initiation. Initial Period.

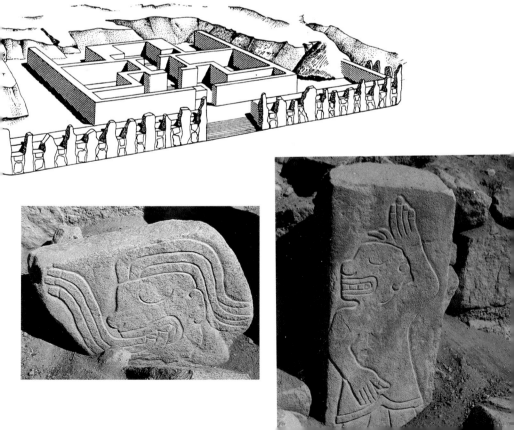

The procession meets at the central doorway, giving a ritual sense to the overall sculptural program (somewhat reminiscent of the parade in the Maya murals of Bonampak). Alana Cordy-Collins further points out that one slab depicts toad eggs, and that certain toads carry hallucinogens, and she also suggests that cross-culturally the initiation of a shaman involves the initiate's symbolic death by dismemberment, acted out by an advanced shaman. Rather than an account of a battle, she sees this monument in a symbolic vein as a ceremony for the figurative death of ordinary persons to make way for their new life as spiritual leaders. (In the study of West Mexican art a similar reappraisal of warrior imagery toward shamanic iconography has taken place.) The building within therefore becomes the place in which such profound transformations likely took place. The toad imagery might also suggest that the wall's terrifying prospect is a visionary one, as trance states often involve frightening conflict and the experience of death. We shall see that the later tenon heads at Chavín de Huantar have a similar role to 24–2 advertise the rituals within a mysterious building.

Many, however, would still see the Cerro Sechín revetments as a memorial to a gruesome massacre, detailed for the viewer in the deeply beveled incised lines. In fact, this angled cutting creates a double line, light where the intense highland sun catches the lower facet and dark where the shadow of the upper one reaches the lowest point of the incision. The images, though extremely shallow in relief, thereby achieve a graphic punch that underscores their intense message. Whether that message is spiritual or historical, or perhaps some of both, early Andean sculpture can be appreciated for its exploration of the power of the line to convey stark issues of life and death.

The Chavín style

Chavín art can be divided into two phases. The first, corresponding largely to the late Initial Period *c.* 900 to 500 BC, includes the architecture and related sculpture of the Old Temple at Chavín de Huantar, the cult center. From around 500 to 200 BC the second phase corresponds to the Early Horizon New Temple construction and its associated arts. Other artworks not directly related to either architectural phase can be generally dated by stylistic similarity to known monuments.

The Chavín synthesis unified the Initial Period aesthetic systems of both coast and highlands: the sunken circular courtyard, the U-shaped structure, and imagery of jaguars, snakes,

and other animal-human transformers came together. Yet, Chavín style also took a highly innovative stance in ceremonial center layout, materials, sculptural type, and sacred imagery. The cult center also controlled commerce in ways that irrevocably changed highland village life. Chavín aesthetics altered the course of Andean art, influencing contemporary coastal styles, primarily by dissemination through textiles, and continuing as revivals in later eras.

Chavín is a very complex, 'baroque,' and esoteric style, intentionally difficult to decipher, intended to disorient, and ultimately to transport the viewer into alternate realities. Much of the cult's enormous success may be ascribed to the intense visual messages sent by buildings, their decoration, and the portable ritual objects. Their strong perceptual effect, certainly calculated by Chavín artists, inspires confusion, surprise, fear, and awe through the use of dynamic, shifting images that contain varying readings depending on the direction in which they are approached. The terms 'hallucinatory' and 'transformational' aptly describe much Chavín subject matter and artistic effect. An important component of the style has been termed by George Kubler 'visual metaphoric substitution,' denoting that certain parts, especially hair, fur, cords, or whiskers, are visually replaced by analogous elements, particularly snakes. Both a great deal of visual complexity and deeply symbolic religious concepts result from the Chavín solutions to the aesthetic problem of portraying two states at once. The iconography features staffbearing deities, predatory animals, human-animal composites, and shamans in transformation.

The center: Chavín de Huantar

The impressive site of Chavín de Huantar lies at 10,330 ft (3150 m) of altitude in the Callejón de Conchucos, east of the Cordillera Blanca (the easternmost, snowy Andean range). Its locale is highly unusual for its access to the arts, architecture, environs, animals, foods, and ideas of all zones of the greater Andean region. Set at the confluence of two rivers and near two of only ten mountain passes, Chavín de Huantar constitutes a natural nexus point. (In the Inca language Quechua such a place is called a *tinkuy*, which also denotes balanced harmony, an age-old Andean concept.) Chavín de Huantar was thus able to be equally centripetal, a pilgrimage center and importer of luxury goods from afar, and centrifugal, a disseminator of the first unifying Andean style. The expansion and changes over 700 years of

Chavín de Huantar illustrate the longterm success of the cult and its aesthetics.

Architecture and sculpture of the Old Temple

The first structure built at Chavín de Huantar, the Old Temple (in the past erroneously called the Castillo, 'castle'), was extremely large and impressive, measuring over 330 ft (100 m) across the back and 36–52 ft (11–16 m) high. The temple faced the rising sun in the east, and the unnavigable Mosna River, turning its back to the trade route and secular buildings. The river and the lack of entrances on any side except the east meant that the approach to the Old Temple was purposefully circuitous; supplicants were forced to experience the formidable temple sides, then approach up a series of plazas and stairways. Inaccessible, introspective, enigmatic, the Old Temple and its surroundings were designed to embody the mysteries of the cult and its new message.

Yet novelty was carefully couched in familiar terms, as the Old Temple placed a sunken circular court in the arms of a U-shaped building. Innovations, such as the east–west stairway entrances to the plaza being wedge-shaped, were not practical but can be seen as typical Chavín flourishes. Funneling stairs embellish processional movement, while also subtly winnowing the number of celebrants reaching the temple itself. Exclusivity continues as an important and insistent architectural message. Several other features of the Sunken Circular Court are equally unusual and significant. Archaeologists have discovered in its pavement remains of darker stones demarcating the human and solar east–west path, succinctly conflating architecture, human ritual procession, and cosmological phenomenon. (A corresponding north–south line is suspected; if one existed originally, then the court also symbolized all directions, becoming an *axis mundi* or center of the world.) Another curious feature is a giant snail fossil set into the floor, perhaps acting as a graphic link with unknown areas to show the cult's control over exotic and mystifying natural wonders.

Around the edges of this circle sunk 8 ft (2.5 m) into the earth, and large enough to hold over 500 people, was a revetment wall of the very finest incised stonework. Rectangular panels alternate fanged humans above and jaguars below, marching in stately procession toward the temple. They obviously mirrored celebrants' passage through the court itself, a common congruence between the depicted and the actual world (as at Cerro

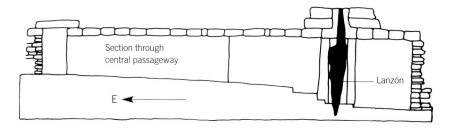

Section through
central passageway

E ◄────────

Lanzón

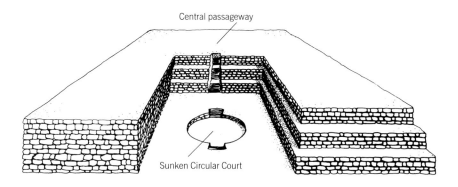

Central passageway

Sunken Circular Court

18. Views of the Old Temple at Chavín de Huantar: elevation showing the position of the Lanzón (see ill. 23) in the center back of the building; the Old Temple with the Sunken Circular Court (see ills. 20, 21, 22) inside its U-shaped configuration. Early Horizon.

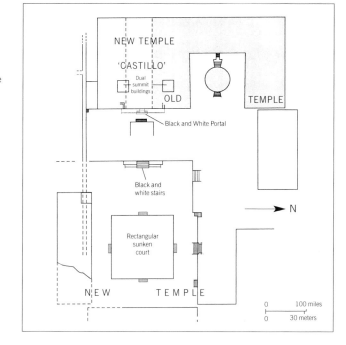

NEW TEMPLE

'CASTILLO'

Dual summit buildings

OLD TEMPLE

Black and White Portal

Black and white stairs

N

Rectangular sunken court

N E W T E M P L E

| 0 | 100 miles |
| 0 | 30 meters |

19. Plan of the Old Temple (shaded) and New Temple and related courtyards at Chavín de Huantar. This cult center was enlarged between 900 and 200 BC; however, the Lanzón remained in situ (see ills. 18, 23). Early Horizon.

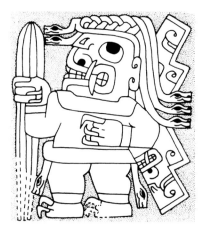

20, 21, 22. The Sunken Circular
Court in front of the Old Temple at
Chavín de Huantar (see ills. 18,
19). Relief panels of parading
shamans – this one carrying the
hallucinogenic San Pedro cactus –
are shown partially transformed
into their jaguar selves (*right*)
and fully changed into felines
(*below right*). Animal and human
pairs were arranged around the
courtyard (*opposite*).
Transformation is also the theme
of the tenon heads on the New
Temple (see ills. 24, 25, 26).
Early Horizon.

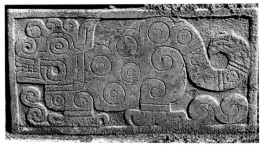

Sechín). One can safely generalize that ancient American art is figured as an active, living presence, a permanent, elevated player in ritual reality.

Yet the Sunken Circular Court panels do not simply reenact processions. The profile jaguars are arrayed in identical pairs, probably seven or more pairs on each side originally. (Chavín de Huantar has suffered major disasters over the centuries, particularly landslides, and many sculptures are buried, destroyed, or out of place, and temple galleries are collapsed. However, the layering these catastrophic events cause allows for new discoveries; for example, recent excavations by John Rick have uncovered additional panels from this courtyard.) The jaguars have identifiable concentric spots, but bear the talons of the harpy eagle, to combine two of the mightiest tropical predators. The larger square panels above depict pairs of elaborately costumed walking figures, one of which blows a strombus (conch) shell trumpet, while another carries the hallucinogenic San Pedro cactus (*Trichocereus pachanoi*) as a staff of authority. Several wear

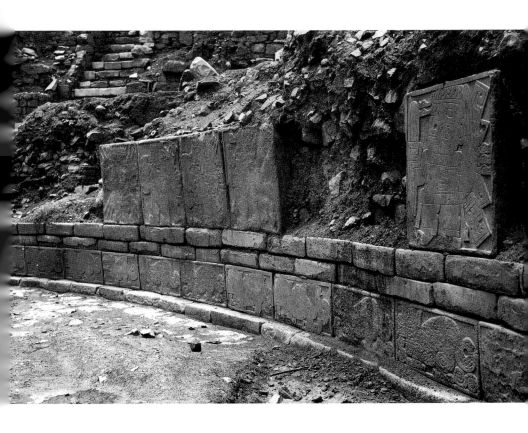

hats with jaguar tails, and all have the crossed fangs of the jaguar, snakes for hair, and vicious eagle talons. These represent shamans taking part in hallucinogenic rituals, beginning their transformation into the fully animal jaguars paired with them below. The sets of related pairs reiterate the importance of complementary dualism in Andean art and thought. This powerful imagery, when united with the actual processions moving toward the impenetrable temple to perform mysterious subterranean rites in animal form, certainly was extremely impressive.

Cult activities were mostly hidden from view, as celebrants disappeared into the windowless structure, honeycombed with labyrinthine unlit passages, only to reappear suddenly on the flat roof to perform public rites. Turned inward, like the priests were to the supernatural realm, the Old Temple was a disorienting place of narrow, indirect passages. Luis Lumbreras has proposed that the many air ducts and water drains that crisscross the building, obviously of practical value in the absence of windows

and given the heavy waterflow during the prolonged rainy season, could also have been manipulated to make the building roar with an eerie applauselike sound. Outside, at least 41 over-lifesize, monstrous tenon heads studded the upper walls, while cornices and wall plaques depicting fierce animals covered portions of the lower walls.

The entire structure was literally built around a centrally-located monolithic sculpture. Erroneously known as the Lanzón

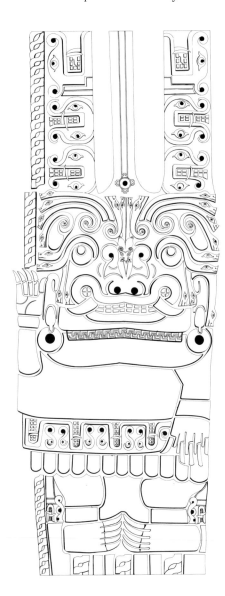

23. The Lanzón cult image, a stone monument over 15 ft (4.5 m) high, set deep in the center of the Old Temple (see ills. 18, 19). This massive figure of the early Chavín supreme deity, gesturing up and down to encompass all realms, was probably an oracle. Early Horizon.

('Great Lance') for its bladelike form, its notched wedge shape probably actually refers to the highland foot plow. Its specifically local highland shape suggests that the supernatural inscribed on its surface ensured successful planting and thus human survival. In the Andes, ceremonial objects often retain a utilitarian shape which does not contradict their aesthetic component, but instills in them enhanced ritual efficacy and power. The Lanzón, the most important early Chavín cult image, was located in a cruci- 18
form gallery deep in the center of the temple. Representing the four directions and sacralizing the spot as a world center, the floor stepped down and the ceiling was slightly corbeled to create an approximate cross in both planes. The gallery above was also cruciform and would have allowed priests to speak for the Lanzón as an oracle, according to Thomas Patterson (as at the later cult center of Pachacamac). 144

Measuring 15 ft (4.5 m) high, embedded in the floor and penetrating the ceiling above, the Lanzón figure acted as a supernatural conduit. Its incised design includes four twisted strands branching out from the base, one of which continues up the back to mark the vertical path from earth to sky. Facing the rising sun, the Lanzón deity held sway with right arm up and left down. The all-encompassing gesture again controls and unites celestial and terrestrial spheres. A small channel carved down the front of the notch to the top of the head leads to a cross-shaped well with a circular depression at its center. Perhaps used to pour liquid offerings down from above like rain, the cross and circle motif reiterates the Lanzón's own gallery as well as the Sunken Circular Court outside. In subtle ways the architecture and sculpture embed center within center. (This channel also points up the important ancient American tradition of finishing all sides of a work of art.)

The Lanzón features all the components of the distinctive Chavín style (although its low-relief carving is unusual, as other Chavín images tend to be incised): round eyes with pendant irises, feline fangs and flat nose, upturned snarling mouth (not to be misread as smiling), and claws/talons as nails. Like other columnar Chavín sculptures, the image has been wrapped around the stone block, thus neither entirely visible from one standpoint nor fully three-dimensional in conception. It is withheld, creating its own reality regardless of the human perspective. In fact, there is no evidence that the Lanzón was ever truly visible to a human audience at all, since there are no light sources to illuminate it and no archaeological evidence of smoke from torches.

Like later Andean art that is functionally invisible, the essence of 142
the object takes precedence over the act of beholding it in this
plane of existence. San Pedro cactus shamans may have visual-
ized, even hallucinated, the Lanzón, a supernatural image
forever in the dark of the Other Side.

In keeping with its supernatural character, elaborate repeat-
ing swirling elements ending in diminutive snake heads cover its
body. These are visual metaphoric substitutions that function as
puns: eyelashes, hairs, fur, or whiskers, are like, and therefore are
shown as, snakes. In its belt fanged mouth bands with eyes to the
right and left can be read as faces in either direction, illustrating
another key stylistic device: contour rivalry. Already seen in
Huaca Prieta twinings, contour rivalry denotes a situation in which 7
the same set of lines belong to two images at once. Here a mouth
forms faces with both the eye on its left and its right. Similarly, on
the Lanzón's own face the eyelash near the eye is read as a hair,
but switches to a snake reading further out. The surprising
alteration of one's perception is at once a visual trick to disorient
and a statement that one thing can be two 'depending on how
you look at it.' Multiple religious entities also characterize other
Chavín sacred images, particularly the later Raimondi Stela. 29

The New Temple
The later phase of the site, 500 to 200 BC, featured extensive
expansion and a shift of focus for the ceremonial center. Renovat-
ed and enlarged, the New Temple constituted a huge addition to 19
the south side of the Old Temple. However, the older building
was neither destroyed nor ritually entombed, so presumably it
and the sacred images it held remained symbolically valent. New
larger plazas, able to hold three times the audience and reflecting
both population growth and cult success, lead from the river to
the New Temple, now graced with a striking black and white
stone portal. Themes of transformation, hidden realms, and 27
fertility continue in ever more succinct artistic statements.

The new addition was adorned with over forty large sculpt-
ed stone heads and numerous relief panels on the walls. Of the 24-26
series of overlife-sized tenon (pegged) heads, only one remains in
situ. Reconstructions place them high on the walls, one every
few meters, and in a sequence from human to supernatural
animal visages. As if in time-lapse photography, they document
the dramatic process of shamanic transformation experienced in
visions. Those with almond-shaped humanoid eyes and vertically
placed features give way to heads with round, bulging eyes and

flattened noses from which mucus, characteristic of drug reaction, streams (as seen previously at Garagay). Finally, some heads display projecting muzzles and obvious fangs, as well as swirling snakes for hair and whiskers. Deep holes drilled for eyes and nostrils made them read well in the strong highland light and shadow, yet the tenon heads were physically inaccessible on the wall; again a powerful, frightening mystery is simultaneously announced and withheld. Typically, to fully comprehend the horrific changes, the viewer would be forced to circumnavigate the building.

This illegible wrapping of image on building is even more extreme in the decoration of the Black and White Portal, which

24, 25, 26. Three of the over forty tenon heads that studded the high walls of the Temple at Chavín de Huantar. These heads encapsulate the spectacular transformation of the hallucinating shaman into a monstrous animal spirit. Early Horizon.

27. The Black and White Portal of the New Temple at Chavín de Huantar. Early Horizon.

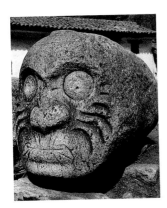
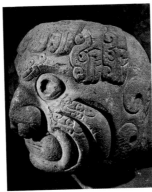
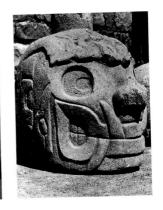

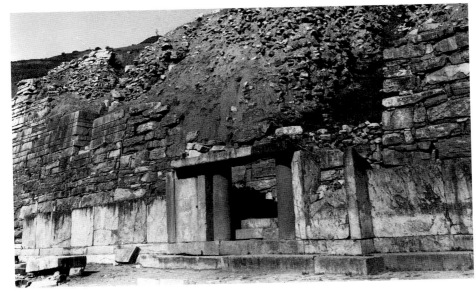

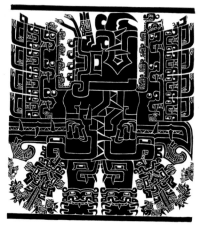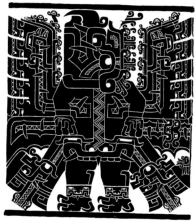

28. Rollout drawings of the incised figures wrapped around the columns of the Black and White Portal (see ill. 27). An impressive gateway to the enlarged New Temple, it summarizes complementarity in a striking dark and light stone lintel as well as the female (left) and male (right) anthropomorphic avian figures. Early Horizon.

gets its name from the fact that the lintels (stones across the top of the doorway) are white granite on the north and black limestone on the south side. Duality and complementarity are thus underscored with natural color, and made clear in the largely invisible reliefs on the two columns to either side of the opening. When drawn rolled out, avian anthropomorphic figures emerge. Their heads have both beaks and fanged mouths, their tails appear split to either side of their legs, and each has the outspread wings of a raptor in hunting flight. Yet important differences become apparent: one is male (by metaphoric substitution for the penis of a central fang on a frontal agnathic [jawless] face), while the other is female (according to the two profile fanged mouths on her thighs leading into a fanged mouth band running up her torso which together represent a 'vagina dentata'). The male is identifiable as a hawk by the band running through his eye and the female as an eagle by her pronounced cere (the round nostril opening on the top of the beak). Perhaps the later Chavín cult emphasized human to bird transformation over human to jaguar, while retaining the crossed feline fangs (seen along with the beaks on these images) to provide continuity. To convey transformation optically, visual metaphoric substitutions appear throughout. For instance, on the female figure the ends of feathers are shown as intertwined snakes. Myriad slightly different visual metaphoric substitutions appear on the two, for example, the ends of the feathers are fanged faces on the male. Eyes, snakes, and teeth motifs do double and triple duty to form faces throughout, especially at joints. For instance, the frontal face at the ankle makes the foot into a giant tongue

protruding from a mouth. Swirling and changing before your eyes, these figures are hard to read even when drawn out, but in their original cylindrical form they are even more elusive: the sides of the columns are too close to the uprights to allow a viewer to see them at all, and the wrap-around nature of the compositions defies visual comprehension. Again Chavín art achieves a conceptual, visionary transcendence of the material plane.

The culminating expression of these ideas is to be found in the Raimondi Stela. Instead of two monuments adding up to the whole, this sophisticated incised composition embodies duality within a single figure. This 7-ft-tall (2-m) highly polished granite ashlar was unfortunately not found in situ, but its style is closely allied to that of the Black and White Portal figures,

29. Two drawings of the Raimondi Stela, showing the upright and inverted readings embedded in this image of the staffbearing deity. Artists employed the perceptual effect known as 'contour rivalry' to allow the same incised lines to create different readings. Early Horizon.

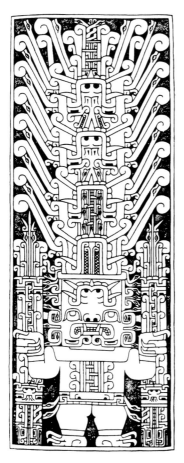
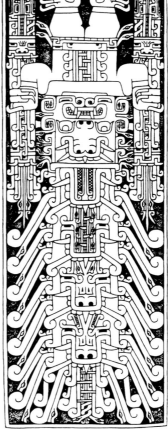

suggesting it is late. Its image is barely perceptible, only lightly incised on the reflective stone surface, and is seen best in drawings. The illustration shows two views of the monument, upright (left) and inverted (right) to clarify the double readings embedded within its one figure. Upright, the lower third of the slab depicts a standing figure with splayed taloned feet, arms to the side holding two vertical staffs made up of faces, snakes, swirls, and vegetation. The principal face has pendant irises hanging from the top of the eyes, a downturned fanged mouth, and is crowned by a huge elaborate headdress ending in alternating volutes and snakes to the sides. This supernatural being, known as the Staff God, has predominantly agricultural fertility associations.

However, when the inverted figure is perceived, the standing earth deity takes on a different face and character as it descends from above. The exact same lines are used to form a completely new image, by the extremely sophisticated use of contour rivalry. The same principal eyes, now with irises at the bottom, join with an agnathic mouth that formerly was on the forehead to form a new animalistic principal face. Another face above the principal one uses the original mouth, now upturned, and adds eyes and a pug nose formerly ignored as part of the chin. The body and staffs remain, but now appear to be plunging down from the sky. Most strikingly, the towering headdress suddenly becomes a series of animal faces: eyes plus mouths emanating one from another create a strange group of nested super-naturals. Through extraordinary, gravityless artistic visualiza-tion, the profound religious message of duality within oneness (not unlike the Judeo-Christian Trinity) is conveyed. Distinct earthly and celestial deities are one and the same, a paradox elegantly resolved in a transformational whole that betrays the real aesthetic and ideological genius of Chavín art. The Raimondi Stela could have been placed upright, in the ceiling, or on the floor, we will likely never know. In any case, informed viewers could be taught to perceive the two versions through mental and physical effort, initiated into the mysteries by a visual challenge that successfully mirrored the sacred concepts.

Although Chavín de Huantar and its cult finally waned around 200 BC, it had enjoyed a phenomenal longevity and sparked a true creative revolution in the Andes. Its reverbera-tions all along the coast via portable art speak to its successful translation into local vocabularies, as well. Chavín de Huantar sent its message far and wide by disseminating its distinctive style of objects.

Portable Chavín art

The Chavín style was not only expressed monumentally, but in all media. Religious tribute, found under the temple at Chavín de Huantar, included: hundreds of ceramic vessels in various styles, exotic cut shells from far to the north, obsidian (volcanic glass) from far to the south, weaving tools, drug paraphernalia (snuff tubes and tablets), and reportedly goldwork. These materials and works of art came from near and far, all along the coast where the Chavín spread their distinctive religious message via portable art objects. Numerous local styles had preceded and run concurrently with it, but the powerful Chavín style and imagery often dominated. Local versions, never absolute copies, remained adaptations, variations on a set of themes. Yet it is remarkable that hundreds of miles away in environments and among cultures quite distinct from those of the highlands, items were produced that are instantly recognizable as Chavín inspired. Chongoyape gold of the North Coast, Karwa textiles of the South Coast, and two ceramic styles known as Cupisnique and Santa Ana represent early Andean examples of fancy sheet metalwork, elaborately painted textiles, and the stirrup-spout vessel form, respectively. The Early Horizon was a time of explosive technological innovations in many media, seemingly fueled by Chavín expressive needs.

Though seen in rudimentary form earlier at Mina Perdida, sheet metal technology finally took off in the Early Horizon with important technological refinements, such as soldering (affixing pieces of metal by melting a few drops of metal like glue at strategic points to convert sheets into three-dimensional objects), and repoussé (patterning metal sheets by hammering on the reverse face to raise relief). Chavín-style goldwork is known generally as Chongoyape for the far North Coast site where a wealth of beaten gold objects were cached and interred. Gold sheets were worked into tall cylinders, probably crowns, and adorned with versions of the staffbearer. Yet other crowns buried with these were decorated in a more representational style known as Cupisnique, showing that local and influencing styles coexisted. In the Chavín-style pieces, the tendency toward illegibility continues as the glittering, reflective surfaces create complex designs only by flickering shadows in the indentations. Burger suggests that the choice of gold itself was typically Chavín in its intention to impress, to be 'wholly other,' and so to immediately and suitably distinguish sacred messages. Gold, being truly immutable as well as seeming to contain the sun it

so beautifully reflects, continued to be the choice for exclusionary, high-status, and sacred imagery from this time onward. Gold objects were almost all headgear, face masks, pectorals, or appliqués on clothing; by the concept of essences, the immutable and energy-filled gold worn on the outside reflected those inner qualities of the wearer.

Smallscale, often reductive versions of faces and figures are incorporated into this wearable gold art. Whether due to the limitations of space or the amount of detail possible in repoussé, or the need to convey new ideas to the uninitiated, on the whole, goldwork images are less complex than those in other media. On the circular pectoral reportedly from Chavín de Huantar, a fairly readable central frontal face has the characteristic upturned fanged mouth, pendant irises, and here a truncated pair of snakes as the missing lower jaw. Although simplified and isolated, the face necessitates decoding to those unfamiliar with the stylistic rules. Around the edge the simple yet finely wrought braid motif is a convention in Chavín-style textiles as well. Although it may serve primarily decorative purposes, the braid is an image of continuity and interrelatedness that subtly reinforces the cult's unifying message. The Chongoyape crown features the whole figure, its face erupting into snakey swirls above in a shorthand headdress, its torso substituted with a frontal face, and hands to the side holding modified staffs. While correct in its imagery, the combination of features is nevertheless unique. Neither pectoral nor crown exactly matches a cult monument or other goldwork; evidently technical creativity also extended to the local artistic interpretation of the sacred iconography, within limits. These artists must also be recognized for the great skill needed to create such small

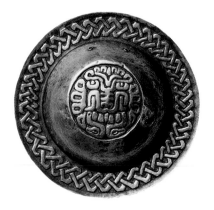

30. Repoussé gold alloy pectoral reportedly found at Chavín de Huantar, with a central frontal feline face emanating snakes and a braided encircling pattern. Early Horizon.

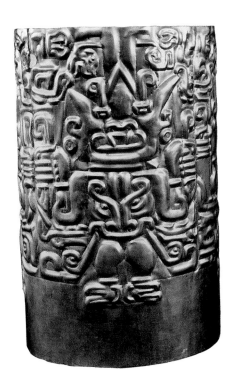

31. A gold repoussé crown, 9¼ inches (23.5 cm) high, found at Chongoyape on the far North Coast. This crown shows a representation of the supernatural Chavín staffbearer, also seen on the Raimondi Stela (see ill. 30). Early Horizon.

masterpieces: from alloying metals at over 800°C (1472°F), to alternately pounding and precisely heating the very thin, fragile metal sheets, to visualizing and executing the intricate designs in reverse.

Textiles in the Chavín style are known from the burials at 32, 33 Karwa, a looted South Coast burial site located over 300 miles (500 km) from the cult center. They recreate in a perishable, portable form a complete ritual environment, paintings resembling closely the layouts and sculpture of Chavín de Huantar. Yet they also betray a decidedly local emphasis on cotton and female imagery. Scholars presume that the Chavín cult spread by establishing secondary cult centers, probably described as wives or children, along the model of the later pilgrimage center of Pachacamac. Karwa seems to have been figured as a wife, sister, or daughter of the main cult center at Chavín de Huantar, given its stylistic and iconographic parallels plus its unique female emphasis.

The Karwa textile compositions were painted in shades of brown and rose dye on plain woven cotton cloths, a local coastal product. Some were sewn together to form very large pieces,

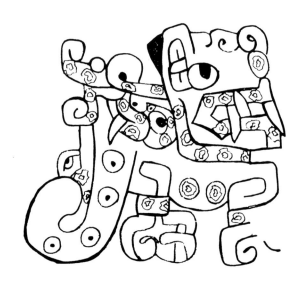

32. Drawing of a painted South Coastal Karwa textile representing parading jaguars as in the Sunken Circular Court at Chavín de Huantar (see ills. 20, 21, 22). Early Horizon.

such as one which represents a circle of jaguars that rivals those from the Sunken Circular Court in relative scale. Hung on the wall it would directly represent the main cult in two-dimensional, easily transported, and comprehensible form. Other Karwa textiles include belts painted very like that depicted on the Lanzón and cloths decorated with staffbearing figures and San Pedro cacti. Hangings, canopies, covers for altars, clothing – over 200 items – represent the full range of ritual items to recreate an entire Chavín cult center in cloth.

Yet, not mere copies, Karwa textiles illustrate many female figures. The supernaturals are always explicitly feminine, with eyes substituting for breasts and opened fanged mouths for vaginas, as on the Black and White Portal figure, and carrying vegetal staffs, as on the Raimondi Stela. Some of the staff goddesses hold intertwining strand staffs, perhaps textile referents, while other compositions depict animated cotton plants with characteristic trilobe leafs and cotton bolls. Profile attendants are portrayed as either male or non-gendered and do not reveal new images when turned, as do the females, which are therefore elevated like the Raimondi image. This configuration of Earth Mother and lesser attendants made clear a familial relationship to the cult center, gave foreign imagery relevance to local concerns by linking Chavín assurances of fertility to a vital South Coast crop, and embodied an age-old association of females and textiles. As propaganda, the cloth ritual environment of Karwa was designed for effectiveness, impressiveness, and appeal.

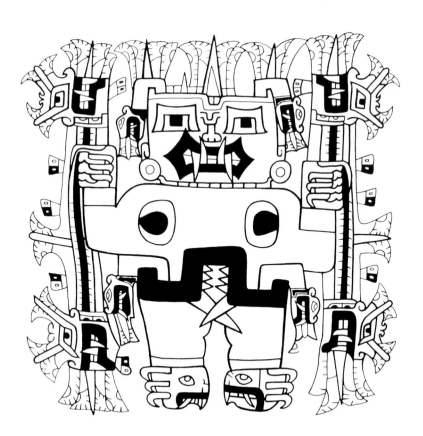

33. Drawing of a painted Karwa textile, showing a female deity figure. Via portable cotton textiles, the Chavín style was exported over 500 miles from Chavín de Huantar to Karwa on the South Coast. Early Horizon.

Chavín-style ceramics were widely distributed along the coast, overlapping and diverging from a plethora of local styles. The working of clay at this time shares certain basic characteristics: particularly the stirrup-spout form, in which a cylindrical upright spout splits into two curved ones joining a globular vessel; and incising with selective burnishing, in which lines drawn into the moist clay separate raised pattern areas rubbed to a glassy sheen from background textured or matte portions. Vessel bodies feature three-dimensional standing jaguars, seated humans, plants or fruits, as well as simple globes with abstract incised patterns, such as double-headed snakes or dynamic swirls. These images are again taken from the stock cult imagery, but even more reduced to essentials. Technically the pottery of this time is of extremely high quality, often with very thin walls, accurate and delicate incised outlines, and a high degree of burnishing (which is very challenging since it involves hard pressure exerted when the vessel is at its most vulnerable before firing). Aesthetically, Chavín-style ceramics epitomize elegance and power.

34, 35

The best known ceramic substyle is named Cupisnique. Having gone through various changes, the typical Cupisnique stirrup-spout is comparatively thick and sports a pronounced lip at the top. Cupisnique ceramic sculptures achieve a bold monumentality. The diagnostic fanged faces covering the vessel body and traveling up the spouts are worked in deep relief of shiny on matte black. Low-contrast understatement once more challenges the viewer to decipher the complex image. Other related substyles abound, such as the earlier Santa Ana, distinctive in its red and black coloration. In fact, both of these Chavín ceramic substyles feature fanged heads connected by an undulating line, which serves as the hair of one head and the tongue of the other. These two styles fall at extremes of a continuum from heavy to light, descriptive to abstract, demonstrating the variation inherent in Chavín-related portable art. Yet, like the Black and White Portal figures, they follow the main style 'rules,' such as the wrapping of images around three-

34. Cupisnique-style ceramic stirrup-spout vessel in typical blackware technique. Raised profile faces, with typical Chavín pendant-iris eyes and crossed fangs, are connected to one another by serpentine lines, as in ill. 35. Early Horizon.

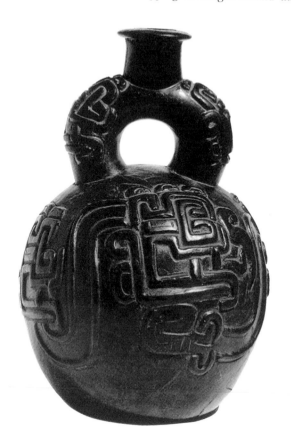

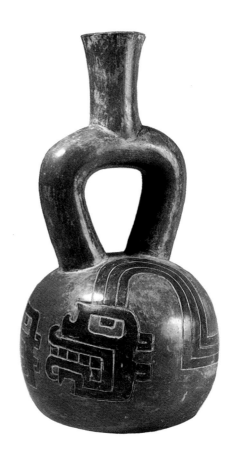

35. Santa Ana stirrup-spout vessel. This substyle of Chavín-style ceramics is distinctive in its red and black coloration and highly abstracted imagery. Early Horizon.

dimensional forms. With the more limited surface area of a stirrup-spout on which to work, the artists have concentrated the images into shorthand form. Nevertheless, by preserving such key features as pendant irises in the eyes or volutes for nose, ears, and lips, these ceramics still convey the essential Chavín elements to the diverse peoples outside the cult center.

Portable art plays this distilling, didactic role not only during its own time, but even continues to do so in later periods. In fact, Chavín art had a long life after its time: the stirrup-spout form pervades many subsequent Andean ceramic styles, fanged heads play a role in the Paracas style and even later the Moche, and staffbearers resurface with the Wari and Tiwanaku empires. However, the global vision of the cult was not recaptured for nearly a millennium as local movements took over during the Early Intermediate Period.

Chapter 3: Paracas and Nasca

In different parts of the Central Andes, during the later Early Horizon and after the Chavín style lost sway, other important local styles emerged. The South Coast Paracas people developed one of the most recognizable and important of these styles, their vision reaching new technical and artistic heights. They spanned the end of the Early Horizon and beginning of the Early Intermediate Period, *c.* 600–175 BC. Chavín influence, strongly visible in early Paracas ceramics, nonetheless was filtered through local colors, techniques, and stylistic choices. Soon the coastal artists went their own way, reveling in color effects, curvilinearity, and exploring local subject matter in one of the more naturalistic styles of the ancient Andes.

The Early Intermediate Period, *c.* 200 BC–AD 500, was a time of varied regional styles sharing different versions of naturalism. Paracas shaded into the Nasca style on the South Coast, while the Moche developed independently on the North Coast (Chapter Four). During this time, when no single cult unified Andean art, several adjacent coastal valleys shared a regional aesthetic, their social ties not entirely clear. Paracas, a village culture with a high-prestige burial center as its focus, differed from Nasca, seemingly a loose confederation of clans or chiefdoms, while the Moche organized at the state level. All three preserved elements of Chavín art but in unique styles.

The Paracas style
Paracas artists took a 'high-intensity' approach to the ceramics, textiles, and goldwork they created: concentrated and time-consuming labor, insistent repetition and variation of motifs, great visual profusion, extreme colorism, and attention to detail. Although internally varied, Paracas art tends towards curvilinear forms and superstructural techniques, from colors painted on ceramic *after* firing, to flowing figures meticulously embroidered on finished cloths. A secondary tendency towards geometry and structural methods can be seen (in the fiber arts in particular), showing that Paracas artists excelled at a variety of substyles and approaches. For instance, they adapted embroidery to two radically different artistic goals and achieved curves

in an especially rectilinear structural fiber technique. The Paracas artists epitomize the Andean creative spirit in this disdain for technical determinism (the medium and working method necessarily determining the resultant look, such as a textile design being insurmountably governed by the warp-weft grid).

The culture that encouraged this expressive exploration was based on the Paracas Peninsula, the most jutting landmass on the South Coast, with bays above and below. Fishing these protected waters of the Humboldt Current, growing crops in the nearby Pisco Valley, and trading for distant luxury goods such as camelid fiber, feathers, and spondylus shells, these villagers built up a life of unexpected richness in the arid dunes. Not hospitable in the least ('Paracas' in Quechua means 'sand falling like rain,' for the blasting late afternoon winds), the environment encouraged subterranean architecture, particularly shaft-tomb burial chambers. Yet over time, the population grew to a height of several thousand and moved inland. They buried their dead bundled with fabulous weavings and offerings, first on the top of the prominent Cerro Colorado ('Red Hill') in bottle-shaped shaft tombs known as Cavernas ('Caverns'). When filled, they established cemeteries to the north of the hill near their village, Arena Blanca ('White Sands'). Finally they interred over 400 mummy bundles in the great Paracas Necropolis of Wari Kayan between the first two cemeteries. These may constitute the world's richest burial grounds in terms of preserved ancient textiles.

However, the story of Paracas art begins with ceramics. An influx of characteristic Chavín imagery and stirrup-spout vessel

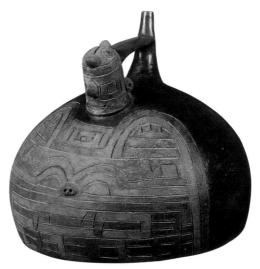

36. Early Paracas ceramic vessel showing Chavín influence in the pendant irises of the effigy head and the frontal fanged feline face incised on the body. Early Horizon.

form is obvious in the earlier Cavernas burial ceramics of this region. The familiar North Highland fanged faces with pendant irises appear on both intrusive stirrup-spout and local spout-and-bridge bottles. Even in these takeoffs there are noticeably non-Chavín features, such as blackware backgrounds with multicolor post-fired paint and incised outlines for every detail, the hallmarks of the Paracas ceramic tradition. Chavínoid interpretations vary, some reaching an extreme of rectilinear reductivism, layering parallel lines cross-cut with fangs until the referent is nearly lost. Here a frontal feline face, with round ears, crossed fangs, and a modeled nose, serves as the body to a human effigy. As so often occurs, an intrusive strain sparks experimentation, then becomes absorbed into a new configuration: Paracas ceramics quickly feature local subjects, especially coastal foxes, owls, swallows, and falcons. The new palette is firmly established as mustard yellow, olive green, terracotta, white, and black.

These colors – the yellow and green being very unusual in ceramics – reflect the freedom inherent in applying pigments after firing. The process is as follows. A pot is formed from wet clay, partially dried, and its surface incised with the outlines of the complete design. It is then fired in a pit, the fire being smothered with ash partway through so that the smoke is driven into the pot's surface to produce 'smudge blackware.' Afterwards resin (probably from the acacia bush), mixed with mineral pigments, is painted on between the outlines and allowed to harden. As a final finishing touch, some pieces seem to have been warmed slightly to remove all brushstrokes, since the color areas are remarkably smooth. Because plant resin remelts, these vessels were purely ceremonial. In fact, their fragile, slightly gritty surfaces can revert to a chalky residue over time. However, post-fired painting was evidently preferred for its capacity to produce bright, varied colors impossible to achieve by other means, as part of the overall Paracas fascination with the rainbow colors of their world. The ceramic artists' ability to sketch an intricate design, then accurately fill it in, is mirrored by the way in which textile artists approached the main embroidery substyle. Often the incised outlines themselves were painted with a contrasting color, another feat of manual dexterity that betrays interest not only in the possibilities of color but also in linearity, a powerful pairing developed further by the subsequent Nasca.

Later Paracas-style ceramics – masks, huge ovoid jars, bugles, and other boldly shaped and brightly decorated objects –

37. This later Paracas ceramic mask of the 'Oculate Being,' probably a shamanic spirit (with double-headed snakes and a human shaman as a forehead ornament). It is incised and painted after firing in the characteristic Paracas palette of green, ocher, orange, and black. Early Intermediate Period.

become very idiosyncratic. The favored local vessel shape is the double-spout-and-bridge, with two upright, tapered, rimless spouts connected by a gently arching element. The vessel body can take on unusual forms, even crescent-shaped double-headed animals. Among the most imaginative and unusual are masks that portray a large-eyed supernatural (known as the 'Oculate 37 Being'). Large eyes are characteristic of a number of related shamanic elements: nocturnal animals' round and reflective eyes,

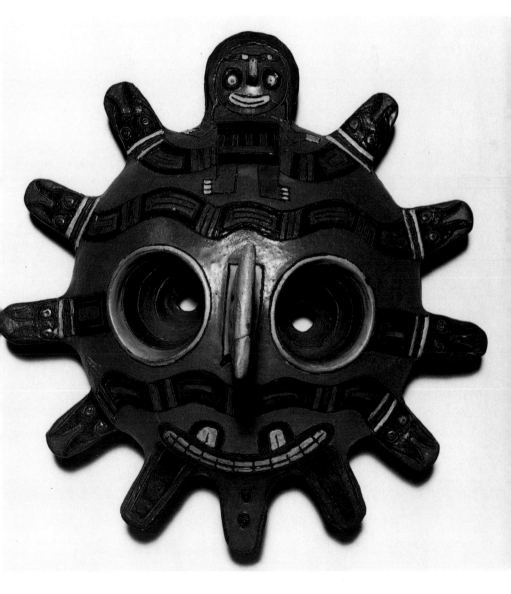

especially those of the owl, a prominent animal alter-ego of the shaman, plus the shaman's own bulging, dilated eyes and resulting special kind of vision(s). This mask is further endowed with undulating double-headed snakes, fantastical creatures seen in hallucinatory visions and standing for shamanic power throughout the ancient Americas. The small human figure has one of these snakes on his forehead and another, which emanates from his sides, forms the forehead snake of the main being, in a tight unity of shaman (above) and supernatural spirit (below). The round eyes and ecstatic mouth are repeated in the human and spirit alike. Shamans are the subject of much Paracas art, especially the embroideries for which this culture is best known.

Paracas textiles

Paracas burials range from the modest to the very sumptuous. Only a few feet under the sand a lower-status person was wrapped in a rough cotton mantle, and surrounded by several simple pots. By contrast, a leader was wrapped in enormous numbers of plain and fancy textiles to form a mummy bundle up to 7 ft (2 m) high. Offerings of gold, feathers, animal skins, and imported shells accompanied him. The earlier Cavernas bottle-shaped tombs contained multiple burials (up to thirty-seven in

38. Schematic diagram of a typical Paracas mummy bundle with the corpse in a fetal position seated in a basket and wrapped with layers of plain and embroidered textiles (the creation of which took from 5000 to as many as 29,000 hours to accomplish). Early Horizon-Early Intermediate Period.

39. Mostly unwrapped Paracas mummy bundle, showing the body adorned with gold nosering, spondylus shell necklace, and embroidered garments. Early Horizon-Early Intermediate Period.

40, 41. Drawings of the layers of a typical Paracas mummy bundle: embroidered mantles in a typical middle layer; outer layer with feather-tipped staff and plain wrapping cloth below. Early Horizon-Early Intermediate Period.

52

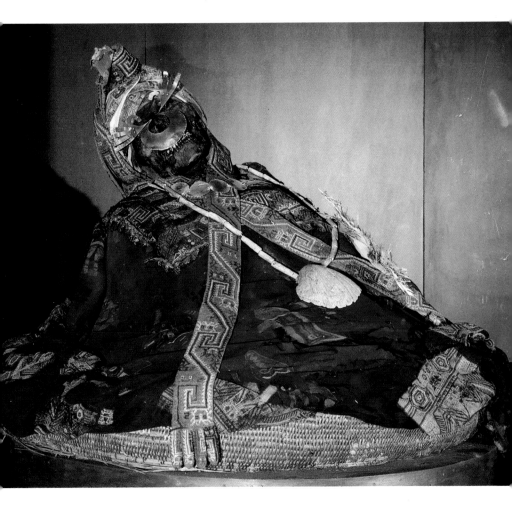

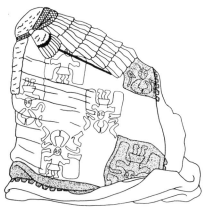

one chamber), the variously sized bundles piled one on top of another. Some burials seem to have had the largest bundle in the center, with medium-sized bundles around it and smaller ones on top, as if the most important person were surrounded by his people. The proportionately larger numbers of everyday and middle-class versus upper-class bundles describe a recognizable social hierarchy. Only large and medium bundles have been opened and all the skeletons inside were reportedly male; presumably the small ones contain mostly females. Not all bundles were interred in rooms; in fact, when first excavated the Necropolis cemetery looked 'like a field of potatoes' with the exposed tops protruding from the sands. The Paracas wound the fetal-position body like a giant bobbin with garments and wrapping cloths, and offerings inside the bundle. In this way, individuals maintained their integrity and associated goods in the mass burial. In fact, specific personalities come through in the Paracas bundles particularly via their textile contents. [38]

To understand these complex textiles it is important to explore briefly their context in the mummy bundle. The exact configuration of various bundles follows basic rules but each is unique. Anne Paul has described one of the largest Necropolis [40, 41] mummy bundles, 5 ft 6 inches (1.7 m) in height and 4 ft 7 inches (1.4 m) across the base, containing 44 fancy and 25 plain cloths. Food offerings of maize, yuca (a potato-like tuber), and peanuts were placed around a large basket containing the body on a complete deerskin. Food offerings bespeak a belief that the body needed sustenance in the afterlife, and may have described the deceased as a fertile producer or controller of different zones. Deer seem to have been especially prestigious animals (among the Moche they were reserved for elite consumption and sacrificed as human substitutes). Around the body was unspun camelid fiber, a spondylus shell, a pouch perhaps with body paint, and a human skull. These imported and hard-won prestige items demonstrate the power of the deceased to command luxuries, take part in powerful rituals, and conquer enemies.

Next in the mummy bundle came layers of plain and fancy textiles, mostly wound around rather than dressed on the body. The first fifteen embroidered garment sets, many unfinished, were probably gifts because of their fragmentary state and distinctive iconographic themes. The whole thing, including the basket, was then wrapped in rough cloths. Plain textiles, some more than 33 ft (10 m) long, increased the bulk of the

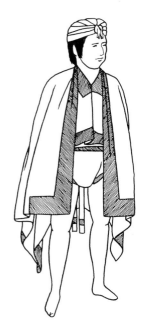

42. Elite Paracas men wore many layers and types of fancy clothing: turbans, shoulder mantles, short ponchos, and loincloths. These embroidered garments were also wrapped around their mummy bundles (see ills. 38–41) at their death. Early Horizon-Early Intermediate Period.

larger bundles, making the more important people 'larger than life' and better protected in death. High-status living people also appeared bulky, wearing layers of loincloths, skirts, tunics, and ponchos with large shoulder mantles, turbans, and headbands. The outer bundle layers featured two staffs and an animal skeleton, six mantles, a leather cape, a yellow tropical bird feather tunic, a staff with feather top, and a final headband. These staffs, placed as if being held, reiterate authority, as do sacrificial animals and the prized feathers of the far-off Amazon. All this concentrated finery was then completely enclosed and buffered in a large plain wrapping cloth sewn up with long stitches.

Other bundles vary as to the number of cloths, the kinds of garments, their decoration, the other offerings included, and the positions of all this finery. Thus, the Paracas people could express a lot about a person, from hierarchical position to clan affiliation. These choices not only express the individuality of the deceased, but also that of the artists who devoted so much time to the wrappings. Textiles on such a massive scale (one measured an almost unbelievable 11 by 85 ft [3.4 by 26 m]) and with so much decoration (often as much as 75 percent of the surface is covered with minute embroidery stitches), demanded extraordinary planning, skilled execution, and time. According

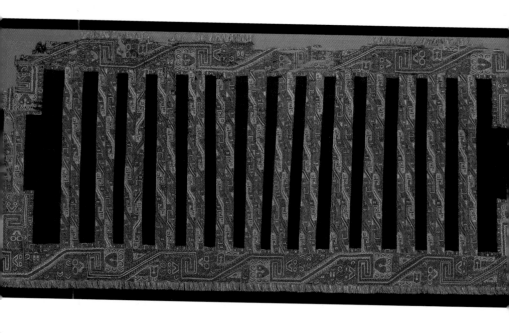

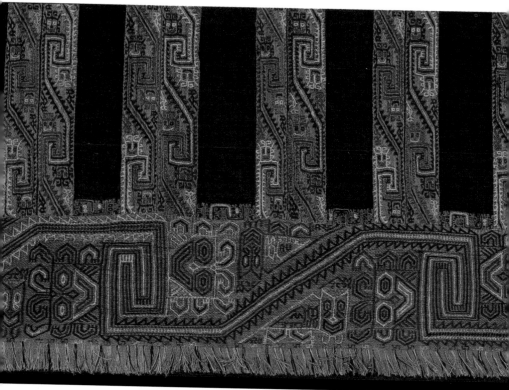

to Paul's estimate, bundles may have taken from 5000 to as many as 29,000 hours to produce. Seemingly whole families devoted their lives to making splendid garments for the dead.

Paracas artists developed an embroiderer's apprentice system, according to a 'training' mantle analyzed by Anne Paul and Susan Niles. A central column of well-embroidered, consistent figures among more tentative, error-filled flanking columns reveals the location of various learners' attempts to copy the master's example. It is fascinating that such a practice piece, as well as unfinished compositions, were interred. Perhaps there was the perceived need for as many fancy cloths as possible when the person died suddenly, or if a given piece were being made expressly for that person it must accompany him or her regardless of its state. Unfinished compositions also leave open the possibility of completion on the Other Side, as in Andean belief death is an open-ended and active state. Whatever the case, such partial compositions reveal the creative process, the various ways Paracas textile artists approached embroidery, and even fundamental beliefs and values.

The vast majority of Paracas textiles are embroidered and fall into two main stylistic groups, Linear and Block Color. The two styles differ greatly, from straight lines to curves, few colors in thin lines to a full palette in broad expanses, and from repetitive to innovative imagery. The creative process was almost opposite as well, despite both being made with simple stitches. In Linear Style the thread is simply sewn in and out of the ground cloth, always in a forward motion, leaving short lines of thread visible on the top, while in Block Color 'stem stitches' were taken (consisting of a forward stitch, half a backward stitch, then another forward stitch) forming a line of slightly overlapping diagonals. When massed up, both create strong color areas and were used to cover a large amount of the ground cloth. This in itself is an unusual use of embroidery, a technique rarely employed for coverage but rather for intermittent accents. Yet Andeans, particularly the Paracas people, favored intense solid color areas and lavished great quantities of time and materials on 'non-efficient' techniques. As burial items, excessive labor and resources themselves praise the power of the deceased.

Linear Style, the first Paracas embroidery style to evolve, is first found with the Cavernas cemetery mummy bundles. It continued almost unchanged for 400 or so years, coexisting with the Block Color in most mummy bundles. Most probably the same artists worked in both widely divergent styles. As its name

implies, it consists only of narrow straight lines on the horizontal, vertical, and diagonal. In nearly every case only four colors are employed: red, green, gold, and blue. Motifs typically fill borders, accent neckslits, and appear in columns in the center of mantles. Control, precision, and strict repetition are the rule, with only slight variations to add dynamism. The characteristic motifs are nested images combining felines, birds, snakes, and faces, all with upturned mouths. All available space is filled, with puzzle-like precision. For instance, on the borders of this mantle a serpentine spiral connects sideways 'Oculate Beings,' the triangular interstices filled with felines, themselves filled with and surrounded by smaller felines.

Such complex embedded series of images remain somewhat visually elusive, since images are built up of only thin lines and the background of the border is one of the body colors as well. This effect has been termed 'transparency' to call attention to the fact that figures appear permeable and insubstantial. The embroiderers have manipulated our perception of figure and ground (a solid clearly portrayed on top of a continuous backdrop); intentional confusion results from the ground invading the figure. Figures cannot be easily separated from their surroundings or from one another. Linear Style artistic choices seem to communicate abstract, conceptual ideas, such as the traditional Paracas supernaturals and the interrelatedness of all Nature. The spirit realms accessed by shamanic visions would not be characterized by images of solid bodies in realistic spaces. (Albeit different in style, medium, culture, and place, this Paracas substyle shares with the Chavín an emphasis on non-human imagery presented in a perceptually disorienting way.)

These abstract concepts, maintained largely unchanged over time, like the principal tenets of all religions, were highly controlled. Artistic innovation was rarely permitted. In order to preserve images intact over time, they had to be communicated exactly from one generation to the next. Unfinished compositions tell us how Linear Style images were made and suggest how they were transmitted. Interestingly, they were *not* made utilizing the inherent freedom of embroidery threads to move independently of the cloth's warp and weft grid, sketching out any chosen design. Rather, embroiderers built up patterns row by row as if they were weaving, counting the number of ground cloth threads to sew over and under. For example, at the mantle edge the embroiderer sewed over and under the ground cloth where the border's background red was to appear

for at least one repetition of the entire serpentine design. The artist left the ground cloth showing where the lines would be filled in subsequently to form the feline's feet, emanations of the face, and zigzag border of the serpentine image. Then the next row of red was added, often sewing over and skipping a different set of the cloth's threads so as to leave spaces for diagonal lines. Only after the entire background was laid out were the lines filled with blue, gold, and green. Thus the design was approached negatively, i.e. the background defined the figure. Such a method could be expressed as a mathematical sequence ('over ten, under four, over six…'; somewhat like modern knitting instructions). One artist could have passed to another only the background sequence, so that complex designs were easily learned and kept stable. The creative process also reveals that the figure was not built up separately from its background, just as it is not perceptually independent in the final product. The way it was made and the end result are one and the same, suggesting the ritualized and unified nature of sacred Linear Style images. In Andean art as a whole, the process is as important as, and instills the basic essence in, the work of art as it finally appears.

Although somewhat regimented for higher spiritual reasons, these compositions remain extremely challenging to create and impressive in design. Even broken down into rows, the complexity of the embedded images forced embroiderers to visualize the whole pattern, keeping track of their place in each detailed image (on the same row are the middle of a large feline's face, the top of a small feline's back, the edge of an 'Oculate Being's' ray, etc.). This requires great focus, on top of the technical skill, to make even stitches in consistent tension so as to prevent puckering. Even one mistake would necessitate taking out all subsequent rows, to keep the pattern regular.

Block Color embroidery was added to the Paracas repertoire 45-47 slightly later than Linear Style, but persisted to the end and appeared alone in the latest mummy bundles. It emphasized creative modification and variety almost as much as Linear Style restricted it. Block Color style features outlined, curvilinear figures whose elaborate costumes and accoutrements are solidly filled in with brightly-colored stitches. The palette includes nineteen different colors. Motifs typically fill borders, as in the Linear Style, but also dot the centers of garments in columnar and checkerboard arrangements. Great dynamism is conveyed by figures' arching, twisting bodies in varying color combinations

that follow complex patterns of repetition. In contrast to the Linear Style, Block Color compositions feature clearly legible, non-transparent figures against the continuous ground cloth with which they contrast in color. This style eschews abstract concepts, to portray palpable humans ritually impersonating and transforming into animals and composite beings; its subjects are of this world, although the shamanic referents are ultimately aimed at the super-human. Block Color is therefore complementary to Linear imagery; it is understandable that they should both have been included in most Paracas mummy bundles. One provides the deceased's connection to the larger social continuity and shared religious beliefs, while the other shows the ritual activities constantly reinforcing the individual's contribution to society and spirituality.

Block Color compositions changed over time, varied one from the next, and give us a lively glimpse into certain real objects and practices of 2000 years ago. There are nearly as many different versions of figures as there are pieces, although only rarely more than one type of figure in a given piece. One, famous for its stunning workmanship and telling clues as to process, features bird impersonators in outspread feathered capes carrying trophy heads and arching batons. Each tiny figure, only 5 inches (13 cm) tall, sports one of four distinct mask patterns and costume color combinations. Not all figures are wholly human, since the feet in this piece hang vertically and sport a back 'talon' like a raptor (or a 'thumb' like a monkey).

45. Partially finished Block Color-style figures of bird shamans with feathered cape/wings and animal feet. In this style of Paracas embroidery, the embroiderers first outlined figures then filled them in (here the faces and trophy heads are not yet complete). A clear visual separation of figure and ground was thus achieved. Early Intermediate Period.

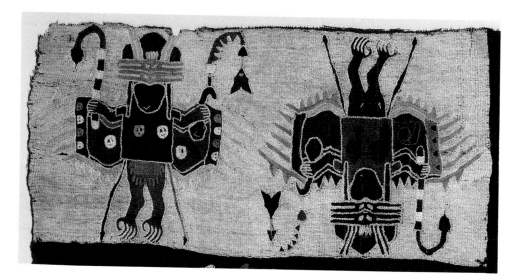

Elsewhere on this mantle are two unfinished figures, the upper one with most of the top, the lower one with only some of the bottom of a bird-man. From this we can tell that the embroiderer began by outlining the silhouette and important internal portions, as in a sketch. Within a border, the outline was the same color as the background, which was then filled in, and finally the internal figure colors were added. In the field just the latter was necessary. This exquisite mantle's matching loincloth (many Paracas pieces are garment sets) has only its bird-men outlined and the border background finished. It is as if the embroiderers heard the tragic news of the patron's death, lifted their needles from the surface, and took the textile masterpiece to the graveside. Recently the poncho that was part of this set was rediscovered and, unlike the other garments in the set, this poncho is completely finished. These pieces show how the Block Color style takes the opposite approach to that taken in the Linear Style creative process: the figure has precedence, both over the ground cloth and the background, which was only established after the figure had been delineated.

In keeping with the individualism of Block Color some outright formal irregularity was permitted in this substyle, especially in images of shamans who, as spiritual leaders, were in many ways 'above the rules.' The illustration here shows the typical shaman, head thrown back, hair streaming, a beard (interestingly a feature of shaman depictions in ancient Mesoamerica as well), and what may be an hallucinogenic mushroom in his hand. In this piece, the clear rows of figures break down (extra ones to the right throw off the design). The shamans seem to dance or fly, just as shamans were believed to do during healing trance states. The exuberant sloppiness of the pattern accentuates the energy and barely-contained chaos of the priestly intervention into the supernatural. Again, the making of the piece, its design, and its intended message are completely congruent.

Even these few examples of the thousands of extant Paracas compositions show how one technique such as embroidery could be applied in many different ways, towards divergent yet complementary goals. It must also be appreciated that these were not just static works of art or wrappings for the dead, but most also had a role to play in clothing the living during the many Paracas rituals. Art in the Andes was made to be activated through pageantry. Just as artists were not bound by technical limits, so sacred garments transcended everyday

45

46, 47

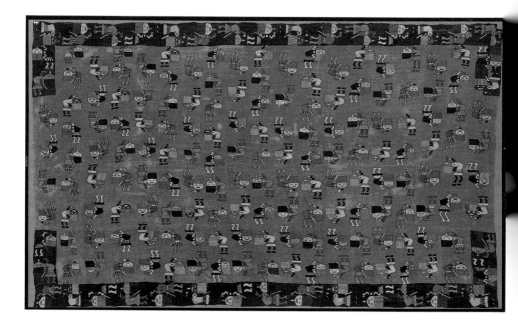

46, 47. Paracas Block Color style mantle and detail with flying shaman motifs. The bent position, loose hair, beard, and probable mushroom in the hand are characteristic of shamans. Early Intermediate Period.

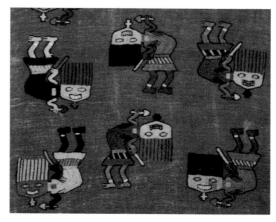

practicality to soar as symbols of other realms and human attempts to access them.

In addition to embroidered garments, the talented Paracas fiber artists mastered a spectacular structural technique (unique to the Andes) known as discontinuous warp and weft. Late Paracas/early Nasca hangings feature huge mythical beings made in one of the most unusual and demanding techniques possible in fiberworking. In weaving, usually the threads in one direction are continuous, i.e. they pass vertically or horizontally across the loom uninterrupted. This is not only the easiest to

accomplish but makes a stronger cloth, especially when the warp is continuous (the load-bearing threads placed on the loom first). But it is possible to create a pattern by making both the warp and the weft threads discontinuous, that is linking up various different colors along the way, though it is tedious and confusing work. It is necessary to stretch temporary scaffold threads across the loom to hold the intersections of one color warp and the next until all the colors are connected. Then the mass of multicolor strings can be drawn tight enough to weave in the crossing wefts in matching color areas. The more complex the design, the more color changes, the more scaffolds needed; in compositions as mind-bogglingly complicated as this, the number of scaffolds can be estimated by tracing the number of different colors along any one line. The actual design would have been almost totally obscured by the scaffolds; perhaps the weavers worked from the reverse side, one of the many working relations to the loom Andean textile artists employed over time. Evidently the weavers chose such a technique because it achieved a contradiction – solid, rich colors in a lightweight,

48. Late Paracas/early Nasca hanging created in the extremely arduous technique known as discontinuous warp and weft. A masked flying figure dominates this fragment. Originally the composition covered perhaps an 8-ft length (2.5-m) in intricate images. Early Intermediate Period.

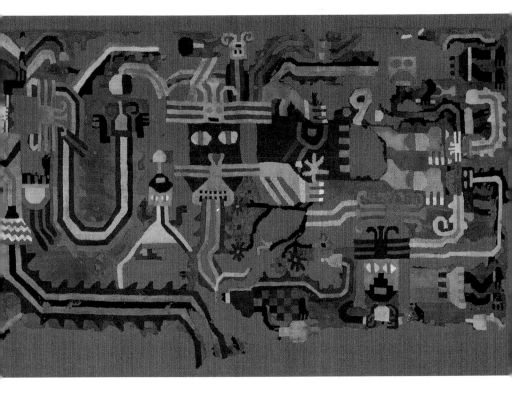

gauzey cloth – but it may also simply embody the height of artistic virtuosity demanded by the most sacred images.

Because of the fragile, incomplete condition of the cloth and the complexity of the design, individual figures may be difficult to read. The horizontal figure (with vertical head) slightly to the left of the upper center has large white eyes, a light blue mouth mask, and serrated mouth emanation. His yellow arm, with white-tipped nails, holds a scraggly bunch of flowers. The technical challenge increases our appreciation of the many curved shapes, such as these flowers, every tiny step of which needed a scaffold. It is impossible to estimate the amount of time lavished on the creation of these hangings and it is no wonder that so few of them are known, in comparison to the embroideries. They were obviously of the highest importance and symbolic power. They are also probably quite late in the Paracas trajectory, forming a transition to the Nasca style, which often featured large-scale versions of Paracas figures and employed discontinuous warp and weft 59 predominantly in geometric patterns.

The Nasca style

Further south in the Ica and Nasca Valleys and later in time (AD 1–700), the Nasca culture began at the tail end of the Paracas trajectory; indeed there was no genetic distinction between the two populations. Paracas occupations are being found under Nasca sites, and their art styles are understandably closely linked, especially in terms of subject matter (shamans, animals, bodiless human heads) and vessel forms (double-spout-and-bridge containers, musical instruments). Yet their technologies differ, post-fired paint yielding to slip painting in ceramics, and embroidery to many other textile techniques. In addition, just as Paracas veered off from an early intersection with Chavín, so too Nasca art developed independently as a style. The ceramics went through a number of changes, from an earlier naturalism to later 'baroque' elaboration and a final encounter with even more abstracting Wari style. Colors were of primary importance in 54 various media, with an unusual inclusion of maroon and blue-grey in ceramics and a characteristic palette of red, yellow, and sometimes green in textiles. Yet, at the same time, linearity is highly diagnostic of Nasca art, whether the black outlining of figures or the famous giant Nasca Lines on the plains them- 60, 61 selves. Sublime abstraction in some textiles shows that over the Early Intermediate Period and around the South Coast there was wide variety in what can be called Nasca, in keeping with the

socio-political diversity scholars such as Helaine Silverman and Donald Proulx are finding in the archaeological record.

The political organization of the Nasca does not fit neatly into either of our categories of state or chiefdom, with its apparently independent but interacting groups. Culturally specific interpretations call these *ayllus* (a longstanding Andean way of grouping people who are either biologically or socially related and agree to exchange labor and trade goods) and organize them into two larger units called moieties. The dispersed, mainly farming population, the pronounced artistic diversity, the overlay of Lines on the plains, plus a very unusual approach to gathering at the large center of Cahuachi, add up to a culture of individualists who nevertheless interacted a great deal. Generation after generation, Nasca peoples seem to have pooled their resources to build an underground water filtration system (so as to survive in a such a dry environment), to construct mounds and gather for shamanic rituals (to petition the spirits of nature, no doubt), and to inscribe the earth itself and walk in mannered processions. The Andean perception of how humans interact with each other and with the rest of the cosmos is one in which notions of uniformity need not be enforced, but agreed-upon balance and reciprocity hold sway. Thus, Nasca art is full of images of agricultural abundance, shamanic ritual, and beautifully calibrated geometries that express a delicate positioning of the human in the natural and supernatural realms.

Nasca ceramics
The ceramics of the Nasca were in many ways the high point of Central Andean creativity in clay. Certainly their vibrant slip-painted surface decoration, displaying more colors than any other in the Americas, merits special recognition. Rounded vessel shapes with very complex compositions wrapped around all sides are characteristic, as are the glossy burnished surfaces and bright colors that look remarkably fresh in spite of their age. Nasca ceramics' typical forms include panpipes, effigy jars, double-spout-and-bridge vessels (continued from Paracas times), and bowls and beakers of various shapes. Some forms are unprecedented, such as those taking the shape of a three-dimensional stepped fret.

Nasca ceramics feature bulbous overall shapes with slight three-dimensional details, as opposed to a sculptural style such as that of the Moche (Chapter Four). The Nasca blend two-dimensional effects with volumetric ones subtly and elegantly;

55

52

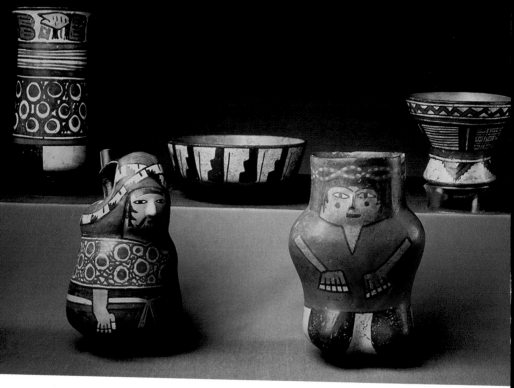

49. Early Nasca ceramic vessels show the influence of weaving. The man's garment pattern is reflected on the tall beaker, his headband echoed on the bowl, and the woman's headband on the flaring beaker. Early Intermediate Period.

50. Double-spout-and-bridge vessel with an image of a tern eating a fish. Colorful, delightfully naturalistic, yet heavily outlined, Nasca ceramic painting is a subtle blend of artistic devices. Early Intermediate Period.

51. Early Nasca ceramic double-spout-and-bridge vessel in the shape of *achira* (a coastal tuber). Its pinwheel sculptural movement, along with the graphic black-and-white surface patterning, epitomizes the dynamic Nasca aesthetic. Early Intermediate Period.

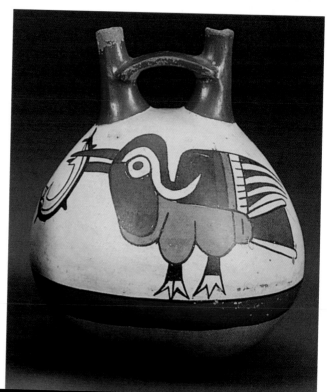

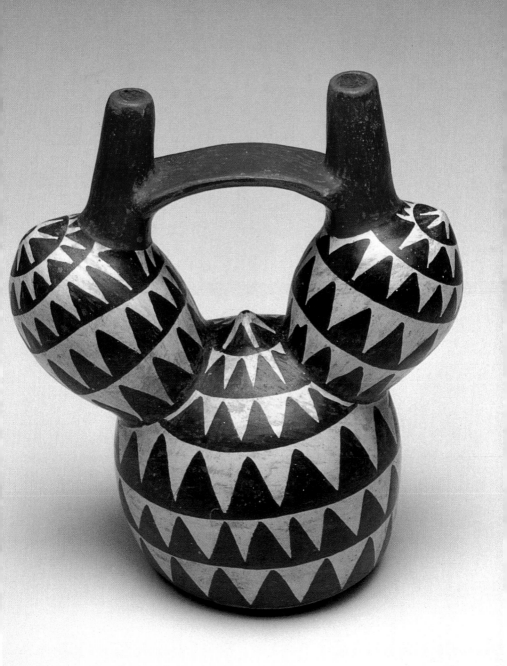

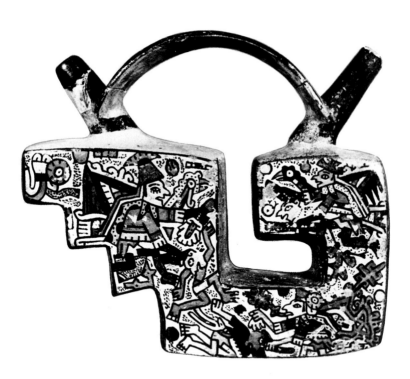

52. Nasca double-spout-and-bridge vessel in the shape of a stepped fret. Painted in multi-color slip, on its surface is a complex battle scene. Early Intermediate Period.

painted-on features complement protruding ones. The control over painting, from color placement to overlapping of shapes, gives the illusion of a layered body. The male effigy in ill. 49 has a criss-crossed turban and his arms appear from under his shoulder mantle and overlay his knotted belt. The female image likewise emphasizes her twisted headband. While vessel surfaces bulge out to indicate noses, Nasca effigies are characteristically more vague about the lower body, which tends to merge with the rounded vessel floor. A seamless sense of corporeality is achieved, yet with few bodily contours actually modeled. The illusion continues on all sides; for instance, the male's headbands gracefully trail across the back of his head as well. Also using the entire vessel, elaborate supernaturals or their components painted around cylindrical and globular vessels become visually subdivided by any one view. Depth and movement effects achieved by overlapping point up a growing interest in natural space and physicality.

At whatever end of the spectrum from two to three dimensional, Nasca design is equally masterful. A tern with a fish in its mouth achieves calligraphic elegance in sure lines and simple colors, seeming to hover in the air. An *achira* – a coastal tuber

50

whose edible subterranean stem sends up shoots above ground – 51
unites graphic and sculptural motion in a supremely dynamic
composition. The shimmering optical effects of the black-and-
white zigzags serve to accentuate the idea of vibrant vegetal
growth, a constant preoccupation of Nasca farmers.

An aesthetic as well as literal balancing act, the innovative
stepped fret vessel dramatically arches clay over negative space 52
in a technical tour-de-force. Like the individual sections of a
discontinuous warp and weft textile, a geometric shape has
achieved prominence as a discrete entity. Here the fret is, however,
a 'canvas' for a complex scene in which winged and bird-head-
emanating shamans appear to battle spiritually with foes. A
newly defeated figure lies prone toward the horizontal lower
edge. The three main spaces of the step fret each have their own
scene, providing an underlying order to the story. Interest in
portraying narrative is also characteristic of the North Coast
Moche, yet in both cultures the naturalistic style can sometimes
mask highly supernatural content. The wrap-around beings are
not wholly human, as ill. 53 attests; a masked human head joins
to a 'centipeded' body filled with abstract heads and spiked
emanations. The supernatural elements and disembodied heads
become independent, repetitive designs in later pieces. The 56
introduction of narrative itself, though it seems to dissolve over
time into shorthand imagery, adds another naturalistic, worldly
concern. It certainly has political ramifications as well, allying
victory over enemies with such fancy ceramics and especially the
step fret motif (a high prestige design throughout the ancient
Americas). When a spout is present it is integrated in a graceful,
seamless way.

Beautifully made, with extremely thin, even walls, Nasca
ceramics result from a range of handbuilding techniques,
particularly coiling. Turntables gently revolved the pot so
decoration could proceed on all sides evenly (these low platelike
implements are not to be confused with the potter's wheel, as
they were not for throwing pots); examples of the success of
this wrap-around approach are the effigies in ill. 49, among
others. Such turntables, used from 500 BC to the present day in
Peru, betray the interest in finishing all sides of an art work so as
to encapsulate more fully its essence. Their long usage also
demonstrates that Andean peoples were not ignorant of the
wheel, but simply adapted it to their own cultural viewpoint in
which a tool rarely if ever takes precedence over human manual
and visual skills.

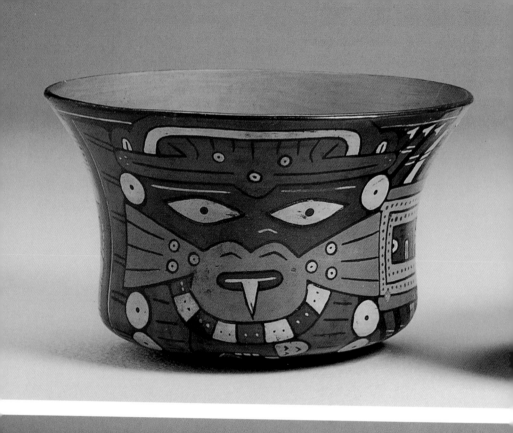
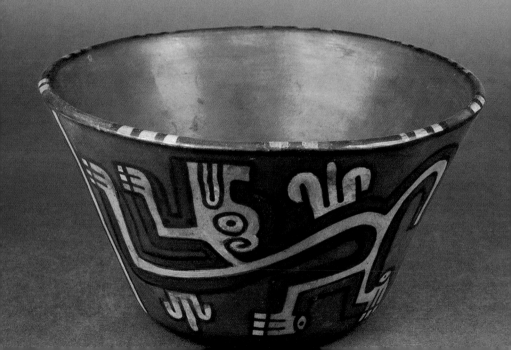

53. Middle Nasca ceramics
feature wrap-around paintings of
flying shamans, here with a
centipede-like body. Artistic
visualization of the entire design
was enhanced by the use of a
turntable, not to throw the pot but
to rotate the finished vessel for
optimum painting. Early
Intermediate Period.

54. Late Nasca ceramics show a
strong interaction with the
conquering Wari, as images such
as this monkey become more
rectilinear and take the Wari
staffbearer position (see ill. 118).
Early Intermediate Period-Middle
Horizon.

After construction, but before firing, painting with slip took place. Slip paints are simply water and mineral pigments, such as iron oxide for red and manganese for black, added to white or terracotta clays to make thin, colorful suspensions. Nasca artists were able to perfect up to thirteen different slip colors, all at relatively low firing temperatures. This extraordinary achievement – most ancient Americans utilized only the obvious shades of red, white, and black – included rare blue-grey, maroon, and light purple. Color as a prominent aesthetic goal was perhaps inherited from the Paracas textile aesthetic, although it is a widespread Andean value, probably based on the fact that shamanic visions feature preternaturally brilliant colors. However, slip painting is a radical departure from resin painting, and binds colors to the vessel to become almost totally permanent. Nasca vessels were then burnished carefully, perhaps more than once, after the slip was nearly dried (to reduce friction and avoid smudging, the artists may have used an oily surface lubricant, which would have burned off in firing). These stellar ceramics underscore the fact that simple technology does *not* equate with crude artistry.

Not surprisingly, Nasca ceramics went through several changes during the 700 years of their creation. Archaeologists discriminate as many as eight stages, but three suffice here: Early, Middle, and Late. One of the enduring Andean aesthetic traditions that first appears in permanent form during the Early phase is the panpipes. Music was evidently a central component of rituals, as can be seen in wall decoration at Cahuachi (see below). Ancient clay panpipes differ from modern versions in that they are a series of sealed tubes, rather than open cylinders. The musician blew precisely across the tops to produce the familiar, haunting, windy sound. As an ethereal entity, sound seems to have been believed well-suited to communicating with the spirits. Other Early Nasca ceramics introduced the characteristic painted black outlines and a broader range of slip colors, most often on a white background. Human effigies and bowls both show an interest in textile patterns. In ill. 49 the man's garment and the beaker behind him match, the bowl between him and the woman has the pattern on his headband, and the zigzags in the far right vessel relate to the twisted strands of her headwrap. As elsewhere in Andean art, the textile arts were highly influential in other media. Sensitively observed naturalistic images of birds and plants nevertheless capture their subjects with bold lines and high-contrast shapes.

55

55. Nasca ceramic panpipes of different sizes. Unlike modern examples, musicians blew across the top of closed pipes to produce the haunting, breathy sounds associated with the Andes. Early Intermediate Period.

Middle Nasca marks the undisputed height of the style, featuring the most colors, peak modeling, painting and burnishing quality, and extraordinary visual complexity. A brown background slip was almost universal during this phase, bowls and cups were built with higher sides, and designs show increasing abstraction. Narrative gives way to a wild proliferation of flying beings and their parts; as in many styles, the height of achievement prefigured the more dispersed, reduced final versions in which coherent figures became a series of repeated elements.

Late Nasca phase ceramics revert to fewer colors, typically no longer feature a brown background, and the vessel forms become even taller, the images more abstract. Tentacles, emanations, and pointed protrusions nearly obscure the flying figures with their repetitive elaboration, while both the geometric and evocative strains of earlier phases are integrated. Thus, Nasca painted ceramics trace a fairly familiar route from limited, tentative experimentation through mature complexity to shifts between reductive and effusive elaboration. In the final decades, Wari conquerors of the South Coast created interesting hybrids, drawing inspiration for their pan-Andean abstraction from the

56. Late Nasca ceramic beaker with typical faces, geometric patterns and disembodied elements from flying supernaturals (see ill. 53). Early Intermediate Period.

richness of the Nasca heritage. A bowl, such as the one with the monkey motifs illustrated here, shows how at the end of Nasca power prestigious foreign styles from the highlands were incorporated. Here it is obvious that Nasca curvilinearity was modified by the primarily rectilinear Wari aesthetic. Without losing the characteristic South Coast colorful palette or dark outline, this interpretation poses the monkey much like a Wari staff-bearer and features a newly flat base. Late Nasca ceramic hybrids reflect the influence of Moche style as well (Chapter Four). Early Intermediate Period art shows not so much overt conquest, as more generalized creative input from the long-distance contacts (which are diagnostic of the Central Andes in all time periods).

Nasca goldwork and textiles
The continuity of Paracas and Nasca cultures meant that their metalwork is virtually indistinguishable, featuring extremely thin, even sheets cut into elaborate silhouettes with few repoussé details. Paracas/Nasca metalwork achieved maximum glitter and shine by emphasizing less interrupted surfaces. Such thin sheets used smaller amounts of gold, which was purer as it did

57. Painted textile fragment in the Nasca style, depicting figures carrying agricultural products, such as maize (center), and ornaments, such as a forehead mask (right). Early Intermediate Period.

58. Detail of the painted Nasca 'Harvest Festival' textile with figures displaying agricultural products. On the dry coastal concerns about survival and natural abundance were paramount. Early Intermediate Period.

59. Detail of a Nasca discontinuous warp and weft textile in gold, red, and black. Nasca art ran the gamut from highly naturalistic (see ill. 50) to boldly geometric. Early Intermediate Period.

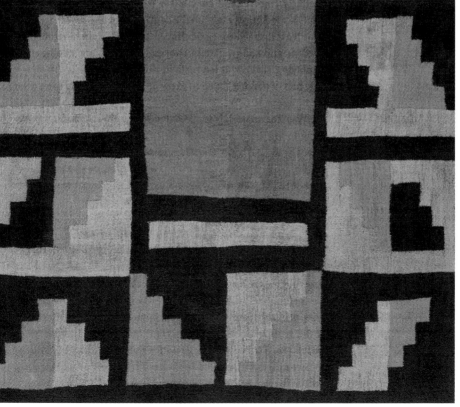

not have to hold much pattern (copper alloying strengthens gold). It is by no means easy to take a small lump of metal and produce a thin and even sheet without breakage or melting; exact knowledge and supreme manual skill are required to hammer and anneal (heat to just below melting) repeatedly so the gold will not become brittle. Object types include whiskered noserings (large enough to be called mouth masks; see ill. 39), entire face masks, forehead ornaments, headdress plumes depicting animals such as stingrays, clothing appliqués, and batons. All these transformed the wearer into a shining and no longer completely human being, as depicted in other media we have already seen, such as the embroidered 'Bird Man' clothing.

Nasca textiles likewise illustrate the many elements of ritual dress, especially in painted compositions of shamans dressed as pampas cats (with rounded ears and striped limbs) carrying agricultural produce (from left to right in ill. 57: *jícama* or yam bean roots, maize, and beans). Though the Nasca still pursued many Paracas techniques including embroidery, they introduced similarly colorful and curvilinear painted textiles. Large- and small-scale figures make up the depictions of masses of shamans or at least dressed-up agriculturalists. They walk in ritual processions and congregate in enormous gatherings, exuberantly displaying successful harvests in this difficult world (in which only half of children lived to grow up and most adults were dead by the age of 40).

Weaving materials are found at Nasca sites, including back-strap looms (four bundles of tied canes were deposited in the Room of the Posts at Cahuachi), needles, spindles, spindle whorls, cotton balls, thread, and even a pot containing magnesium sulphate, a common mordant (a mineral treatment used before dyeing to help the dyes set). One now-destroyed area at Cahuachi seems to have been a weavers' workshop. The often large textiles of this era suggest multiple weavers at work, as was the case with Wari tapestries, and the wide variety of styles and techniques explored in the Early Intermediate Period South Coast point to a large number of workshops spread throughout the area.

A completely different type of Nasca textile from the painted ones, probably dating to late in the period, continues the interest in the arduous technique of discontinuous warp and weft seen earlier. In a strikingly bold and rectilinear manner, stepped patterns fill mantles and tunics often in red, yellow, and black, as well as green and even maroon, blue, and lavender (perhaps different palettes reflected particular workshops). As in ceramics,

geometry and abstraction come to dominate the aesthetic, achieving a true interest in shape and color that was to profoundly influence the Wari.

Nasca earthworks and architecture
Perhaps the most distinctive of all Nasca arts, the great Nasca 60, 61 Lines continue to be the most famous and 'mysterious' remains of ancient South America. First located in the 1920s from aerial reconnaissance, they have provoked scholarly disagreement and popular speculation, from the breathlessly mystified to the patently absurd. However, recent excavations have filled in our understanding of the Nasca people and dispelled some of the 'mystery' by uncovering more evidence of habitation, including a major pilgrimage center at Cahuachi and the remains of perishable houses with telltale refuse nearby on the plains. Both at Cahuachi and near the Lines houses leave little mark on the landscape, and at the former accommodations may have been cloth tents, set up and torn down periodically as shelter from the punishing sun and dust-filled winds. Nasca earthworks, as both the subtractive drawings of the Pampa de Nasca and the modified hill temples of Cahuachi may be loosely termed, show their concern for the earth, equal parts reverence and propitiation. They also show a lack of preplanning and centralization that demonstrates the importance of different social groups expressing themselves over time. Yet the internal similarity of the Lines and temples bespeaks a strong religious and ethnic identity. Thus, architecture expresses two complementary aspects of Nasca communal effort, the dispersive and the cohesive.

The city of Cahuachi is unusual. It is located on the south bank of the Nasca River, opposite one of the most concentrated groups of Lines, marking with both additive and subtractive 'architecture' the magical place in the water table where the water almost never dries up. Rare in this area, the presence of water year-round made this a sacred spot, a *huaca* (Quechua for special place or thing). In the 1950s it was thought to be a large (150-hectare) walled capital of substantial population; however, excavations in the 1980s by Helaine Silverman found forty or so mounds facing the Pampas drawings and adjoined by plazas (over 75 percent of the city is open space). Burials exist, and feastwares are abundant, but there is no domestic housing or refuse to suggest much population at all. The wall turned out to be only 16 inches (40 cm) high, not a defensive structure but another Nasca linear outline, this time of a sacred space. Posts and

postholes were found in various parts of the site, as if temporary canopies were erected rather than permanent walls. Ritual items seem to have been swept up and placed in caches and in construction fill (along with maize husks) for building other mounds. These findings were puzzling to Silverman until she visited a modern Catholic pilgrimage center and witnessed a transitory city erected and torn down in a matter of days. Likewise, Cahuachi, its vast plazas suitable for huge gatherings, but with almost no living quarters, could have been filled periodically by all the Nasca people, the temples built onto the existing hills, then swept clean as a ritual gesture and abandoned. The windswept sands would remove other remnants of the celebrations, which may well have been harvest festivals as depicted in textiles.

Temples, each a modified hill topped by adobe walls and fill, follow a similar pattern of construction, face the same general direction, but vary in size, elaboration, and detailing. The largest, known as Unit 2, is part of an aggregation that may be a central acropolis, although the additive nature of the city makes for no true center. Its step fret-shaped terrace and abundant ritual paraphernalia remains suggest it was a focus for large group religious activity. To the southeast, however, a fully intact buried structure known as the Room of the Posts reveals a bit more about the nature of Nasca rituals. A central altar was protected by a roof or textile canopy erected on columns, while rather crudely incised images of panpipes and rayed faces adorn adobe walls. Certainly the clay panpipes figured prominently in rituals performed here, perhaps dedicated to deities with solar associations typically important to agriculturalists.

The celebrants who filled these empty rooms and huge plazas almost certainly arrived at the ceremonial capital by traversing the great Lines drawn on the adjacent plains. The 130-square mile (220-square km) natural blackboard, essentially a layer of dark over light stone, was gradually filled with over 1000 miles of lines. The Lines mostly consist of trapezoids and radiating lines (called ray centers), but also include thirty immense figures of animals, humans, plants, objects, and fantastical patterns (including a monkey, dog, killer whale, lizards, eight types of birds, rayed face, standing human, flower, tree, tuber, fan, mantle pin, loom, forehead ornament, as well as several geometric figures and unidentifiable images). The bases of trapezoids are often larger than football fields, the monkey image stretches 180 ft, and the hummingbird spans over five lengths of a jumbo jet. They overlay one another to create a giant

60. Aerial view of the plains of Nasca, a 'natural blackboard' with hundreds of overlapping lines, trapezoids, and figures (see ill. 61). The Nasca Lines were made over a period of several centuries simply by selectively removing dark stones to reveal the light ones below. Early Intermediate Period.

61. The Nasca Lines hummingbird figure with a jumbo jet for scale. These enormous ground drawings were made for the earth, the deities, and perhaps the constellations, rather than for a human audience, since the Lines are too large to be comprehended from the ground or the low hills around the plains. Early Intermediate Period.

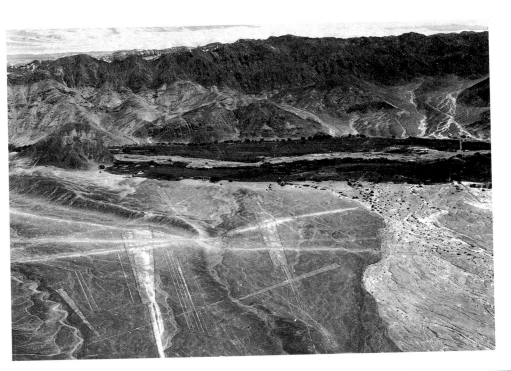

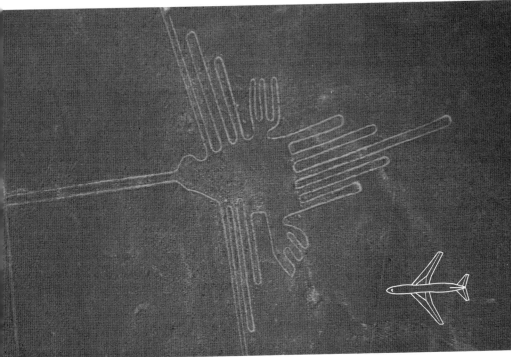

palimpsest, like the cave paintings of Paleolithic Europe. Their significance, while multi-faceted, may not be totally foreign to the latter, in that the Lines may have served primarily ritual purposes, as sympathetic magic to help ensure a good harvest. A great many of the Lines point to the sun's position on the horizon during the exact time of year when the rains begin (according to mapping and computer analysis by Anthony Aveni and Gary Urton). Likewise, most have their axis parallel to the direction that streams flow through the plains. Two rivers, the Nasca and the Ingenio, flank the plains and thus surround the Lines with the precious water so crucial for survival. The Lines circuitously connect the two rivers, and by analogy with continuing Andean rituals, they may have been made, maintained, and traversed over the centuries to connect humans to water and to each other in complex ways. The heavy, ritualized use of the Lines is shown by the presence of thousands of fancy potsherds, especially near the river banks. The giant figures are all created as one unbroken line, suitable for processions, while the many ray centers bring diverse paths together and piles of rocks (cairns) help guide walkers through low areas to the next Lines. Thus, there are structural messages of unification and order encoded within what appears to be visual chaos. While many theories exist as to the overall meaning of this incredible earthwork composition, including that the Lines map subterranean water sources, most can be encompassed by the idea of repeated ritual action, which explains why so many were made then overlaid. Certain groups may have 'owned' and reused certain areas of the plains, recognizing current lines by their relative brightness (oxidation gradually darkens the exposed pale pink sand; unfortunately all the Lines have been swept to brighten them for tourists, thus erasing evidence of relative chronology).

Lack of a single explanation should not contribute to maintaining the illogical 'mystery' of the Lines. One source of their popular enigma has been their enormous scale (one line goes perfectly straight for 13 miles [20 km]). These dimensions are difficult to grasp conceptually and are equally elusive visually; they are simply too large to be perceived by humans on the ground. A shaman in his bird self might have been one intended audience and the idea that a *human* audience is not necessarily privileged should come as no surprise, given the values of Andean art as a whole. The immensity of the Lines was scaled to that of the Earth itself, which automatically orients them to the celestial world above and hence to the supernatural. The fact

that we enjoy their full beauty from low-flying aircraft does not mean that the ancients were incapable of making them. (This has given rise to the insulting idea that they were created by space aliens. Medieval European cathedrals were erected in the shape of crosses largely invisible to the populace who made and used them, yet no one attributes them to little green men!) Technically the Lines are quite simple to create and it has been proven repeatedly that the Nasca were the ones who did so. Scientific dating of the wooden posts that mark the ends of some, the style of the many potsherds found on the surface, and the almost identical motifs on the ground and in Nasca painted ceramics, demonstrate without a doubt who constructed the Lines.

To reveal the light layer in contrast to the dark overlay of rocks, the Nasca carefully swept an area, leaving a line of displaced rocks along the edge (another outlining tendency). Geometric thinking and surveying techniques allowed them to place poles and sight along them to generate straight lines, create circles with strings tied to those poles, and measure out other units according to the human body (such as the average hand width or forearm length). This can be done without an aerial perspective, to any size desired. The particular climatic conditions of the plains prevent almost any natural destruction of the Lines once made, although modern depredations – such as the Pan-American Highway that now bisects the Pampa de Nasca – are a current threat to this magnificent monument to human effort.

Chapter 4: Moche Art and Architecture

Moche is the name given to the site, river valley, culture, style, and state that dominated the North Coast for the first 600 years AD. Arguably the first true state in the Andes, at its height it covered from the Piura Valley in the far north to the Huarmey Valley in the south. Two related languages were spoken, Muchic from Lambayeque northward and Quingan from there southward, helping to delineate two major spheres within this culture. The southern sphere had the site of Moche as its capital and mounted an expansive conquest campaign around the fourth century, probably to gain precious farmland. Sudden appearances of characteristic monumental adobe mounds and defensive structures attest to this imposition over local peoples. Images of warfare, prisoner sacrifice and portraits of important individuals all signal a time of strong political leaders. Some scholars see the battle imagery in Moche murals and ceramics as more ceremonial than real (pitting Moche against Moche). In any case, mass sacrifices have been verified at the Huaca de la Luna at Moche and at Sipán. Yet somehow the southern sphere seems to have briefly dominated the northern one, then later the north seems to have had more power, and finally both collapsed around the time that the Wari were beginning their state. Throughout this trajectory the northern sphere was more self-contained (and this cohesion was carried forward by the subsequent Lambayeque culture). Its capital was Pampa Grande, which eclipsed Moche during the later northern florescence.

Whatever the exact political situation, the enormous adobe mounds of Moche, including the largest adobe structure in the Americas, and the grand tombs at the northern-sphere site of Sipán, surely the most exciting and revealing excavations in recent times, show the great wealth and power that the Moche amassed in their time. The murals, metalwork, and ceramics of this culture were outstanding artistic expressions, intricate and detailed, colorful and complex, beautiful and well crafted. Moche art is justifiably hailed as a high point in Andean aesthetics, likely because its secular and sacred aspects meld in new ways across a varied subject matter. The Moche style uses naturalism as a basis for its messages about the many levels of existence, from

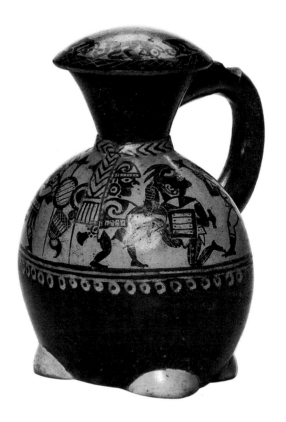

62. Early Moche battle scene with the victor grasping the loser by the hair, the universal ancient American symbol of dominance. Notice the chevron-patterned scarf tied around the neck of the vessel, as depicted in ill. 85, to anthropomorphic effect. Early Intermediate Period.

the hunting of animals and bleeding of prisoners of war to the healing visions of shamans with owl heads and fanged jaguar alter-egos.

The challenge that Moche art poses for Westerners is that the accessible, often charming style that observes and presents appearances so well – a deer's horns, a man sitting in a house, a woman in the last stages of labor – may well be operating on a higher symbolic plane. Moche ceramics do not comprise an encyclopedia of daily life, since cooking, childrearing, farming, and so on, were not illustrated. It is clear that very readable images of a conflated man and a peanut or an owl and a trumpet are 'unrealistic,' yet deeply symbolic. In spite of artistic attention to appearances, the style thus still betrays a marked interest in essences, especially in accentuating what is inside, physically and spiritually. From eyes that are sculpted as round eyeballs in sockets and bodies bulging inside garments, to emotional states such as tenderness, the internal manifests itself externally. Such artistic sophistication is easy to appreciate as it more closely

92

84

corresponds to our own concerns; however, its intentions are to show the symbolic and invisible just as in any other Andean style, only via representationalism. Even a specific moment of suspense, terror, or violence is frozen, formalized in keeping with the importance of the subject. The Moche style is not simply naturalistic but represents selective naturalism at its height, with decidedly more attention given to faces than bodies, for example. It is this striking interplay of moment and essence that gives Moche art its enduring power.

Instead of documenting quotidian existence, depictions concentrate on political, mythical, and supernatural values, such as the importance of individual leaders, the stories of chaos restored to order, or the transformations of the shaman. For each purely human depiction there is another in which a warrior sports a fox's head or a boat legs; one of the key myths seems to have been a 'Revolt of the Objects' in which weapons and every-day things turn on humans (a story that was still told to the Spanish, in fact). Deeply Andean approaches to a fully and fantastically animate world are maintained despite the apparent contrast between Moche and other more geometric or blatantly spiritual styles that came before and after.

63, 64. Drawings of a now-destroyed mural known as the 'Revolt of the Objects' at Huaca de la Luna, Moche. The imagery includes a club-wielding headdress ornament chasing a warrior. In Moche art nearly everything may be portrayed as actively alive. Early Intermediate Period.

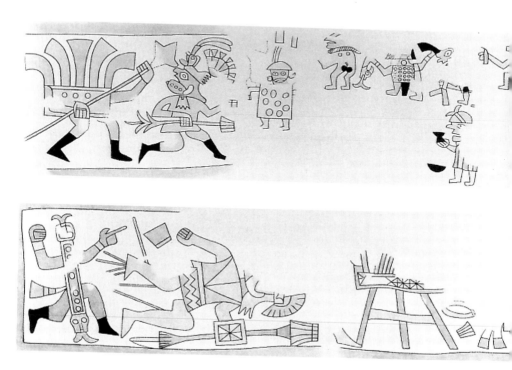

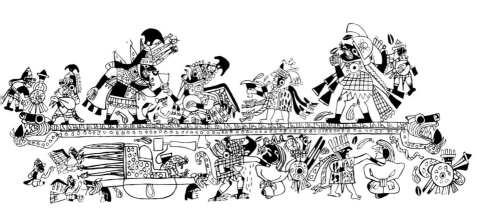

65. Rollout drawing of the Moche fineline Sacrifice Ceremony, in which victims' blood (lower register, right) is offered to the Lord of Sipán (upper register, left) by the Owl Priest (upper register, left center) with the Priestess (upper register, right center) in attendance. These actual people, or at least roles, have been located in tombs at Sipán (see ills. 77–83) and San José de Moro (see ill. 76).

Moche art in general may be characterized as very active, with stronger interest in narrative than other Andean styles. Bodies are shown with almost frenetic energy, flying across hilltops, limbs cocked at sharp angles. Figures may sit or walk in a solemn procession as well, but nevertheless one could call Moche art 'transitive' because so often an action is perpetrated on something, a transition is marked. Sea lions are clubbed, prisoners are taken by the hair, tied, and bled, and shamans become owls. The natural extension of this active approach is to tie together series of actions into coherent narratives, as Jeffrey Quilter and others have found in analyses of Moche iconography that reconstruct history/myth and the rituals that reenact the stories. Sipán's rich tombs have shown us that the stories laid out on stirrup-spout vessels' sides had a reality to them: the Lord of Sipán, the Owl Priest, and the Priestess were all actual people (and roles they and others filled) whose processing of war victims, the Sacrifice Ceremony, did take place. From another perspective, stories tell parts of larger, typically Andean cycles of order suppressing chaos; the 'Revolt of the Objects' can be seen as a chaotic event, and the Sacrifice Ceremony as a restoration of order. Some of the same players appear in different tales, leading scholars to see them as a compendium of symbolic, but potentially also real, actions.

The personal sense of the past we are gaining brings up another important element in Moche art and architecture: its dynamic interplay between individuality and standardization, a key characteristic of highly organized political units. The use of adobe bricks, made in molds but marked with geometric designs that identify their makers, is one example of mass-production that nevertheless records peoples' contribution to the overall

structure. It is not their individuality so much as a completed work assignment that is noted by these maker's marks, but the dynamic still exists. Some everyday ceramic vessels also have maker's marks visibly scratched into their necks. Yet most ceramics were made with molds to produce identical vessels (found hundreds of miles apart), though individual pieces were slip-painted and modified to be distinctive. The famous portrait head stirrup-spout vessels are a case in point, their attention to 86, 8 individual physiognomy extreme, yet their repetition via molds assured. The tensions between the personal and the political gestalt may have even contributed to the ultimate collapse of the Moche, according to Garth Bawden, in that the Andean corporate mentality was in conflict with the power of leaders in the southern sphere. In any case, while appreciating the sublime artistry of a given pot, one must keep in mind that mass-produced ones are prevalent; at Sipán one offering of ceramics contained 1137 fairly repetitive pieces, mostly depicting musicians and prisoners.

In terms of general features, Moche expressions are characteristically volumetric, and are made up of many smaller parts, rely on color contrast, often binary, and feature smooth, glossy surfaces. The adobe structures are solid mountains – literally and figuratively – of bricks stacked up by the million. They take up space on the earth and into the sky; they overwhelm. Moche vessels are highly sculptural, their swelling shapes used to pillow an owl's breast or a laughing man's cheeks; the monumental impression so achieved belies their small size. Even the tiny figure on a gold earring has modeled kneecaps or on a bead a bulbous spider perches on its web. Many individual sections of bricks, balls of gold, or beads, make up larger compositions. Color may be exuberant in murals, but is often limited to red with cream in ceramics or gold with turquoise (sometimes gold with silver) in metalwork. Binary color can be seen as another expression of Andean interest in duality and the Moche environment, desert/sea and desert/mountain contrasts evident to all, may again be invoked. Whatever the inspiration, the sculptural and detail elements of Moche portable arts are brought to the fore when color is kept to contrast mode. Surfaces are finely finished in various media, with consummate burnishing of clay and polishing of gold. The few Moche textiles that survive (due to the deleterious effects of El Niño floods and high saltpeter content of the sands) are also finely made. Overall the Moche aesthetic impression is one of powerful volumes, strong colors,

and opulent texture, all artistic choices well suited to a state's desire to impress the masses. Messages in the iconography reinforce social inequity, another assumption of state art, with clear victims and victors, higher planes for more important people, and so on.

Other features of state art were intended to tie the Moche to a glorious, specifically North Coast past through a revival of the Chavín style. Located near Caballo Muerto and Chavín centers along the coast, the Moche were aware of the earlier broadly disseminated North Coast styles. They consciously revived Chavín elements, such as the fanged mouth for priests and deities. Chavín emphasis on incisions, processions, crucial moments (such as those of shamanic transformation, as in the tenon heads), as well as overall visual power and persuasiveness, also figure in the Moche style.

Precursors and contemporaries of the Moche
Other northern cultures influenced the Moche, both precursors such as Salinar, and contemporaries such as the coastal Gallinazo, the coastal-highland Vicús, and the highland Recuay. Around 200 BC the Salinar emerged, their ceramic style forming a bridge between the Chavín and the Moche. Through figural sculpture rising from the vessel body and topped with the familiar stirrup-spout, Salinar ceramic artists explored the

66. Salinar-style stirrup-spout vessel of a monkey. Earlier sculptural mastery of complex hollow forms set the stage for Moche achievements in clay. Early Intermediate Period.

naturalistic and volumetric in a monochromatic mode. Salinar people built a large, defensible center at Cerro Arena in the Moche Valley, establishing a pattern of urbanism that remained a feature of North Coast life from then on.

Slightly later, the Gallinazo flourished in the Virú Valley, building towering tapia then adobe platforms as the Moche would soon after. At Paredones in the La Leche Valley a Gallinazo platform still stands over 65 ft (20 m) tall. Gallinazo ceramics and architecture have now been located from the Santa Valley to the borders of present-day Ecuador. This successful group was the first to be conquered in the southern Moche sphere's expansion, and Moche construction techniques appear deeply indebted to Gallinazo ones. Resist-painted ceramics differentiate Gallinazo ceramics from Moche, but share this technical approach with the highland contemporaries of the Moche, the Recuay.

Recuay and Moche ceramics sometimes both appear at the same site, for example at a fortress in the Nepeña Valley (that seems to represent a failed Moche attempt to occupy that valley). Contact with the highland Recuay can be inferred by the strong similarities that can be seen between Recuay textiles and Moche murals. Centered in the Callejón de Huaylas the

67. Recuay tapestry fragment showing characteristic rayed faces. These contemporaries of the Moche strongly influenced the makers of one mural layer at the Huaca de la Luna at Moche (see ill. 68). Early Intermediate Period.

68. Detail of a mural on Platform I, Huaca de la Luna (see ill. 74) at Moche, featuring a textile-like checkerboard pattern of shamanic faces emanating birds. Note the similarity to Recuay tapestry design (see ill. 67). Early Intermediate Period.

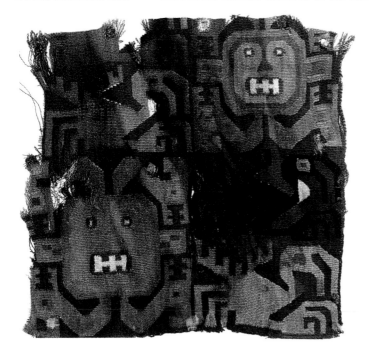

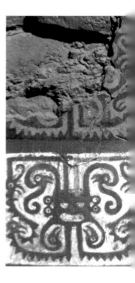

69. Recuay ceramic vessel depicting an enlarged head between two storehouses, decorated in typical negative painting. Early Intermediate Period.

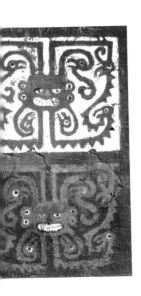

Recuay form another link between the Chavín and the Moche. Their distinctive tricolor resist ceramics feature warriors, herders, and figures associated with storehouses (the vessel in ill. 69 has two square buildings with high, small doors and ventilation slits under the eaves, characteristics of storehouses with their need to keep out rodents and allow air circulation). Guarding the harvest on a walled hilltop, the main figure wears earspools with circles around the edges, a trait also found in Moche goldwork.

Moche architecture and metalwork

The state constructed buildings in nearly every valley on the North Coast, their adobe constructions recognizable to all with their distinctive profiles of graduated levels, long, sloping ramps, and small, slant-roofed structures on top. The different levels were neither necessarily symmetrical in layout nor square in footprint and did not rise to a point, so they cannot be called pyramids except in the loosest sense. These stepped constructions are a series of slant-sided platforms of dimishing size joined by ramps and probably adorned with colorful murals. The

small non-adobe buildings on top do not survive, but ceramic depictions of elites sitting in buildings suggest certain basic characteristics: an open front, pitched or slanted roofs, and roofline decorations of war clubs. No real need existed for protection from rain, but the heat could be punishing, so openings on the sides allowed for good ventilation. The structures elevated, literally and figuratively, the figures within their elaborate walls. Ritual processions – depicted repeatedly in the ceramics and in murals – accentuated the ascension of certain peoples above the masses' level. Large-scale performances that took place on high were a staple of the Moche state's repertoire, perhaps even more so than among earlier Andean cultures.

Moche architecture completes a progression in coastal building: early U-shaped structures were oriented toward the mountains, then centers were built in or on the foothills, and finally the Moche basically erected their own mountains on the coast (the site of Moche is only 3 miles [5 km] from the sea). Their constructions were not only shaped like, but nearly on the scale of, natural formations. Originally the Huaca del Sol, the main temple at Moche, stood as tall as 165 ft (50 m). In this grand scale Moche building recalls the contemporaneous Nasca Lines; enormity may be seen as a widespread Early Intermediate Period trait, realized not only by the vision of powerful elites but also the labor of large, diverse groups of people. These giant structures were constructed of millions of adobe bricks, made of

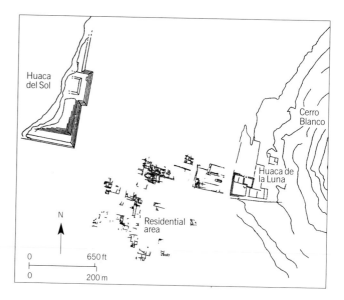

70. The city of Moche features the huge Huaca del Sol to the west (see ill. 73), the Huaca de la Luna to the east (see ill. 74), and a newly-excavated city center with residences, storage areas, and artists' workshops between the two. Early Intermediate Period.

71. Moche ceramic vessel depicting a tiered platform with a staircase topped by an elite structure. An important figure is shown seated in a typical many-gabled building with war clubs along the rooflines and pierced walls for ventilation. Unfortunately actual buildings, made of adobe and other perishable materials, do not survive. Early Intermediate Period.

molded, smoothed, and sun-dried mud. This traditionally coastal process was only possible on such a scale because the Moche could obtain water from multi-valley sources and control countless work parties. The adobes were amassed in 'segmented construction' technique: tall sections, up to 6 ½ ft (2 m) wide, were mortared internally but not joined together. A cross-section of the Huaca del Sol can be likened to a loaf of sliced bread. By this additive approach an astounding 143 million bricks went into the Huaca del Sol and 50 million into the Huaca de la Luna. The building process and discrete contributions of labor groups is evidenced by the maker's marks inscribed on many of these 72 bricks. More than one hundred geometric patterns, which cluster together in sections, indicate where each group worked. (It is interesting to note that when Andean peoples use notation, what we might call a kind of writing, it remains resolutely abstract; the later Inca *quipu* is even more so than the maker's 147 marks.) These marks are true signatures that clearly express how pervasive Moche personalism was nevertheless dedicated to state interests.

72. Diagram of the various makers' marks incised on the adobe bricks in particular sections of the Huaca del Sol, the main pyramid at Moche. These identifying patterns prove that work units documented Moche subjects' contributions to the staggering 143 million bricks laid in this mountain-like structure. Early Intermediate Period.

73. The great Moche pyramid known as the Huaca del Sol ('Pyramid of the Sun') at Moche. Before the Spanish diverted the river in their attempt to find hidden gold, this truly monumental structure stood over 135 ft (41 m) tall. Ritual use and royal residence, as well as burial, were its evident functions in the Moche capital. Early Intermediate Period.

The Huaca del Sol dominates the site of Moche, which consists of this monument to the west, the Huaca de la Luna platforms to the east, and a residential area in between. The Huaca del Sol covers over 1100 by 500 ft (340 by 160 m) on the ground and its four levels rise to at least 130 ft (40 m) in one section. It exists in a fragmentary form because in the seventeenth century the Spanish diverted the river to wash most of it away in order to search for gold hidden in its burials. Originally it took the shape of a cross. Traces of red on the façade, remnants of elaborate burials, and considerable refuse suggest this structure served as a supremely important center of state life. Both religious, probably with a main temple on top, and political, most likely with the royal residence and tombs, it was rebuilt and enlarged by different rulers as the theocracy evolved. Even at a fraction of its original glory, the Huaca del Sol maintains the power to command, to dwarf the commoner while elevating the noble. It was visually unambiguous.

While little archaeology has been devoted to the Huaca del Sol in recent times, the center of the site and the Huaca de la Luna have been radically reevaluated in light of new excavations.

74. Artist's rendering of the platforms and plazas of the Huaca de la Luna. Later murals in the Great Patio on top of Platform I feature a fanged face repeated in a textile-like diamond pattern with interlocking snake motifs (see ill. 75). Earlier ones have rayed faces like Recuay textiles (see ill. 68). Early Intermediate Period.

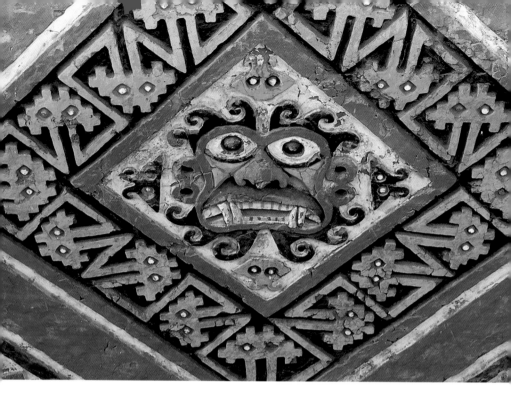

75. Newly discovered murals on the Huaca de la Luna feature a wide-eyed fanged shamanic face within diamonds of interlocked snakes. Bulging eyes and visions of snakes are typical signs of shamanic trance (see ills. 24–26). Early Intermediate Period.

Between the two main monuments, Claude Chapdelaine has found the remains of compounds with patios, storerooms, and workshops, connected by plazas and streets. Instead of two isolated monuments, a city has emerged from the sands. Art-making for the capital took place in proximity to the great Huaca de la Luna, now understood to consist of three main platforms, I and II joined and III off on higher ground, and four plazas. Murals and painted reliefs have been found in many locations, 6 indicating that during all its building phases this complex of structures was colorfully decorated in reds, yellows, white, and black. The walls of Platform I and the Great Patio display diamond and checkerboard patterns of supernatural faces, 7 strongly textile-like in layout, plus the Decapitator, and ranks of armed warriors (the latter have also been found at the site of Huaca Cao Viejo). Platform III had the now-lost mural depicting 63, 6 the 'Revolt of the Objects.'

Easy to see and understand, Moche public art presented straightforward humans and transformational shamanic beings and served as a dramatic backdrop for the ceremonies conducted in these spaces. Quilter perhaps has stated it best: 'Moche was

about blood in the sand under a harsh sky and the murmur of the crowd; the flash of the sacrificial knife wielded by a god impersonator.' Indeed, the knife was used on seventy young men found in the plaza off Platform II and human blood has been found in at least two Moche goblets. Art seems to restate actual violent sacrifices in the murals of Moche and Pañamarca, events also characterized on ceramics and attested to in the burials at Sipán. The taking of prisoners, if not traditional warfare, takes place under the aegis of the shamanic frontal fanged face, emanating various animals as with the Recuay (and later the Wari and 67, 104 Tiwanaku). Thus, ritual sacrifice is presented as a spiritual necessity in state aesthetics.

76. Drawing of Pañamarca Mural E, showing a portion of the Sacrifice Ceremony featuring the Priestess (left), attendants and victims (center), and bowl of goblets (lower right, center) for blood offerings presumably to the Lord of Sipán to the left. At San José de Moro archaeologists have found the actual Priestess interred with this kind of tasseled headdress. Early Intermediate Period.

Pañamarca's now-destroyed Mural E shows part of this pervasive ritual of presenting the blood of victims to a main priest. The large figure to the left is a Priestess, wearing a distinctive headdress and feathered tunic. The smaller celebrants bring her goblets, seen amassed in a large bowl to the right, while she may in turn be offering her goblet to the Lord of Sipán. 76

Ceramic depictions describe the whole ceremony of which Pañamarca preserves a portion. Toward the left side of the top register of a representative fineline vessel's rolled out design, 65

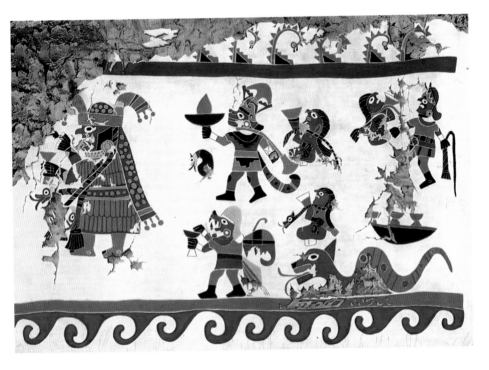

the principal Lord with a large crescent headdress and similar-shaped backflap faces a series of others and accepts a goblet from the owl-headed one. We already know that blood-filled goblets existed and the presence on the lower register of nude, bound victims being bled from the neck likewise seems to point to this liquid as the one being proffered. Behind the Owl Priest stands a Priestess, the one seen in the Pañamarca mural, with her characteristic tasseled headdress. Below is the jaguar litter that likely brought the Lord to the ritual, as rays on it match those on the Lord's headdress and a scepter is attached to the front. Shield bundles help describe the victims as prisoners of war and lesser military personnel work to secure the sacrificial blood. All these figures appear in Pañamarca, with its emphasis on the Priestess, the victims, and the goblets; in its original extent no doubt the Owl Priest and the Lord would have appeared to the left. In Moche narrative fashion the ritual unfolds counterclockwise from the lower left: parking the litter and obtaining the blood leads to a grand procession to transfer the sacred and powerful liquid to the main official.

Extraordinarily, since 1987 Walter Alva and Christopher Donnan have found the burials of nearly every one of these figures in the adobe platforms of Sipán and San José de Moro in the northern Moche sphere. The burials span a long period of time, showing that this ritual and its participants, now known to be real, were a presence throughout Moche spiritual/political life and times. Twelve tombs of leaders, priests, retainers, and assistants have been located at Sipán, among them the richest in the western hemisphere, Tomb 1, containing the tall, middle-aged man known as the Lord of Sipán. He was the man in the Sacrifice Ceremony who received the blood, as he was buried with a solid gold crescent headdress over 23 inches (60 cm) across, a set of gold and silver backflaps, and even the spotted dog seen at his feet in the ceramic scene. Four hundred and fifty-one objects of precious gold, silver, turquoise, spondylus shell, and cloth (now disintegrated) were interred with the Lord. Some of the most spectacular are his three pairs of gold and turquoise earspools, one of a deer with gold antlers and one of the Lord himself dressed for war, his henchmen at his sides (just as male retainers were buried flanking his body in Tomb 1). The minute warclub detaches from his hand and his nosering swings realistically; even his owl-bead necklace is double strung like real ones, such as the stunning gold and silver peanut-shell bead necklace he wore. Ethnobotanists have determined that a new strain of

77

81, 82

83

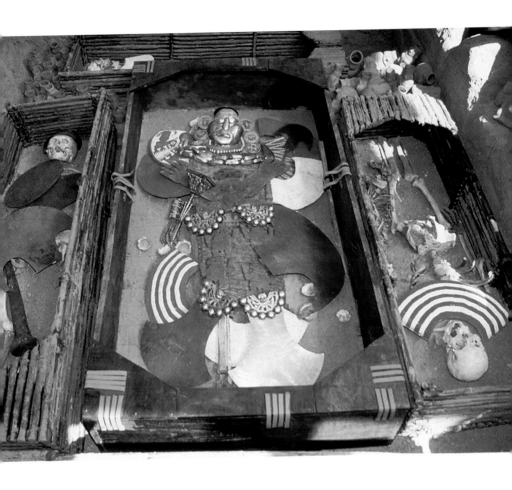

77. Reconstruction of the center section of Tomb 1 at Sipán, the burial of the Lord of Sipán. Retainers to either side, the main body was lavishly covered in multiple belt bells (see ill. 78), earspools (see ills. 81, 82), and necklaces (see ill. 83). In his right hand he holds a scepter that matches the one depicted in Sacrifice Ceremony ceramic images (see ill. 65, lower register, left). Indeed, the man buried in Tomb 1 played the role of accepting the goblet of blood (ill. 65, top register, left). Early Intermediate Period.

peanut was introduced around this time, AD 300, and a fatty protein source in a desert world was an obviously prestigious commodity (seen in ceramics as well). Images of head-taking by the Decapitator, also seen in the murals at the Huaca de la Luna, appear on backflaps and sets of bells, and were joined by scenes of enemy submission on a gold scepter (shaped like the one tied to the litter, see ill. 65). The opulence and power of this individual and the role he played cannot be denied. 90 78

Tomb 3, deep in the structure and perhaps five generations earlier, held a middle-aged man much like the Lord of Sipán, who has been named the Old Lord. Two small scepters, one of gold and one of silver, and six necklaces, three of each metal, were among his burial goods. The gold ten-bead spider necklace shows the ingenuity, virtuosity, and technological sophistication of Moche metalwork, even at its earliest phases. Primarily built 79

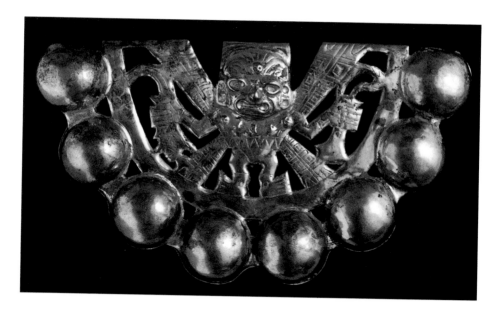

78. Gold bell depicting the 'Decapitator,' with a knife in one hand and a severed head in the other, from Tomb 1 at Sipán. The Lord of Sipán was buried with several sumptuous ornaments showing this gruesome image, proclaiming him to be a formidable warrior. Early Intermediate Period.

up in an architectonic manner, Moche metallurgists achieved full three-dimensionality from flat parts. They could cast, solder, alloy, bind separate metals into single objects, and gild, encompassing nearly every technical possibility. Each spider bead contains over 100 solder points. In Tomb 3 the types and arrangements of the grave goods were strikingly similar to

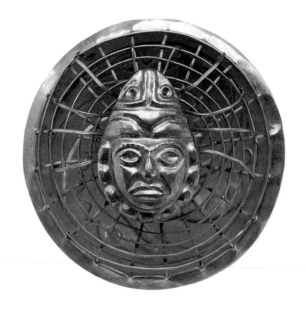

79. A gold spider bead, one of ten, from the earlier Old Lord's Tomb 3 at Sipán. A human face on the back of a spider, itself clinging to a web over a bowl-like backing, creates a particularly complex object, both technically and artistically. Early Intermediate Period.

those of Tomb 1, suggesting that the two men played similar roles in different eras.

On the other hand, Tomb 2, contemporaneous with that of the Lord of Sipán, revealed the remains of a man who must have played the handing-over role of the Owl Priest, according to his towering gilded copper headdress of an owl with outstretched wings. Tellingly, he was buried with a copper goblet in his right hand (this is even the actual hand he uses in the ceramic illustration). In what may be a Moche interest in emotion, or simply two ways to show animal aggression, the Owl Priest wore a double necklace of faces with upturned and downturned mouths. There are a few Moche portrait vessels that depict laughter, but often in Andean art drawn-back lips are meant to evoke the snarl of an angry cat. Duality is likewise stressed in the man's half-silver and half-gold versions of a backflap and a nosering; with the gilded copper these items signal a slightly lesser status than that of the Lord, as befits his place in the ritual hierarchy.

80. Gilded copper necklace of the Owl Priest from Tomb 2 at Sipán. The inner strand of double-strung beads has upturned mouths, the outer strand, downturned mouths, suggesting complementary emotional states (although both can be seen as variants of ferocious grimaces). Early Intermediate Period.

80

87

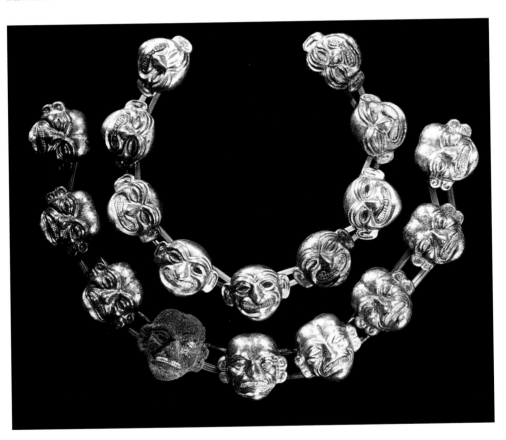

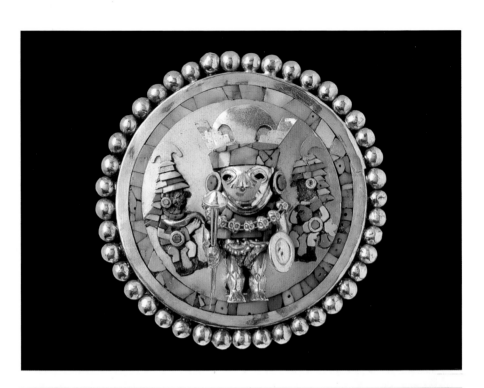

81, 82. Two of the three gold and turquoise earspools of the Lord of Sipán in Tomb 1. (*Opposite above*) A warrior figure, representing the Lord of Sipán himself, carries a removable war club. (*Opposite below*) Earspool of a cutout figure of a running deer. Early Intermediate Period.

83. The gold and silver peanut shell necklace worn by the Lord of Sipán in Tomb 1. The largest bead measures nearly 4 inches (9 cm) in length. Early Intermediate Period.

The rest of the tombs at Sipán, containing mostly copper and even sheathed wood objects, allow us to see the many levels delineated in the Moche political/spiritual hierarchy. So far, nine tombs contain what appear to be warriors and ritual assistants, the military graves characterizing the north side of the platform, more priestly ones the south. These lower-status celebrants even include a panpipe musician in Tomb 5. Recurrent imagery of these lesser tombs includes crescent head-dresses (but in copper), peanuts, the Priestess (and one of the deceased was female), scepters, and many types of weapons. The complexities of the Sipán finds will take years to analyze,

as the archaeology has taken many exciting years to conduct, and likely will continue to thrill us with new discoveries of beautiful art devoted to the promotion of Moche leaders. Sipán is a veritable treasure trove.

Other Moche sites, while not as gold-filled as Sipán, are impressive architecturally and/or contain important information in their burials. At Dos Cabezas slightly south of Sipán, a very tall man with a congenital disease was buried wearing a bat-motif hat and nosering and holding a metalworking tool. His eighteen headdresses may signal his many changes of costume for shamanic ceremonies and his artistic role may have dovetailed with his spiritual one. Shamans are often individuals with different bodies or survivors of disease (see ill. 90, lower right). However, the most dominant late Moche city was Pampa Grande, perhaps the short-lived capital according to Izumi Shimada. Like the site of Moche, Pampa Grande had two huge structures, with Huaca Fortaleza as the most dominant (its surrounding compound measuring a staggering 2000 by 1300 ft [600 by 400 m]). Artistic workshops (including ones for the creation of spondylus shell items) were again located near the power centers, maker's marks denoted architectural work units, and administrative residences can be identified. The layout of a residential copper workshop – containing tools, ingots, molds, and even andesite worktables – shows that the hammering and annealing, then the shaping of objects, took place in different rooms.

As a final note on the vast subject of Moche metalwork, gilding, though lower in status, holds the key to an important element of Moche art and culture. The gilding process was reconstructed by Heather Lechtman from objects from the northern site of Loma Negra. Rather than the application of gold to the exterior, the Moche developed depletion gilding in which the piece essentially gilds itself from within. By bathing the finished alloy object in naturally-occurring acids, the outermost layer of non-gold metals, particularly copper, is depleted, leaving only a very thin layer of pure gold visible. Lechtman coined the phrase 'the technology of essence' to describe this pervasive approach to materials in which what is inside is revealed outside. Hidden gold on the inside is not wasted but rather crucial to the piece, for it to be 'truthful' (gold on the outside stands for gold on the inside). The overarching Andean value placed on essence is perfectly encapsulated by this unusual approach to gilding.

Moche ceramics

Nearly every type of object found in the grave offerings is depicted in paintings on Moche ceramics, providing a wealth of clues as to their art and worldview. Tens of thousands of such ceramics exist and scholars have barely made a dent in this amazingly varied corpus. Artists employed two-piece press mold technology so that more vessels were produced than ever before. Replication, the creation of exact copies, fits with state goals to disseminate a message widely and consistently. In fact, images painted on ceramics show clay bottles and bowls being transported on boats, the preferred long-distance mode of transportation. The Moche left offerings as far south as the Chincha Islands which they reached by reed boat in order to garner the bird *guano* used for agricultural fertilizer. Another way in which the Moche were unusual within the Andean tradition is that their style was disseminated via clay rather than textiles; however, since textiles rarely survive the saltpeter-rich North Coast sands, the exact extent of Moche fiber arts remains unclear. Certainly the complicated stories told on some Moche ceramics would not translate well into weaving. Equally important, the Moche unquestionably spent a great deal – perhaps the majority – of their artistic time on ceramics, given the extraordinary number of compositions generated. And most are by no means exact repeats, despite the use of molds: even utilizing a mold, a hand-built original model must first be crafted from which the mold can be taken, and all appliquéd, modeled, and painted decoration must be done freehand. Thus, the rigid standardization that could result from molding was avoided, technical excellence was routinely achieved, and artistic license is quite prominent. Through close visual analysis of painted pieces individual artists' hands have even been detected.

Vessel types are as varied as artists' hands and subject matter. While the traditional stirrup-spout bottle remains the most common form, particularly for elite use, the Moche also made spout-and-handle vessels, double-chambered whistling vessels, flaring bowls, dippers, and long-necked jars. A few other forms are illustrated but have not yet been located archaeologically. Diversity seems to have been of importance to the Moche, no doubt stimulated by complex ritual needs.

The characteristic stirrup-spout vessel was a technical challenge to create, with its closed body and complex spouts. Given this, its practical and symbolic advantages must have been important to the Moche. It was especially well adapted to the dry

85

84. Moche stirrup-spout vessel with a mother deer tenderly nuzzling her offspring. Although extremely rare in ancient Andean art – and ancient American art in general – emotional states were communicated in some Moche works of art (see ill. 87). Early Intermediate Period.

environment because the small top opening allowed only minimal evaporation of liquid, probably the high-status corn beer. The stirrup-spout pours smoothly because air enters one spout as liquid passes from the other. The spout is ergonomic for carrying and easy to suspend from a belt or rope. Beyond such concerns, since these were not primarily practical items, it was doubtless crucial to announce membership of the North Coast visual tradition. Similarity of the vessels to the previously hegemonic Chavín style helped to proclaim that Chavín was the ancestral culture, and perhaps even sanctified Moche state religion. (Yet artistic revival always introduces a strong element of change: the Moche spout tends to be oriented front to back in relation to the main image whereas the Chavín was typically placed side to side. Kubler points out that the Moche arrangement creates a more urgent need for the viewer to turn the vessel. Even this choice can be seen as part of the general exhortation to action, the 'verbal' Moche approach, with the premium placed on restless movement.) The underlying duality of the two spouts probably had symbolic significance as well.

All types of Moche ceramics have added decoration, either in the form of three-dimensional appliquéd or fully modeled elements, two-dimensional painted patterns, or both. Moche sculptors were often boldly virtuosic in their modeled additions, casually defying the risks of solid suspended clay parts drying, shrinking, and breaking off. They were equally talented at painting

88

terracotta red and creamy white slip accurately, and burnishing
surfaces to a satiny sheen. The occasional blackware is found, but
the vast majority were fired in an oxidizing atmosphere with few
mistakes; grey splotchy fire clouds are rare. In many cases,
although it has abraded off most, after firing an organic black
pigment was scorched on to emphasize details, such as a barn 90
owl's radiating eye feathers. On occasion ceramics were even
inlaid, as in metalwork. Thus, a great number of steps and skills
were involved in each of the thousands of pieces produced.

Moche ceramics did not remain static for 500 years. Both
modeled and painted fineline types existed from the earliest
phases. The fineline tradition began with geometric patterns
painted in broad brushstrokes, then featured filled-in silhouette
figures, very like Greek Black Figure vase painting (except in 62
red). Simple scenes preceded complex ones, for instance, a battle
conveyed through two pairs of struggling figures rather than a
multitude. The silhouettes were nevertheless full of energy, uti-
lizing the dynamic asymmetry of profile figures, legs in leaping 85
position, arms akimbo. Some overlap of parts in space was
allowed, if the clarity of the action was not compromised. Again
like the Greek trajectory, Moche artists, desiring more detail,
added thin lines in white slip over the red figures and/or incised
through the red layer to the white background below. *Pentimenti*
(evident changes of mind by the artist from sketch to final image,
called 'ghostlining' by Christopher Donnan) reveal the creative
process of fineline painting. Apparently many vessels were
incised lightly with the plan for the overall composition, difficult
to envision on such round surfaces, then the painted lines fol-
lowed (or sometimes the design was adjusted, since preliminary
and final versions do not always coincide). Sketch lines were
burnished out in most cases.

As mastery grew and painted compositions became more
compex, such preplanning must have been increasingly necessary.
Thinner and more precise linear outlining replaced silhouettes
and only a few elements were filled-in, such as clothing and 67, 93
ornamentation. This artistic trend may correlate with the
increasing complexity of the state and its rituals (as the contrast
between the Old Lord and later Sipán burials attests). With the
increasing elaboration, painted scenes approached illegibility.
Although earlier fineline unfilled outlines had been transparent,
numerous small figures had kept their integrity as figure against
ground. However, over time the addition of filler elements
(smaller figures, plants, animals, even dots), crowding of figures,

description of background, inclusion of several different scenes, and exploration of minute detail gradually made late Moche finelines almost impossible to decode. Perhaps the visual pace quickens in a larger and more complex state. This type of late 'baroque' phase does nevertheless form part of an artistic cycle the world over. Once an iconographic code is totally understood, artists take more liberties with it. In addition, illegibility can be exploited by a political hierarchy for its exclusivity; an esoteric or mysterious image may be read only by the privileged few.

As with Moche architecture and metalworking, our knowledge of ceramics has benefited from recent archaeological discoveries, such as those at Galindo and Cerro Mayal. Both sites have a ceramic workshop at the periphery; the workshop near Galindo was located on the road to the coast so as to accommodate the llama caravans bringing in materials and out finished wares (there was even a llama corral adjoined to the workshop). The late Chicama Valley ceramic workshop at Cerro Mayal was located near Mocollope and covered over 29,000 square ft (9000 square m). Its many kilns were placed to make best use of winds coming down the ravine (allowing for hotter fires). Ceramicists ate well, suggesting their patron was the local leader and their status was concomitantly high, and they worked with a very fine orange clay. Here the high-quality Moche wares, with their thin walls, glossy surfaces, and elaborate sculptural details, were created in their many forms: stirrup-spout vessels, flaring bowls, figurines, and serving wares. At Cerro Mayal they seem to have specialized in figurines of women, perhaps for shamanic use as fertility spirit vehicles (note that the owl-headed shaman in ill. 89 is female). The many serving wares suggest that the patron feasted workers in traditional Andean style. The remains of molds included one for a portrait head vessel, perhaps an image of the lordly patron himself.

Though neither the earliest nor the most widespread form, the portrait vessel is particular to the Moche and thus stands out in Andean art as a whole. This type seems localized to the Chicama, 86, 87 Moche, and Virú Valleys of the southern sphere and limited to a middle date, corresponding to the height of Moche expansionism. Their abrupt disappearance may signal the political climate for that degree of individualism shifted along with the dominance of the south. (Later Moche ceramics include more blackwares, further evidence of the momentum swinging in a northerly direction [see Chapter Six]). That these are true portraits is not in doubt, as even a cursory comparison of ills. 86 and

87 attests. A handsome, thin-lipped, solemn man contrasts with a smiling one with fuller lips and nose. Thus, not only physiognomy but personality are immediately conveyed by these marvelous images. Others show people who were plump, lopsided, or regal, young, middle-aged, or older; one extraordinary series of over forty-five portraits of the same individual, noted for a scar on his lip, spans much of his life. The face portraits dominate the corpus, but seated and standing full-figure images also occur and sometimes can be correlated to the faces. Several sets of portraits show high-status men who later become captives, stripped of their finery and wearing ropes around their necks. One such individual, a man with a distinctly lopsided face, was immortalized in ignominious defeat in a vessel found at the Huaca de la Luna. This helps build the case that much Moche sacrifice was not of foreigners in battle, but rather of Moche individuals, even powerful ones. To sacrifice the powerful and well-known was a gesture of supreme, perhaps spiritual as well as political dominance.

Men in Moche ceramic art are not all rendered in such personal detail, and various social status levels and roles are shown. Besides the symbolic holding of the hair of their victim, men are shown hunting, inside structures, playing music, and posed as shamans with their hands on their knees, among many other actions (including sexual intercourse, dancing as skeletons, and art-making). Some male figures are shown quite elderly, with distinctly wrinkled faces.

Hunting was largely an elite male activity, but was not always depicted simply as a way to obtain meat. Sea lions being killed on a *guano* island may serve to show Moche control over far-off valued places and products. The circles in front of the dead sea lions' mouths are the bezoars (smooth deposits of minerals

85. Rollout drawing of the painted scene on a Moche fineline vessel depicting the violent clubbing of sea lions near a *guano* island. A gabled structure and ceramic offerings illustrate actual Moche presence in the South Coast islands, which were important sources of agricultural fertilizer. Early Intermediate Period.

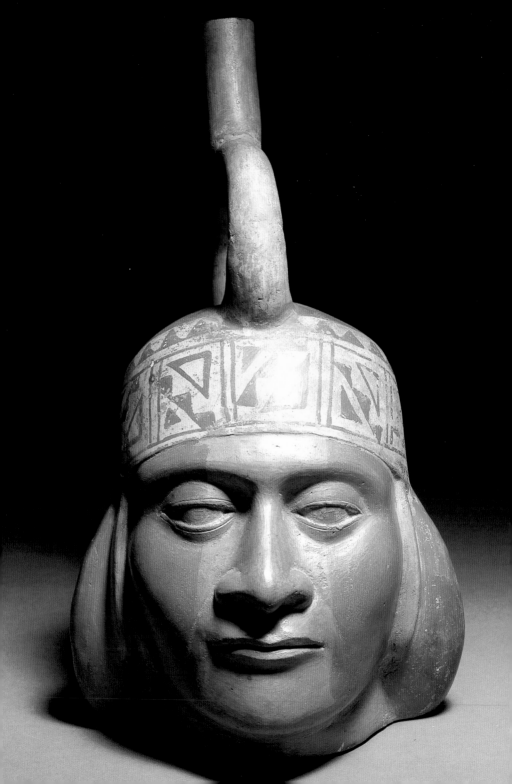

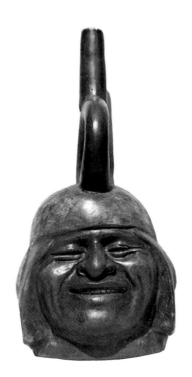

86. Moche ceramic portrait head vessel of an important man wearing a regal expression. When compared with ill. 87, it becomes obvious that the idiosyncratic physiognomies of distinctive individuals were recorded. Early Intermediate Period.

87. Like the beads from Sipán's Tomb 2 (see ill. 80), this stirrup-spout vessel depicts a smiling man. Moche art, unlike most Andean styles, favors physiognomic and emotional description. Early Intermediate Period.

found in sea lions' stomachs) prized in shamanic ceremonies as healing stones. In other hunt scenes, deer are shown being clubbed, and sets of deer antlers have been found in a cotton-processing compound at Pampa Grande, associating actual hunting with high-status art production. In other compositions deer-headed human captives are shown, so even hunting may not be shown to describe everyday life but as an analogy to sacrifice. Finally, deer may also figure in a touching maternal scene, revealing the many sides to Moche art and the many ways in which we may be influenced by its naturalistic style to disregard symbolic content. In any case, consummate artistry, whether the ability of a painter to wrap a complex scene around a stirrup-spout vessel's body or a sculptor to capture the delicate touch of a muzzle, can be appreciated in these compositions. The hiding man hunting a bird with a blowgun, an exotic jungle device, may be both symbolic and an artistic tour-de-force. The control over clay shown by the suspended weapon and the clever two-dimensional/three-dimensional spout-tree in whose branches the hunter perches is remarkable.

 Men in seated positions, such as inside a house, constitute a more static type of Moche composition. Their stately containment

84

88

71

88. Moche stirrup-spout vessel with the scene of a hunter in a tree shooting a bird with a blowgun. Ceramic artists defied the technical problems associated with unsupported solid portions to capture the dramatic moment before the kill. Early Intermediate Period.

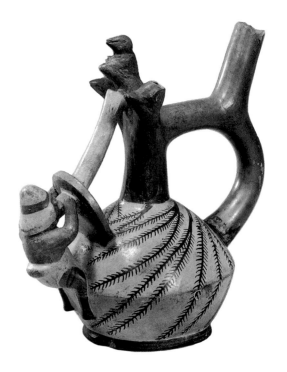

and hands-on-knees pose represents that of shamans in much Andean and Central American art. Another man sitting in meditation pose, on close observation, has no eyelids, upper lip, or tip to his nose and thus seems to be a survivor of the dreaded parasitic disease leishmaniasis. From a modern scientific point of view this disease has different strains that can occur together or separately, a visceral type that is fatal and a mucosal type that is not. If this individual contracted only the disfiguring latter kind, while others got both and died of the visceral, he would have seemed to have special survival powers. His trance pose suggests his defiance of death may have inspired him to become a healer himself. While conjectural, the scientific and spiritual data support such an interpretation (as shamans the world around are called to the profession by surviving an illness or coming into the world with an unusual body). A male musician dressed as – or simply as – a peanut, shows a shamanic sense of the interchangeability of humans and other living things such as plants and animals. The peanut, which we have seen was a prestige image at Sipán, was associated with flute-playing (elsewhere bean-men are warriors and maize-beings fanged), showing a

fluidity of symbols, ritual actions, and identities that continue to belie a simple naturalism. A peanut shaman, responsible for the fertility of that important foodstuff, is not hard to suggest as an interpretation of this enigmatic image (as flutes figure prominently in trance-induction). A Chavín-revival goblet, with a fanged human head wearing a jaguar headdress and bird-like face painting, illustrates the more typical transformation of human into powerful cat. This goblet, which was tested for but did not reveal human blood, could have been used for a mind-altering substance and its handle contains rattles (capable of producing a trance-inducing type of percussive sound). 90

Female images in Moche art also trace a strongly shamanic theme, and, of the world's religious complexes, shamanism perhaps uniquely promotes female spiritual leaders because the role of the shaman is seen as a calling from above, not an election from below. In the scene of the owl-headed shaman and her supernaturally-fanged client, the shawl gives away the gender identity of the healer. She acts in her transformed owl capacity, 89

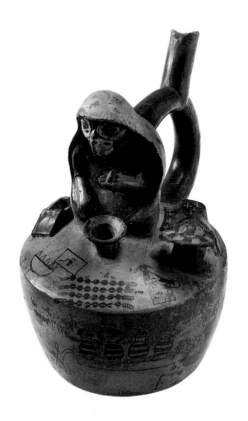

89. Moche vessel of an owl-headed woman shaman in the process of curing a patient. Modern shamans can identify all the tools of the trade arrayed around her, including the four strings of espingo seeds, a potent hallucinogen, in front of her. Early Intermediate Period.

the owl being an appropriate animal self due to its nocturnal hunting prowess, indebted to its silent flight and magical sense of sight (that we know as echolocation). Before her lie strings of espingo seeds, a powerful hallucinogen, to aid in her metamorphosis. Owls also appear in Moche ceramics in animal form together with symbols of predation (a snake in its talons), and music (a conch shell trumpet welded to its back). Combining the elements of shamanic ritual (music) and visions (which are universally replete with snakes), and referring to combat as well (other owl-headed males are dressed as warriors), such compositions show the many levels of reference possible in a composite image. Once again a naturalistic image achieves symbolic nuance. Owls serve as ideal models for Moche sacrifice as well, because they capture their prey and bring it home to decapitate, eat whole, and regurgitate the bones. This owl can be identified as a species of barn owl, *Tyto alba contempta*, still found in Peru; as its name implies, it lives in proximity to people and could therefore serve as a familiar point of reference for the Moche.

The desire to capture *all* realities in art extends to a small number of curious Moche vessels, such as ill. 91. It has become obvious that most Moche ceramic compositions represent clear figures, actions, and details, and whether we can fathom their many meanings or not, they are well-balanced and coherent. A few very odd pieces, however, break these rules and may well represent hallucinations themselves. The feline, human, and intermediate beings' faces on this and several other pieces are chaotically arranged, interpenetrating, and often incomplete, as if emerging or not quite there. The lumpy, asymmetrical composition, while not characterizing beings on this plane of existence, does amply describe the impossible, indescribable fluctuations of the visionary experience. As Moche art explores the means to visions, such as espingo seeds and San Pedro cactus, and shows the practitioners in healing trances and states of flux between human and animal/plant states of being, it would not be surprising to find that it depicts the visions on which shamanism relies for its information. If so, mimesis is extended to the edges of the cosmos, beyond the perception of most Moche viewers, in order to characterize visual transcendence of this world.

The meeting of worlds, the celebration of creative flux, and the role of women's particular powers are also shown in another rare image, a woman giving birth. Besides llamas having babies as shown in a unique Wari textile, this image stands nearly alone in Andean art. The abiding Moche interest in narrative may be

90

92

91. Some Moche stirrup-spout vessels seem to depict the fantastical visions experienced by shamans. Early Intermediate Period.

92. A rare Moche depiction of a woman giving birth. Early Intermediate Period.

partially responsible, but the miraculous generativity of women could also be the subject. Like the Priestess, and the female shamans who preside at various rituals of death leading to life, the dangerous female act of issuing forth life may represent the crux of the natural cycle. The drama of birth seen in this vessel cannot be denied, the artist capturing the head emerging during the mother's stoic push (a motion seemingly reflected in the unusually bowed stirrup-spout). Midwives and shamans still have overlapping roles in modern times, as fertility and moments of transition are common responsibilities.

93. Top view of a flaring bowl depicting weaving workshops and ritual presentations. Female weavers are shown in accurate detail with backstrap looms, bobbins of thread, and either models or finished products matching their work. Males in elaborate dress interact in an outside courtyard. Early Intermediate Period.

A final representation of female creativity, a flaring bowl's rim design of women weaving is another unusual, but telling, image. A weaving workshop recently discovered at Pampa Grande now reveals how accurately the painted representation characterizes textile creation (another high-status female occupation). Weaving tools, edges polished from use, were found in a compound that had a roofed platform across from a roofed room consisting of three adobe walls and a fourth bench side. Underneath one of the holes for the wooden posts (seen in the ceramic depiction) was a dedicatory burial of a macaw. The Andean love of color and fiber extends to a high value placed on images of birds, and on featherwork itself (in addition, visions typically include a sense of flying). In the painted version, women sit in roofed structures and men on adjacent platforms,

pursuing related but different activities. The female weavers use backstrap looms to create patterned cloth (the matching models and/or completed pieces seen next to them), while the men share maize beer (they are actually seen handing vessels back and forth). The implication is that male patrons, clients, and supervisors conducted business while the weavings in question were being produced. The image and the actual place to which it refers convey a deeply Andean sense of complementarity, control over valued fiber production (see Chapter Seven), and ritualized approach to creativity (a drum was found in the Pampa Grande workshop, which may have been played in rhythm with the weaving strokes or for courtyard ceremonies).

Moche textiles have not survived in any number, although their powdery remains are found in fancy graves and images of men holding up elaborate tunics seem to represent tribute payers. At Sipán, metal appliqués were sewn to simple ground cloths, now disintegrated. The few extant fabrics are complex structural cotton cloths that use colorful, imported camelid fiber sparingly. In late Moche times tapestries with distinct Wari influence feature angular warrior and staffbearer figures.

The Moche collapse
While no evidence exists that the Wari conquered the Moche, the threat of their great state beyond the Moche borders may have contributed to the destabilization of the largest coastal power of the Early Intermediate Period. There is a direct record of devastating floods followed by droughts, one of which lasted for the last thirty years of the sixth century. Internal stresses caused by perhaps overweening leaders (the demands on artistic production were obviously high) may also have been a factor in the collapse of Moche power. When shamanic leaders cannot control and balance the natural and social realms, their unique connection to the supernatural may be called into question and their power can dry up along with the water in the canals. By around AD 600–700 Moche sites were abandoned, production of ceramics in this style ceased, and other peoples such as the Lambayeque, and later the Chimú, gained hegemony over the North Coast.

Chapter 5: Tiwanaku and Wari Imperial Styles

While the Early Intermediate Period was characterized by the Nasca confederacy and the Moche state, the Middle Horizon was the first Andean period to be dominated by two interconnected empires, the Tiwanaku and the Wari. Tiwanaku, situated near Lake Titicaca in western Bolivia, had begun to flourish in the Early Intermediate Period, and hit an imperial highpoint in the later first millennium AD. Its far-reaching trade networks spread throughout the southern *altiplano* and to the Atacama Desert in Chile a distinctive new iconography based on a staffbearing shamanic nature deity. Five hundred miles away the state centered at Huari in the southern highlands of Peru spread its similar, but more militaristic message in an analogous time-frame, beginning nearly as early as Tiwanaku and quickly reaching northern areas after AD 600. Both fell from power between about AD 900 and 1000. The Tiwanaku-Wari relationship remains enigmatic, seemingly as much antagonistic as cooperative, but nevertheless the art they produced serves as an excellent example of how shared iconography can be interpreted in widely divergent styles. In some ceramics the Wari took up the staffbearer imagery and the style of the sculptural program at Tiwanaku, but in textile interpretations abstracted it to the point of near illegibility. While portable arts may be allied visually, the architecture and sense of space in the two capitals is quite dissimilar. Planned, processional movement through a precisely-sculpted program of dressed-stone constructed monumental mountains and valleys characterizes Tiwanaku, while Huari is an additive, high-walled labyrinth with militaristic overtones of containment. Yet both spatial approaches incorporated changes over the years, bespeaking not only their development as powers but a characteristic Andean emphasis on flexibility – seen in tapestry designs as well – and perhaps even the value placed on transformation found throughout shamanic societies.

Complex interrelations between religion, politics, and art styles in the Middle Horizon are still being debated. It was first postulated that Tiwanaku was a peaceful theocracy and the warlike Wari adopted its powerful imagery to their bellicose ends. Now these roles, while retaining a kernel of truth, are modified:

each had religious and military aspects as well as being the hub of a thriving economy. They apparently overlapped in the mineral -rich far South Coastal Moquegua Valley, not to coexist there as in a unified empire, but rather to exchange hostilities. The Wari left, but may possibly have taken Tiwanaku prisoners to build a new style of wall at Huari (just as the later Inca relocated Chimú artists). Current theories favor a more complex picture of the interactions between the two, and, instead of Tiwanaku acting as the originator, see for them a common cultural origin, probably in Pukará. Subsequent divergence, later contacts and influences, and a pervasive difference in style characterize our sense of these two interconnected empires. Ongoing archaeology and scholarly debate over how to interpret findings further complicates matters.

Generally speaking, in art historical terms, the Middle Horizon staffbearer and its attendants may represent a kind of Chavín revival, though the great temporal and spatial distances may preclude direct transmission. However, the deeply Andean immediacy of the past, as seen in pervasive practices such as serial site rebuilding, mummies sometimes kept above ground, and revivals like the Moche one of Chavín, do suggest a premium 90 placed on reinterpretations of earlier imagery. Similarities between Wari-Tiwanaku and Chavín staffbearers, as seen in the Raimondi Stela and the Karwa textiles, include frontality, elab- 29, 33 orate head projections, heads at the ends of the staffs, and arm position. Yet Chavín frontal examples emphasize fanged mouths and snake belts, as well as vegetal, snake, or spiral head emana- tions, while Tiwanaku ones have toothless mouths and puma 104 head belts and head projections. Strict bilateral symmetry in the Chavín figures is tempered in the Sun Gate central figure by the difference between two spears and a spear-thrower. In both periods a frontal staffbearer also can be associated with a profile, winged figure, as in the Black and White Portal. In the Middle 28 Horizon these attendants also carry one staff ahead of their bent legs, while the Early Horizon ones (who flank a doorway and not a frontal figure, unless that has been lost over time) do not. Yet early and late profile figures share an unusually-positioned upturned head, which may be that of a bird, feline, human, or some combination thereof in true shamanic style. Pumas and condors, the highland predators, figure more prominently in the later presentation of mountain-dominant empires. However, by the same token, the continuities are intriguing and suggest a constant relationship between what is seen as the primary being

to venerate and the transformational secondary ones, perhaps the shaman-leaders, who attend to supernatural needs.

The interplay of constancy and change is likewise key in the telling contrasts between staffbearers within the Middle Horizon itself. Tiwanaku examples emphasize the central frontal being more often than do the Wari, who predominantly explore profile figures with various types of heads and staffs. Tiwanaku textiles and wood carving also promote a puma-headed attendant not seen on the Sun Gate itself. Most importantly, the two empires established distinctive interpretations of the same iconography, the Tiwanaku always remaining more legible, in a clearly outlined, more curvilinear style, and the Wari deconstructing the canonical image into perceptually elusive splashes of color and rectilinear shape. One could argue that the audience at the time was familiar enough with the imagery to recognize it deep within the Wari abstractions, but nevertheless the presentation of the staffbearer in two completely different modes represents an obvious example of the power of artistic interpretation. The ability of state art to incorporate extreme abstraction also underscores the uniqueness of Andean statecraft and aesthetics alike.

The fascinating artistically distinct characters of the two spheres were perhaps responses to different political styles. Tiwanaku imports, but not architectural outposts, are found as many as 500 miles (800 km) south of the capital, thus betraying a centripetal economic/religious strategy. The Tiwanaku style may have kept clarity as a priority in the interests of promoting a new religious hierarchy. By contrast, although parts of the northern sphere were merely influenced, many seem to have been brought under Wari sway directly, according to the presence of intrusive administrative and military architectural statements. The Wari aesthetic system, if largely imposed, was perhaps less concerned with legibility than with the exclusivity and mysteriousness conveyed by these marvelously abstract images.

The success of both state strategies is obvious. Both Tiwanaku and Wari developed important agricultural approaches, ridged fields and canalized terraces respectively, that – like coastal canalization – gave them extraordinary advantages and changed the character of later Andean organizations. Both were able to prosper and control vast territories at a time when ecological adversity had dismantled earlier unifications. The two states used powerful ideology that drew on earlier

Andean icons, which they widely disseminated in many artistic media and packaged with economic advantages (and, at least for the Wari, backed up by military might). The later Incas built on many of these successful practices in their subsequent mega empire.

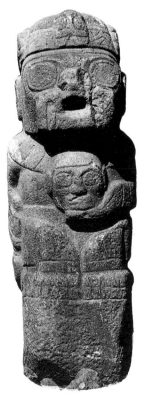

94. Pukará stone sculpture of a man holding a trophy head. Obvious similarities between these and later Tiwanaku sculptures (see ill. 102) lead scholars to see Pukará as seminal. Early Horizon-Early Intermediate Period.

95. Pukará ceramic fragment showing incised outlining, bold features, and polychromy that seem to have influenced later Wari and Tiwanaku styles. Early Intermediate Period.

Origins of the Middle Horizon empires

The two dominant powers of the Middle Horizon did not appear suddenly or without precedents. In the second millennium BC, the herding village Wankarani culture, located near the south shore of Lake Titicaca, worked copper and carved blocky stone llama head sculptures. Around 1200 BC in the same area, the site of Chiripá constituted the first public monumental expression of the religious ideas that would spread through the highlands. Stone plaques and stelae often depict a fertility deity as a head surrounded by rays and small llamas, linking herding animals with frontal shamanic deities whose visionary power extends from their heads (as in Tiwanaku's Sun Gate). Large, organized groups of workers erected stone-lined mounds with sunken courtyards on their summits, the probable location of these sculptures. These various architectural elements are all seen later at Tiwanaku; the ingredients of the southern power's art and architecture existed well before their imperial expression.

North of the lake, Pukará had a brief, but important, florescence c. 200 BC–AD 300. At the same time the pre-Wari Huarpa culture began terracing the southern highlands of Peru and set the stage for the growth of Huari, and Tiwanaku began building

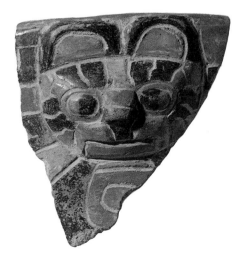

its monumental city east of the lake. The early interactions of these three cultures remain sketchy, and archaeological refinements seem to make Huari, Tiwanaku, and Pukará more and more contemporaneous, but in terms of the initial timing, location, and look of its art, a prime candidate for being the most seminal is still Pukará.

Pukará's buildings were adobe on stone foundations, as at Tiwanaku, and its tombs were built of large stone slabs, a feature found at both Tiwanaku and Huari. But its sculpture seems the most influential to both imperial styles, with its large-scale, blocky columnar figures notable for their huge, flat, squared oval eyes. Pukará pieces are, however, characterized by prominent ribs and the movement of limbs in space. Well-incised plaques continue to show the rayed heads with feathers and animal emanations. Ceramics are also quite similar to the later styles in the modeled *qero* form, stepped patterns and bright colors, as well as in the subject matter of herders, effigies, trophy heads, sacrificial victims, and felines. Yet the Pukará style features more oval eyes, deeply incised outlining of features and geometric patterns, and greater overall curvilinearity than either Wari or Tiwanaku. In later versions the formalism typical of empires elevates and constricts Pukará images to more hieratic and hierarchical expressions. However, if Pukará was not the sole or primary transmitter of this imagery, then this new look was at least widely shared in the southern highlands from this point onwards.

North of Pukará, in the Ayacucho Valley where the Wari would later dominate, the Huarpa culture set the stage with strong ties to the South Coast, especially the Nasca area. The two areas traded camelid fiber for salt, among other products, and deeply influenced each other's ceramics. However, Huarpa art remained rather rough and undistinguished compared with other Andean traditions. Practically speaking, the Huarpa began the very successful land reclamation program based on terracing the *quichua* zone, the steep but lower-altitude lands farther from the highland river sources of water. Terracing and canalization allowed new, vast areas of flat irrigable land to grow maize, a high-protein crop capable of feeding large populations, easily transportable, and vital to a state desiring to store quantities of food to redistribute to subjects, armies, or the nobility. (Continuation and expansion of Wari terraces allowed the Incas to feed as many as ten million subjects a millennium later.) Terrace agriculture certainly gave the Wari an edge at a crucial moment, providing the survival advantage that allowed their

arts to flourish and be spread far and wide. As a stepped mod-
ification of the landscape it also may have increased the potency
of the stepped outline and the zigzag in the arts of the Middle 100
Horizon.

Scientific analysis of glaciers shows that a major, generation-
long drought took place in the sixth century. This probably
helped destroy the Nasca and the Moche hegemonies, while pro-
pelling the innovators of Ayacucho and the *altiplano* into greater
prominence. The power to sustain life during such a disaster,
attributed no doubt to supernatural sponsorship, must have
added persuasiveness to their growing cults and communities.
Fertility and its corollary sacrifice, as well as shamanic interven-
tion, are also strong artistic themes stemming from the same,
somewhat anxiety-ridden, relationship to the environment and
the supernaturals 'responsible' for it.

Tiwanaku

The site of Tiwanaku is located just southeast of Lake Titicaca, a
large inland sea, over 600 ft (180 m) deep at points. It dominated
the wide high plains known as the *altiplano*, at 12,600 ft (3840 m)
of altitude. To the east are sacred mountain water sources,
dominated by Mt Illimani, and the paths down to the fertile
yungas or mid-altitude agricultural regions abutting the jungle.
To the west are the lake (with its rich resources of fish, wildfowl,
and plants) and the dry highland herding areas. Anthropologists
agree that Tiwanaku was sited to mark the nexus of these two 101
fundamentally complementary zones, and that from its highest
building, the Akapana, one can see both. Yet to develop this
naturally salty land to best advantage (only the grain *quinoa*
prospers in saline conditions), there had to be a new agricultural
strategy: a long canal from Titicaca plus a system of raised fields.
Long strips of mounded earth direct canalized water to deep
trenches on either side, so that salt leeches out, water levels stay
constant, the soil resists frost, and silt forms a perfect fertilizer
that, periodically spread back on the ridges, nourishes and
restores their elevation. A superbly productive method of farming,
modern raised field agricultural experiments produce many
times usual yields.

The economic advantages of environmental balancing,
combined herding and agriculture, gave rise to surpluses that
allowed true urbanism to evolve, even in this inhospitable land-
scape. During the first millennium BC the village gradually grew
and by AD 100 monumental stone architecture was being built.

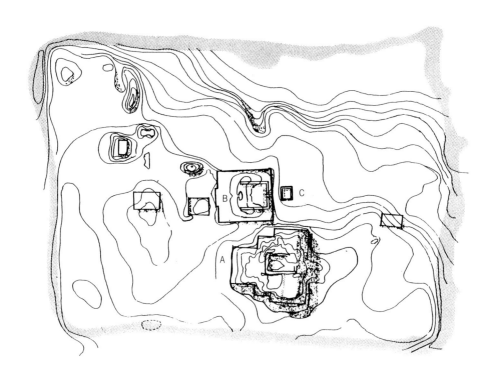

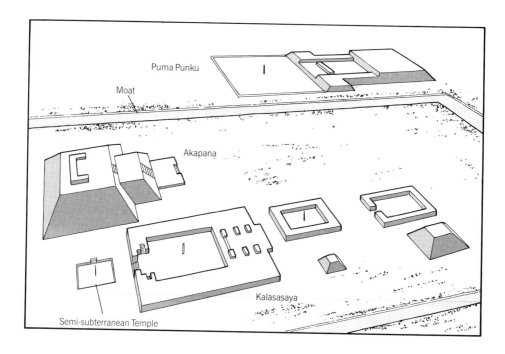

Puma Punku

Moat

Akapana

Kalasasaya

Semi-subterranean Temple

96. Plan of Tiwanaku, the capital of the southern empire that dominated the Middle Horizon. Principal structures include the Akapana (A), shaped like half a stepped diamond, large rectangular Kalasasaya (B), the small square Semi-subterranean Temple (C), and to the south, Puma Punku (see ills. 97, top right, 100). Early Intermediate Period-Middle Horizon.

97. Reconstruction drawing of Tiwanaku as seen from the north, showing the site's principal buildings and their relation to nearby Puma Punku, on the top right. Early Intermediate Period-Middle Horizon.

Tiwanaku hit its imperial apex between AD 400 and 800, declining c. AD 1000. At its height, the core area covered at least 4 square miles (10 square km) and housed between 30,000 and 70,000 people. The ephemeral nature of Tiwanaku houses, which sometimes do not even leave a foundation and were made of sod or adobe, means that the entire city may have stretched much more widely. A sharp distinction was drawn between everyday residences and the civic center with its strikingly permanent and visible architecture (a distinction absent at Huari, by contrast). Archaeologists now disagree on the existence of a moat surrounding the core area: Alan Kolata sees it as a symbolic device to make Tiwanaku into an island like sacred ones in Lake Titicaca, while William Isbell suggests a moat would drown the footings and drains in the core itself. However, as 'a line drawn in the sand' even a non-functional ditch would serve the symbolic purposes of delineating sacred space, especially in such a profoundly flat environment. It is agreed that Tiwanaku and Lake Titicaca, like Teotihuacan and its natural cave in ancient Mesoamerica, played an important role in the creation and origin myths of the later Inca and possibly during earlier times as well. 111

In any case, there is no mistaking the magnificent distinctiveness of the stone city rising from the *altiplano* and the power it gave its residents to see the path of the sun mediate different ecological zones. In fact, in Aymara, the language of this eastern area, the city was known as Taypikhala, 'the Stone in the Center' (also with connotations of 'the Place of Conjunction or Emergence'). The giant Akapana mound, Semi-subterranean Temple, and other impressive structures befit such an appellation. The iconography found on the buildings and carved sculptures features geometric symbols and transformational supernaturals, reinforcing the city as a self-proclaimed cosmic interpreter and genesis point. Internal hierarchy, both supernatural and human, was definitely reinforced by the city plan, its architecture and monumental sculpture increasingly impressive and sacred as one reached the center of the center.

Reconstructing the exact look or looks of that center has proven, however, to be an extremely difficult, contradictory task. Since Tiwanaku has been built, rebuilt, known, visited, plundered, and reconstituted for two thousand years, agreed-upon archaeological reconstruction remains elusive, to say the least. 'One man's pyramid is another man's palace,' in fact, and sculptures such as the famous Sun Gate were found in unlikely 103

98, 99. Tiwanaku's Semi-subterranean Temple (*right*) and view from it of the reconstructed entrance to the Kalasasaya (*below*). Numerous monoliths interspersed with smaller stones, grand portals, and tall sculptures are found throughout this capital city. Early Intermediate Period-Middle Horizon.

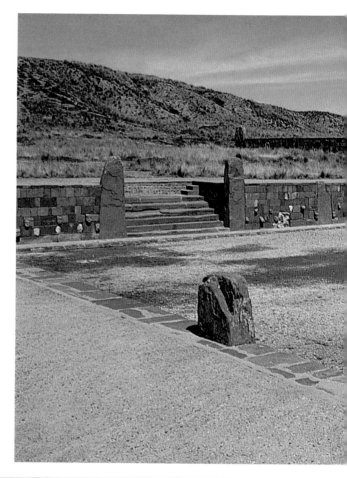

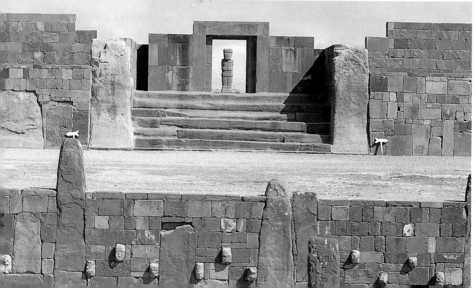

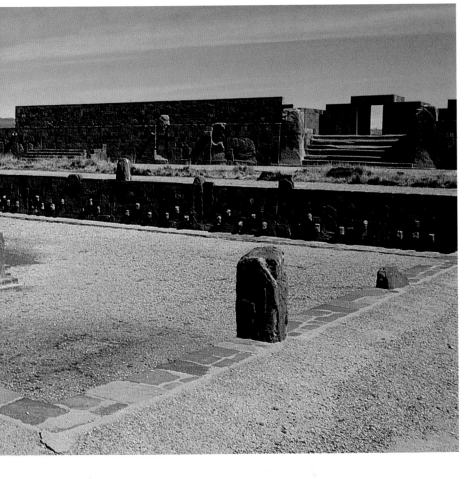

places. The exquisitely sculpted monoliths of Puma Punku, a 100 secondary monument about half a mile from the other main buildings, are like a puzzle slowly being put together. All scholars agree that many profound changes took place over the time that the imperial capital was occupied, so fixing functions of buildings which had several different reincarnations will remain challenging. As Jean-Pierre Protzen's work has shown, the fact that Tiwanaku stonework was mass-produced and uniform, ready for assembly in many different configurations, does not help matters.

The exact cutting and sculpting of stone at this site has long been admired, from Inca times to today. While the Incas told the Spanish they conscripted building labor from this area because of its stoneworking reputation, Inca masonry is actually quite

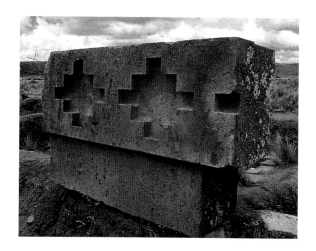

100. One of many finely carved architectural fragments at Puma Punku to the south of the main ceremonial precinct of Tiwanaku. The stepped diamond pattern also appears in Middle Horizon as well as later Inca textiles. Early Intermediate Period-Middle Horizon.

different from that of Tiwanaku. Two types of stonework are found at the Stone in the Center: 'random-range' (different sizes of rectangular stones not laid in regular courses, i.e., not in rows; seen in the Semi-subterranean Temple, for instance) and 'regularly coursed ashlars' (squared stones in regular rows, that may be of different heights). Both types feature perfectly flat faces, as opposed to the beveled edges of usually polygonal Inca stones that 'pillow' out. Stones that required no fitting on site, antithetical to Inca thinking, were but one of Tiwanaku's major innovations in Andean cut stone technology. They imply the use of standard measurement units and tools such as squares and straight edges, in short, a technology pre-planned for consummate precision. Other innovations were stones ingeniously carved with grooves to facilitate the use of ropes to jockey them into position, and the clamping together of stones with metal cast directly into T- and I-shaped sockets. Protzen sees this latter technique as utterly unique to Tiwanaku. The sharp edges and 90-degree interior angles, as seen on the Puma Punku stepped diamond stones, also suggest a new and unusual use of chisels and files (whereas, like the Inca, cobblestones were used to rough out, as evidenced by the small pits where they struck).

Such admirable stones lined the over 600-ft (200-m) sides of the Akapana, an entirely human-made mound in the shape of half a stepped diamond (known popularly as the 'Andean Cross'). Tall upright stones intermixed with smaller ones faced the stepped levels, the top one accessed by stairs on the east and the west (archaeological sensing equipment suggests the western one may be a double staircase). Extensive looting of the summit both

indicates important treasures there and interferes with reconstructions, which alternatively postulate a sunken court or pond, and a palace building. On the top there were definitely some structures where people at least ate food, under which there were numerous burials, including a primary one of a seated man holding a puma effigy incense burner. This High Priest-Puma Shaman faced a row of other mummies, underscoring his importance. In addition, the complex seemed to have been sealed *c.* AD 1000 with a cache of disarticulated llama bone sacrifices and objects of various media, ritualistically arrayed like a modern shamanic altar. In many ways, the Akapana seems to be a monument to shamanic transformation into the puma, the great cat that dominates the mountains, since tenon heads of pumas and humans stud the upper terraces. In addition, a black basalt image of a seated, puma-headed human holding a severed head in its lap was found at the base of the western stairs (traditionally the direction of night and death, as the sun sinks there daily). Another *chachapuma* sculpture stands and holds a head dangling from one hand. Skeletons found on the first terrace and under the foundations were, in fact, headless in most cases, strongly implying that the sculptural record is in some sense accurate. Puma-transformed priests might have used heads as ritual devices (the Inca drank from their enemies' skulls) and *chachapuma* images may have symbolized their predatory power to capture malevolent spirits. Ritually smashed *qeros* found with the burials show that art, and specifically those objects used to

101. One reconstruction of the Akapana mound with its stone-faced tiers, staircase, and sunken courtyard on the top level. Puma tenon heads also dotted its surface and a burial of a High Priest held a puma effigy incense burner (like that in ill. 105). Middle Horizon.

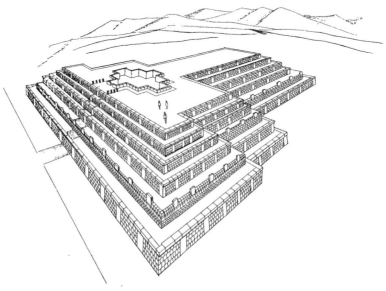

share drink in ceremonies, was 'killed' as were people themselves. (Interestingly, Wari ceramics were also ritually destroyed at Conchopata.)

Beneath the Akapana's sunken court, almost certainly the ritual center of the empire, and within the Akapana as a whole, ran a complex and highly symbolic system of drains and spouts. During the heavy rains the court would need to be drained; however, Tiwanaku engineers designed a decidedly non-practical solution to the problem. Draining water entered the body of the structure to re-emerge on each terrace, cascading from one and disappearing into the next. This made the Akapana into an enormous fountain, and perhaps a calculatedly noisy one, much like the Temple at Chavín de Huantar. But Alan Kolata and Carlos 18, 19 Ponce Sangines point out that this play of water directly imitates the sacred water source of Mt Illimani with its subterranean and above-ground streams. In addition, from the Quimsachata mountain range south of the city, the architects of the Akapana imported a bluish-green gravel to place in layers in the upper terraces' fill and all over the summit. This invoked the color of water during dry periods, and was the same rare and precious blue as the indigo prized in Middle Horizon textiles and the turquoise figurines cached at the Wari site of Pikillacta. The powerfully unique visual message of the Akapana, then, was a combination of green water, black puma, and stepped mountain. One could interpret this as a claim that Tiwanaku's puma-transforming shamans can ensure that water continually flows from the mountains to give the Tiwanaku people life.

Just to the east of the Akapana lies the Semi-subterranean 98 Temple, a square sunken courtyard. The walls, studded with tenon heads in slightly different styles, suggest that it was reused over an extended period of time. These human heads, most somewhat coarsely carved out, have characteristic large squared oval eyes. They recall Chavín and Akapana tenons, but 24–26 as currently reconstructed do not accentuate puma transformation. Like the sculptures found in the center of the courtyard, which were from various periods and places, the heads may represent the many ethnicities in the Tiwanaku sphere or propel the city's power propagandistically into the past.

The most major stela found in the Semi-subterranean Temple was the gargantuan Bennett Monolith, named for a prominent archaeologist of the period, Wendell C. Bennett. It stands an impressive 24 ft (7.3 m) tall, and is the tallest Andean stela. The Ponce Stela, found elsewhere, shares the typical facial features,

102. Detail of the Ponce Stela, from Tiwanaku. Characteristic of sculptures in this style are the square eyes and detailed shallow relief. Middle Horizon.

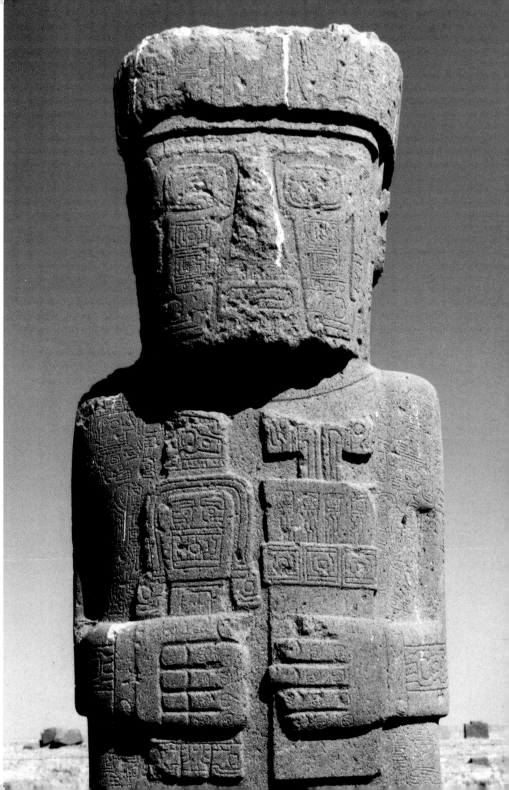

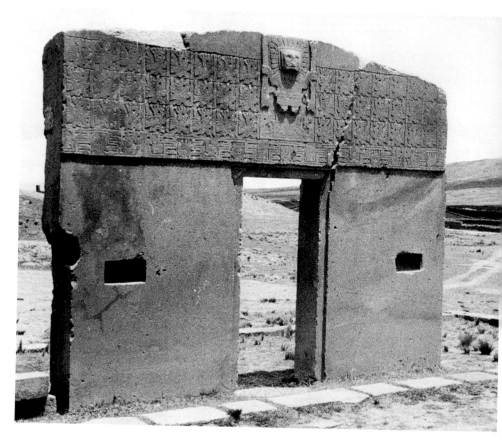

the tight columnar form, and the all-over shallow relief. The figures hold *qeros*, shells, batons, and other ritual objects. Thus the stelae likely represent priests, perhaps the Bennett Monolith even the High Priest himself, his height a measure of his relative importance. Delicately and precisely etched into the surface, barely visible in fact, are elaborate tunics, belts, and headdresses.

The Bennett Monolith is literally clothed in shamanic visions, and provides a key to the frontal rayed face motif, as the ones seen around his waist sprout hallucinogenic San Pedro cacti from their crowns. Profile human-headed staffbearers, like those on the Sun Gate, fly between the vision-induced/inducing heads and standing llamas, whose tails are replaced by more of the mescaline-rich cacti. All over his body range the bird- and human-headed flying shamans, while a version of the frontal being on a dais holds its arms aloft at the small of his back. The

vision-llamas may be another way in which the religious leaders sought to show their power over natural fertility, intervening in their trances to facilitate the delicate survival of the highland's most crucial animal.

The Sun Gate is like the Bennett Monolith unwrapped, and both are like textiles draped across stone. The monolithic portal that best sums up the iconographic program presented at Tiwanaku was found in a far corner of the large Kalasasaya, a huge courtyard over 300 ft (100 m) long north of the Akapana and west of the Semi-subterranean Temple. It was originally part of a larger series of doorways, as the broken proper right side attests; recently a number of similar portals, both functional and blind, have been found at Puma Punku, suggesting that the Sun Gate may once have been located there.

The Sun Gate is carved from a solid piece of stone, its front penetrated by a double-jambed door (a feature adopted by the Incas) surmounted by an intricate frieze in relief. Boldly projecting from the top center is the frontal rayed figure holding arrows and a spear-thrower, both with bird heads (presumably to exhort the arrows to fly like birds). He stands on a stepped triangular form, called a dais but possibly referring to the Akapana

103
104
99

104. Drawing of the center portion of the Sun Gate (see ill. 103). The frontal, rayed being on the dais (which may represent the Akapana) holds in his right hand a spear-thrower and in his left arrows. Winged attendants are human- or bird-headed and also carry arrows as staffs. Early Intermediate Period-Middle Horizon.

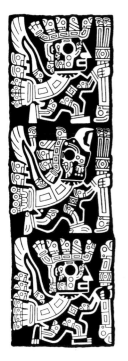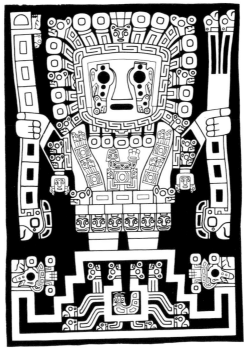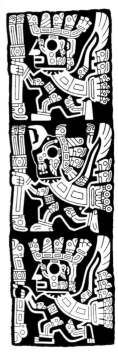

itself, making him the proposed Puma Shaman. His projecting face, centrality, dominant size, and puma accoutrements certainly signal a supernatural state of being. To either side, like the lesser shamans of a hierarchy, fly bird- and human-headed attendants, each carrying a single staff/arrow with which to attack spirits or enemies. (Most imperial portable arts feature the lesser shamans in trance flight, suggesting that their owners carry out the orders of the High Priest.) To place this imagery on a gate is highly appropriate, whether for ritual purposes to shepherd performers dressed as birds and pumas from one sacred space to another or, on a higher symbolic level, to embody the change of consciousness as a passage through a cosmic portal to other realms (i.e., the vision trance). Many shamanic cultures today still liken the means of altering consciousness, whether drugs or other trance-inducing practices, to going through doorways to the Other Side.

Half-scale and full-scale doors are being reconstructed by Protzen to shed light on the original configuration of the puzzle that is Puma Punku, the southern counterpart to the Akapana. A confusing array of fragmentary architectural sculpture is only now taking shape, probably as a palace structure. Current reconstructions favor a T-shaped footprint, one step less than the Akapana's as seen from above, and enclosed courtyards perhaps both east and west. A shift in power might have occurred, as Puma Punku seems later than the Akapana. At any rate, series of symmetrical door and niche compositions show that repetitive funneling of people and the reiteration of openings both useful and symbolic, was the leitmotif of Tiwanaku architecture.

Outside Tiwanaku proper, a number of sites in the environs and the hinterlands show how the city's presence was felt beyond the monumental core. Outposts such as Lukurmata share Tiwanaku's long canals connecting them to the lake, moats circumscribing ceremonial cores, drained terraced mounds, monolithic slab architecture, gateways, and columnar statuary. Each supervised its portion of the vast network of raised fields. Further from the heartland, Tiwanaku sent enormous llama caravans far and wide to export religion and import foreign products and materials. Evidence of Tiwanaku objects and representatives is found as far away as San Pedro de Atacama in northern Chile, a 500-mile (800-km) trip, six weeks' walk each way. However, the principal Tiwanaku colony is Omo in the coastal Moquegua Valley, housing around 500 people stationed there no doubt to procure the rare minerals, volcanic glass, and

metal for Tiwanaku luxury goods in turquoise, lapis lazuli, obsidian, gold, and copper. An undefended outpost, Omo had houses, a space especially set aside for beer-making, caches of portrait head *qeros* for ceremonial drinking, and many imported and local copies of Tiwanaku arts. If the Inca pattern applies, colonizers encouraged local participation in a far-off state's labor plans by exchanging work and products for beer and food in large quantities. Omo's longlived presence indicates a powerful but seemingly peaceful colonization; the Wari attempt to share the wealth here was neither as successful nor as pacific. 107

Tiwanaku portable arts

As in architecture and monumental sculpture, the portable Tiwanaku-style arts tend to feature versions of the staffbearer, both whole and shorthand, in wood, pyro-engraved bone, and cloth. The range of objects includes puma and jaguar effigy incense burners, carved wooden hallucinogenic snuff tablets, and human portrait head vessels. In all media the technical level

105. Ceramic incense burner in the form of a jaguar, found in a secular building in the northern part of the ceremonial precinct at Tiwanaku. Middle Horizon.

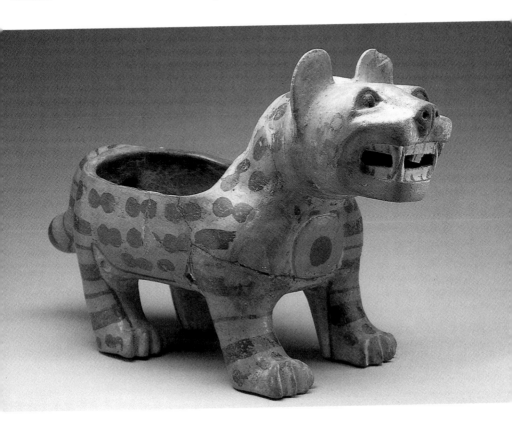

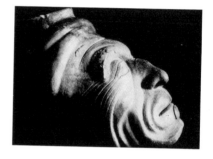

106. Wooden *qero* with carved attendant staffbearer facing viewer's left (see ill. 104). The staff is held to the left of center, the figure's head is upturned, his legs are bent, and his wings are to the right. The *qero*, or drinking cup, form was taken up by the Incas and continued into Colonial times (see ill. 179). Middle Horizon.

107. Drawing of a provincial effigy head *qero* found at Omo, the Tiwanaku colony in the South Coastal Moquegua Valley. Comparing this vessel with the one found at the capital (ill. 108), the range of portraiture styles at this time becomes obvious. Middle Horizon.

108. Portrait head ceramic vessel found in the Kalasasaya at Tiwanaku. With its inset eyes, deeply furrowed cheeks, and prominent nose, this image captures the idiosyncracies of a specific person, as did the Moche portrait vessels (see ills. 86, 87). Middle Horizon.

is quite high, as the exquisite carving of the wooden *qero* or the weaving of the miniature tunic attest. Provincial versions may be more rudimentary, such as the ceramic *qero* from the Moquegua Valley site of Omo which does not feature the physiognomic emphasis of the one found in the Kalasasaya. The latter, somewhat like Moche portraits, sets the eyeballs into their sockets and shows the character of an individual nose, giving an uncanny sense of the man's interior presence. The stylistic range of imperial Tiwanaku art is obviously quite broad, as would be expected in such a wide-ranging merchant empire.

In keeping with the long-distance trade emphasis, Tiwanaku objects are often small in scale, portable ritual items charged with the complex religious message of the center. The tiny tapestry tunic features a version of the Sun Gate attendants, this time with puma heads and no wings. Dark outlines replace the shadows from the shallow relief, while the textile's rich tones of gold and red may suggest the original coloring of the Gate itself. The detail is exceptional, considering each figure is only about 3 inches (7 cm) tall; features such as toenails are painstakingly delineated. Not wearable, even by a baby, this tunic concentrates

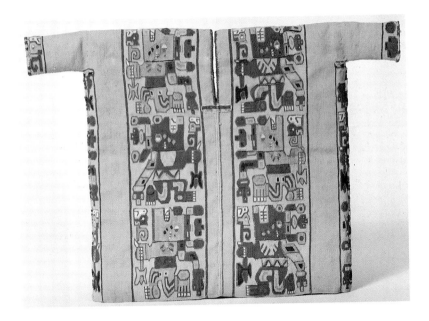

109. Miniature Tiwanaku-style tunic with human-headed attendant figures (see ills. 104, 106). Only 12 inches (30 cm) wide, this tunic would not even fit a baby, but represents a virtuoso offering (with over 80 threads per cm). Middle Horizon.

the Tiwanaku iconography and the tunic form into a virtuoso essence. It is fascinating to see how the Wari textile artists worked with the same set of forms in such different ways.

Wari city planning and architecture

Despite adherence to the same kinds of spiritual imagery as Tiwanaku, the architecture of the Wari empire, and its whole aesthetic approach, was quite distinct from the other Middle Horizon power. Wari architecture and art partition space or figures in similar ways, meaning they wall off space and set up a rectangular structure that is then subdivided, whether in an adminstrative compound or a tapestry tunic. Access, physical and visual alike, is thereby cordoned off; even streets are walled in the capital city of Huari and nearby Pikillacta. Wari architecture consisted of a striking contrast between white plastered floors and massive walls, mostly made of rough stone in mud mortar, but a few of finely dressed stone. Walls are truly overwhelming, measuring as much as 13 ft (4 m) thick and over 30 ft (10 m) tall, emphatically enclosing rectangular courtyards with mazes of rooms around and between them. Residences may be smaller, but have the same basic properties as other structures (recall that Tiwanaku houses were not at all like other buildings and that rough stonework was an anathema). Wari architecture was con-summately bold, projecting strength and power for all to see.

113
116

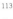

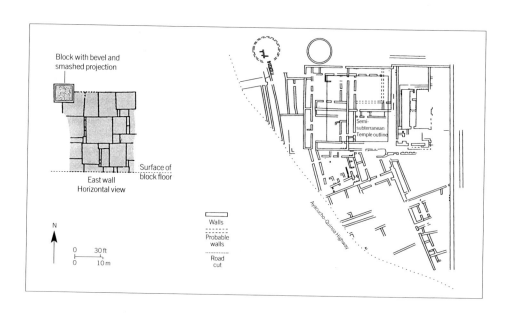

Block with bevel and
smashed projection

East wall
Horizontal view

Surface of
block floor

Semi-
subterranean
Temple outline

Ayacucho-Quinoa Highway

N

0 30 ft
0 10 m

Walls

Probable
walls

Road
cut

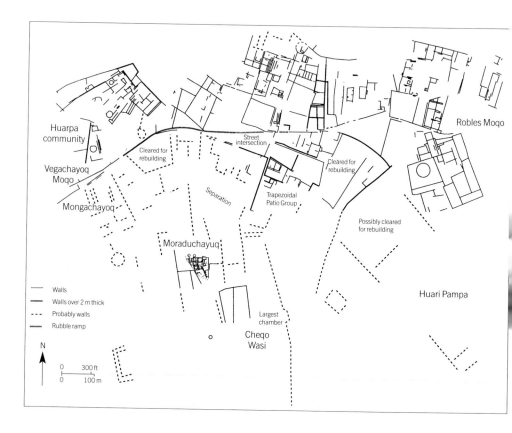

Huarpa
community

Vegachayoq
Moqo

Mongachayoq

Moraduchayuq

Cleared for
rebuilding

Street
intersection

Separation

Trapezoidal
Patio Group

Cleared for
rebuilding

Robles Moqo

Possibly cleared
for rebuilding

Huari Pampa

Walls

Walls over 2 m thick

Probably walls

Rubble ramp

Largest
chamber

Cheqo
Wasi

N

0 300 ft
0 100 m

110. Plan of the Moraduchayuq
Compound at Huari and detail
drawing of a polygonal stonework
wall that underlies the courtyard
level. Changes from ritual to
administrative concerns are
documented in the evolution of
this compound. Middle Horizon.

111. Plan of the architecture in
central Huari, the capital city of
the northern Middle Horizon
empire. Its freeform arrangement
contrasts strongly with the axial
plan of Tiwanaku (see ill. 96),
as does the stonework. Middle
Horizon.

The city of Huari, like the others in the empire, grew up in an organic rather than a preplanned way, and changed a great deal over the hundreds of years it was occupied. At its height the city covered approximately 6 square miles (15 square km) and population estimates vary from 10,000 to 70,000. In a final phase, high walls were erected across the city, probably as the beginnings of huge compounds left unfinished when the metropolis was abandoned around AD 800. The overall gestalt is of a densely packed, even contradictory accumulation of joined, but separate structures. Isbell even suggests that military garrisons built far from the Ayacucho Valley capital influenced its design, a centripetal effect perhaps unusual in state architecture. The rise of successful generals and a militaristic aesthetic is not surprising, however, considering how widespread the Wari state became, seemingly by the use of force. Recurrently bellicose imagery alongside spir- 120 itual depictions show how integrated art, politics, and religion were during this period in the ancient Andes.

Archaeologists are gaining a better sense of this large and important city, though it is by no means completely excavated or reconstructed. Isbell and others have recently found some textiles in situ, and sketched in a longer and more complex evolution of the city than previously imagined, and even pin-pointed a royal tomb. For instance, the oldest part of the city, Vegachayoq Moqo in the northwest, was first a royal palace, then a mortuary monument, then a cemetery. Some parts were ritually interred, or retired, when their role was complete (in a typically Andean treatment of buildings as alive and requiring burial, like people and art). Here some fine eighth-century Wari textiles were found with burials placed within the niches of the western wall; this is unusual given the usually poor preservation conditions of the highlands.

To the southeast, Moraduchayuq shows how a sixth-century red-painted semi-subterranean temple (shown as an inscribed square in ill. 110), with strikingly Tiwanakoid stonework, was first laid down. One wall retains a broken-off tenon, perhaps originally the support for a sculpted head. The temple (never fully excavated and now destroyed) may also have had sculptures in the center, like Tiwanaku's Semi-subterranean Temple. Like Vegachayoq Moqo, this too was ritually buried with clean soil and the temple's walls intentionally toppled into the sunken court so that it could be built over by the militaristic patio group architecture that characterizes the middle years of the city. These second layer buildings were erected in single construction

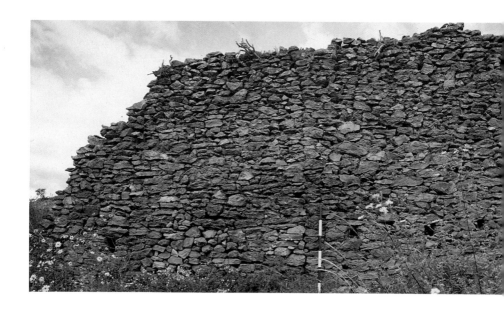

112. A typical Wari-style wall at Pikillacta. These multi-story, rough stone walls were built by Wari subjects in sections (a seam is visible to the left of the scale marker). Originally they were plastered and painted. Middle Horizon.

113. Plan of Pikillacta, the Wari provincial center between the capitals Huari and Tiwanaku. A single entrance near the southeastern corner pierces this enormous, high-walled complex. Middle Horizon.

114. Aerial view of Pikillacta showing its geometry imposed on the landscape. The terrain actually slopes 262 ft (80 m) from one side to the other. In a similar way, Wari tunics imposed their rectilinear format over the human body (see ills. 116–19). Middle Horizon.

phases (they have bonded walls, whereas structures that are made bit by bit do not), suggesting conscripted labor was used. That the secular was imposed over the sacred is clearly demonstrated at Moraduchayuq. It is most likely that administrators lived here, as ceramic wares for feasting are found, but there is no evidence of cooking itself or the making of art.

The royal tomb was located in the middle of Monjachayoq, south of Vegachayoq Moqo. Four layers of slab-stone burial chambers were superimposed, creating a very complex underground architecture for the dead. Four rooms on the top level, each about 5 ft high and 4 ft wide (1.6 m by 1.4 m), were laid above an impressive 21-chamber second level. The third level contained what is seen as the royal tomb, a shaft then a chamber in the shape of a profile llama, which was entered through a doorway in the animal's 'mouth.' Its 'tail' was the fourth level down, a cylindrical tomb of rough stonework. A carbon 14 date points to a ruler of c. AD 750–800 as the probable occupant of the llama tomb, which is heavily looted. Llama imagery appears on the Bennett Monolith, on a number of Wari textiles, and in this special tomb, showing that the herding iconography continued to be associated with power in both Middle Horizon states.

The southern provincial capital of Pikillacta, strategically located between Huari and Tiwanaku, is the largest of the administrative and/or military compounds found in many valleys north and south of Huari. Its enormous rectangular center,

Sector 4

Sector 1

Sector 2

Sector 3

| 0 | 300 ft |
| 0 | 100 m |

N

2445 by 2067 ft (745 by 630 m), was built in the Lucre Basin at
the southern end of the Cuzco Valley at an altitude of 10,660 ft
(3250 m). Seen from above – a vantage not possible in ancient
times, as with the Nasca Lines – its right angles belie the fact that 60
the undulating ground slopes nearly 262 ft (80 m) from end to
end. Geometric imposition rather than an organic relationship
to the terrain is obvious. Yet absolute regularity is not para-
mount: note the 'missing' three units on the northeast and the
adjunct section to the west. These are intentional deviations
rather than the result of additive building. The settlement was
planned and erected in one episode, according to the construc-
tion evidence elucidated by archaeologist Gordon McEwan.
Such preplanned irregularities equally characterize other Wari 1
media.

Pikillacta is subdivided into four main parts, separated by a
very few interior passageways. There is but one exterior
entrance into the main compound, along the eastern wall,
leading through an extremely long, easily policed corridor and
finally piercing the compound between Sectors 1 and 2. This
circuitous entryway in itself speaks eloquently about control of
access. Northernmost Sector 1, like the others, is made up of
many very large enclosures (averaging 115–130 ft [35–40 m]
on a side). McEwan has devised a typology of the many ways in
which a grid section can be configured, combining the basic
elements of empty walled enclosure, peripheral gallery, and
rectangular building. In most, the central part of an enormous
room is a patio, while long halls line the edges. Although five
main schemes can be defined, there is great variety in individual
spaces, betraying a flexible approach ensuring a recognizable
overall arrangement without specifying particulars. This is
noticeably less regimented than many imperial architectures,
implying that the participants in the state could determine their
own ways to accomplish a given task, from living space to more
sacred duties.

Even the three sectors have their own distinctive patterns:
Sector 2 has many more irregular elements than the others, from
an anomalous diagonal wall to a special large central patio prob-
ably for mass celebrations and even two caches of forty green-
stone figurines. Sector 2 seems obviously to be higher prestige
with different, special-purpose spaces rather than repeated
units. Below, Sector 3 has units either side of a huge open terrace,
perhaps for colossal gatherings. Adjunct Sector 4 has 501
repeated units, possibly for storage but more probably for the

garrisoning of troops. Together the four sectors allow for living, administration, ritual, and storage/defense, fulfilling the many functions of a provincial capital. The countless people, products, riches, and events that took place here are lost, but the gargantuan structure and the values it embodies remain. A series of smaller Wari settlements filled the rest of the Lucre Basin, showing an administrative hierarchy. Likewise, large Wari cities to the north, such as Viracochapampa, Jincamocco, and Azángaro, had their own local networks. All Wari outposts are similar architec-turally, yet different in arrangement, reinforcing this pattern of standardization with individual variations.

Specifically defensive Wari architecture has been found, such as large walls guarding the entrances to the Lucre Basin. Most significantly, only a few miles from Tiwanaku's Omo colony in the Moquegua Valley is the Wari fort of Cerro Baúl and a typical hierarchy of local Wari settlements. The fort was built on the half-mile-long (1-km) summit of a sheer-sided mesa some 1970 ft (600 m) in height, with the terraces, walls, and switchback paths below created to prevent access. The walled fort was filled with rectangular courtyards and large deep pits (probably cisterns, since the nearest water source is an hour's walk away). The same type of building techniques, typical multi-story constructions,

115. Plan of the Wari fortress of Cerro Baúl in the Moquegua Valley. Atop a high spur of land, intrusive colonists were protected from Tiwanaku settlers at Omo; however, the Wari group soon left the area. Both groups apparently sought the rich mineral resources found there. Middle Horizon.

and the overall irregular arrangement rather closely follow that of the capital of Huari itself. Ceramics found there seem to be either imports from Wari or local copies. But, as an intrusion into Tiwanaku territory, this fort was occupied only briefly; apparently a confrontation caused the Wari colonists to leave while the Tiwanaku people remained.

Wari fiber arts

Because the Wari expanded their operations from highlands to coast and buried some of their dead (probably state representatives) in the dry desert sands, hundreds of their spectacular textiles have survived – as against comparatively few Tiwanaku ones. Textile primacy characterizes the Middle Horizon as much or more than any other period, considering the close ties of the Tiwanaku reliefs to textile canons, the dissemination of styles via portable fiber arts, the state-wide dedication to the production of these labor-intensive objects, and their illustration in other media. Another way in which textiles were favored is that fiber artists seem to have played a driving role in establishing the look of state style that extended across various media. The imperial approach toward administrative architecture – a rectilinear geometric structure filled with repeated but consciously varied elements and deliberate anomalies – also applies to textiles. Variations in individual sectors and enclosures of the architecture parallel those in the columns and motifs of the official Wari tapestry tunic. It is no accident that two distinct media share a common orientation, especially when the powerful controlling hand of an empire commissioned both.

Tapestry, the highest prestige technique, dominates the corpus. Some non-garment tapestries feature images of camelids, even pregnant or in the act of giving birth, which betray the concerns of herders who depended on camelid fiber. However, most are tunics, probably woven for imperial officials commemorated wearing them in ceramic and metalwork effigies (see ill. 120). Creating many hundreds of these large, two-piece garments entailed enormous expenditure of materials, time, and artistry; there are 6–9 miles (10–14 km) of thread in each tunic and the various colors of thread were interlocked up to a million-and-a-half times per tunic. Their colorful, nearly illegible patterns make Wari tunics among the most striking, abstract works of Andean art. They served to aggrandize their wearers, express the idiosyncratic creativity of specific weavers, and even potentially communicate imperial messages about order and chaos itself.

116. Wari tapestry tunic with 479 stepped frets and a single profile face motif (lower right, center). Such intentional anomalies appear in different but analogous ways in most Wari tunics, and may signal the contribution of individual weavers to the set design. Middle Horizon.

117. Wari tapestry tunic with profile face and stepped fret motifs. Wari tunics include an average of 6 miles (10 km) of dyed camelid fiber and cotton thread. Middle Horizon.

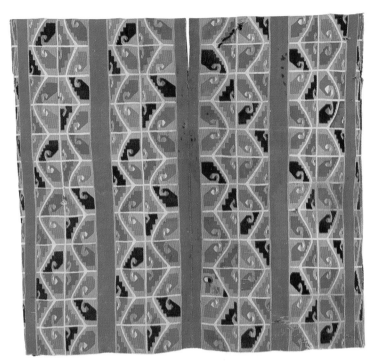

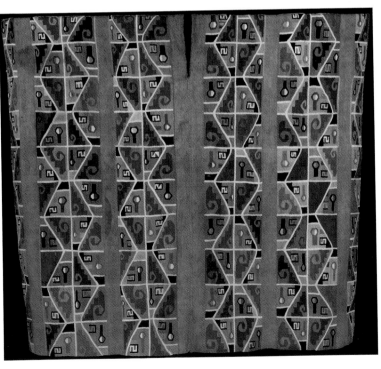

A B C1

118. Drawings of the bird-headed Sun Gate staffbearing attendant (A) as it becomes translated into textile versions (B–D). The figure may be simply rectilinearized (B), but is more often distorted so that the parts of the figure toward the tunic's center seam are wider (for instance, the tail portions of C1, D1, and D2). Middle Horizon.

Tunics bore the rather circumscribed iconography seen most clearly on the Sun Gate, concentrating mainly on the profile attendant figure and generating formal offshoots through abstraction. First the image was transformed by being rendered in the grid of warp and weft, which rectilinearized it (118B). Weavers then systematically distorted the image as it was repeated in rows and columns. Those portions of the figure that were toward the tunic's vertical central seam (118 between C1 and C2, D2 and D3) were expanded, while those parts toward the side seams were contracted. For instance, in ill. 118 C1, D1, and D2 the wing portions are widened, while in C2, D3, and D4 the staffs are more pronounced. Although the weavers have followed the apparent letter of the law ('all figures are the same') their interpretation alters how one looks in relation to another. Such manipulation of a stock image represents a quintessentially artistic act that lends extraordinary dynamism to repetitive compositions.

In fact, weavers followed the lead of colors and shapes fairly far away from the strict communication of the repeated figures, until sometimes only color and shape remain (except to the initiated). The 'Lima Tapestry' shows an extreme manipulation of the staffbearer, each rendition so truncated on the tunic-edge side as to appear to be only a half a figure and neither version with much of the head or headdress left. A glimpse may be caught of a white wing or a split eye, but any hold the viewer achieves on the figure itself is transitory. Only great familiarity allows viewers to recognize a bar or two of color as a hand. It can be argued that the subject has lost priority to the artistic process itself.

Further abstraction atomizes the figure and emphasizes geometric patterns on their own. The most popular motif combination is a triangular simplified profile face with another inverted triangle containing a stepped fret motif. The face has

2 D1 D2 D3 D4

the typical split eye, crossed fangs, a hat or headband, and some-times a nose. Any number of shape and color variations are played on the spare facial features, which can be almost entirely deleted in some cases. Again, set iconography is only the beginning point for creative artistic exploration. Geometric and animal motifs seem related to the figures but veer off into abstraction. For instance, stepped frets occur alone, and stepped diamonds, reminiscent of the carving at Puma Punku, combine with double-headed snakes (a recurrent shamanic symbol of visionary transformation). Since we do not know where the vast majority of tunics were buried and, even if we did, their portability renders their place of origin unclear, it is nearly impossible to accurately localize the various patterns and substyles. However, there is enough standardization in tunic size, thread count, palette, and motifs to show that the hand of the state heavily regulated the art form. Interestingly, it seems as if artistic license and imperial control dovetail in the official Wari style.

The advantages gained by promulgating social exclusivity in a state style might help explain the premium placed on abstraction. Tunic pattern illegibility or reductionism acted as a mysterious esoteric code to keep out uninitiated foreign subjects. Yet it also made Wari administrators into walking geometric billboards, the bright colors and tall columns of their garments making them appear larger than life, impressive to subjects. In fact, the distortion of the width of the columns, wide toward the center of the torso and narrow toward the sides, perceptually makes the wearer seem rounder, more cylindrical. Interestingly, thousands of years living at high altitude has altered mountain peoples' bodies to have noticeably larger barrel chests, just the shape promoted in tunic compositions. Like the puma and con-dor imagery, textile design emphasized the characteristics of the highland world, proclaiming it as dominant.

119. The so-called Lima Tapestry, a masterfully abstract interpretation of the staffbearing attendant figure (see ills. 103, 104). Middle Horizon.

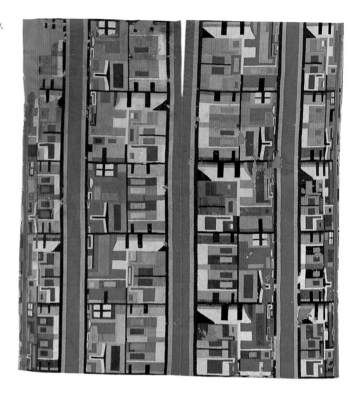

Perhaps more subconsciously, Wari tunic compositions may contain deeper state propagandistic messages about order and chaos itself. Besides esoteric abstraction and rigidly controlled grids of motifs, there is a pattern of very obvious, unprecedented formal choices that appear in almost every complete tunic known. These anomalies are fully intentional (tapestry is too slow and laborious a technique to allow these elements to be undetected mistakes). In a composition dominated by one motif, another suddenly materializes. For example: one tunic sports 479 stepped frets and, abruptly, one profile face motif (third row from the bottom, third column in from the viewer's right). This anomaly is certainly 'hidden in plain view'. Such chaotic introductions almost take on a humorous quality, like Haydn's 'Surprise Symphony.' Several motifs are also assigned a completely unprecedented bright green color, the hue most typical for color anomalies (fourth row from the top, second column in from the viewer's right). Most anomalies are in the blue to green range, probably because indigo dyeing was a supremely difficult process and therefore this color was highly prized. Indigo as a

116

dye has a magical element in that the fiber only becomes blue when brought out of the vat into the air, changing before one's very eyes. This physical surprise correlates well with its wild-card role in Wari tunic designs. Tunics may have one red shape, five blue-green stripes, or some type of reversed shape, as ways to vary the formal regularity. There are no two tunics that vary in the same way; each has its own deviations from the norm. It is possible to claim with confidence that one of the Wari artistic rules was to break the rules. Even aberrant walls and greenstone figurines at Pikillacta can be seen as architectural anomalies. [113] Signatures of individual artists are a primary way to interpret these anomalies in tunics.

It is also possible to suggest that the state allowed such variability as part of its official message – that it was an ordering system containing and controlling chaos. In the Andes chaos can be environmental: unpredictable floods, frosts, earthquakes, droughts and the like. It may be important to recall that Wari initial political success was predicated on their unique ability to mitigate the environmental disasters of the sixth century. A state's organizational schemes control deleterious effects of natural disaster by mobilizing work forces, moving food and supplies around, growing plants on terraces, and so on. Thus, the Wari may have consciously or unconsciously embraced a statement of orderliness – ranks of repeated, grid-contained sacred images – that was enlivened, but not unbalanced, by chaotic formal elements. This hypothesis assumes that the structures in art mirror those in thought, that all artistic statements are meaningful and intentional, and that individual creativity and imperial propaganda are not mutually exclusive. If nothing else, it fits with Andean, and particularly Wari, traditions of embracing change, such as in the architecture at Huari. Flexible control and artistic innovation carried Wari textiles to a creative pinnacle.

Wari metalwork and ceramics
As parts of an overall corporate style and reflecting the primacy of the fiber arts in the Andes, Wari metalwork and ceramics often reflect textile imagery and style. In some ways the relationship is a direct one, such as in high-status silver effigies wearing clearly [120] delineated tunics and hats. In other ways the link is indirect, as in bowls that quote textile patterns in bands or in various non-textile media that unnecessarily adopt the rectilinear designs that the warp and weft encourage. Rarer than textiles and often more stylistically spare, Wari metalwork survives more often in

silver and copper but occasionally in gold as well. Forms include *qeros*, bowls, jewelry, mummy bundle masks, mantle pins, and sheet figures. Flat pieces nevertheless feature three-dimensional faces or facial features, rather like Nasca ceramics. The elaborately bedecked head of the warrior shown here has the characteristic Wari wide almond eyes and prominent nose. He is wearing a realistic four-cornered hat of the period, a tunic with a hook pattern that is a simplified version of a double-headed animal motif seen in actual tunics, and he carries a spear-thrower in one hand and a shield in the other. Thus, he is a dazzlingly geometricized and elite aggressor, the Wari ideal. An identical gold one exists, embodying the typical Andean duality. Bits of gold offerings have been found in the highest-status burials at Conchopata, the second most important Wari city in the Ayacucho Valley, alerting us that much more goldwork existed at the time.

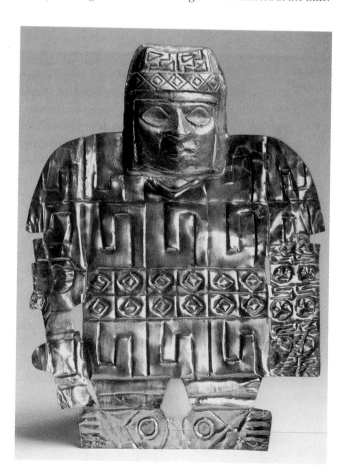

120. This hammered silver figure shows the typical Wari four-cornered hat and tunic, as well as a shield and spear-thrower (like on the Sun Gate, ills. 103, 104). This piece was originally one of a pair, the other figure rendered in gold. Middle Horizon.

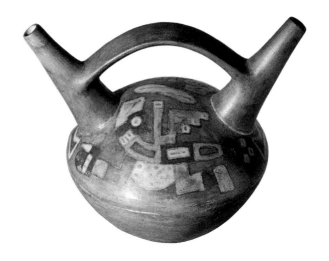

121. Wari-style polychrome ceramic double-spout-and-bridge vessel with a winged, bird-headed figure seen in various versions during the Middle Horizon (see ills. 104, 118). Wari ceramics were heavily influenced by Nasca forms and slip painting, as well as the imagery of Tiwanaku. Middle Horizon.

Ceramics, on the other hand, were extraordinarily plentiful and tend toward more realistic images of natural and supernatural profusion. Camelid effigies stand more rigidly than Moche examples, but portray the animals' vividly polychrome coat patterns; single spouts emerge from their backs. Flat painted images of herders leading llamas wrap around *qeros* as well. Many foods are shown, especially maize, potatoes, and *quinoa*, mostly highland crops to proclaim, or invoke, the dominance of upland fertility. However, Wari ceramics maintain a strong visual affinity to those of the Nasca, as seen in the continued use of double-spout-and-bridge vessels, although many substyles (often blended with local palettes) spread over much of what is now Peru. Shamanic subjects include many winged, half-human, half-animal transformational beings, as well as the rayed staff-bearer. Like the multi-story walls at Huari or Pikillacta, some Wari ceramics achieve a new large scale, such as beer-serving urns and effigy jars over 3 ft (1 m) tall from Conchopata. In ceramics grand size served (both literally and figuratively) imperial feasting needs.

Recent excavations at Conchopata by William Isbell, Anita Cook, Jose Ochatoma, and Martha Cabrera have revealed several interesting aspects of Wari ceramic production. Tiwanakoid imagery of the frontal staffbearer seen on the Sun Gate has long been associated with this site, but new carbon 14 dating suggests these may belong to later times, *c.* AD 800 (unless significant heir-looming was taking place). Instead of initiating Wari ceramics, Tiwanaku could be a later direct influence (implying once more

51

121

that both styles originated in a third, such as Pukará). A tantalizing pottery depiction of heavily-armed Wari warriors kneeling in reed boats, perhaps representing a raiding party southward bound on Lake Titicaca, likewise underscores an antagonistic relationship between the two great states (as seen in the Moquegua Valley).

Conchopata was evidently the ceramic center of the Wari empire, as it is strewn with pottery tools (some cached and buried as important offerings in their own right), firing rooms and pit kilns, ceremonially broken wares, plus ceramic molds and their products. Over the centuries significant numbers of entire rooms in household compounds were used to fire large quantities of pots, while a few pit kilns were attached to palaces, evidently so that elites could control specialists' creation of the large ceremonial serving vessels. The stone floors of the pits had depressions precisely carved to support the rounded bases of the oversized containers. Broken pots were reused to form and rotate these same bases as the pots were skillfully hand-built, and smoothed potsherd scrapers plus chipped andesite paddles were used to create and finish their surfaces. A cyclical approach to ceramics was maintained by the final ritual smashing of many vessels, sometimes accompanying the sacrifice of humans. This shows the strong Andean orientation toward the afterlife and the conviction that art is animate and therefore mortal, but continues its efficacy on the Other Side. Finally, ceramic evidence at Conchopata shows that high-quality ceramics were made continuously up to c. AD 1000, painting a new picture of a longer and more gradual end to the Wari state than previously thought.

Chapter 6: Late Intermediate Period Styles

The centuries between the fall of the Tiwanaku and Wari empires and the rise of the Incas feature distinctive regional styles along the desert coast. By the end of the Late Intermediate Period, the Chimú held sway over the North and North-Central Coasts, subsuming the Lambayeque culture (also known as Sicán). On the Central Coast the Chancay and further south the Ica (not to be confused with the Inca) went their own artistic ways. The offerings all four groups gave the oracle at the independent pilgrimage center of Pachacamac, located just south of present-day Lima, preserved the remarkable variety of coexisting Late Intermediate Period works of art for posterity. The various peoples of this time period shared certain general political characteristics (an increased emphasis on secular hierarchy and the accumulation of wealth), artistic approaches (additive construction, mass-production, and increased standardization), general formal choices (particularly repetitive patterning related to textile design), and subject matter (often related to the sea and to a crescent-headdressed figure). Yet their individual styles nevertheless vary in important and recognizable ways. It was indeed a time of regionalism. All were eventually conquered by the Incas around 1460–70, yet maintained a measure of their strong traditional identities through this and the Spanish colonizations.

The Late Intermediate Period peoples, while not uniting the numbers that the Incas did, certainly operated on a grand scale. Vast quantities of art objects from this time dominate museum collections, mainly because art production became one, if not the, focus of the expansive kingdom of Chimor. Mass-production of middle-class objects and voracious elite appetites for luxury goods also led to enormous quantities of objects being produced. William Conklin has even called the immense palaces/offices/mausolea of the Chimú capital of Chan Chan 'museums' for their dedication to amassing, displaying, and preserving objects, especially luxury art works. While most have been looted (including by the Incas themselves, and by the Spanish who set up a commercial mining company to extract the burial offerings from Chan Chan), many have also been excavated

recently so a great deal of reconstruction and art historical interpretation is nevertheless possible.

The overarching Late Intermediate Period artistic approach can be termed piecemeal or additive, non-individualized, and reiterative. An emphasis on the parts seems to dominate production process and aesthetic result alike. Specialists worked in close coordination on various elements of a complex assemblage, such as a litter compiled from a wooden base, sheet metal sheathing, paint, and feathers. Importation of high-status materials was even more widespread than in earlier times. Literally tons of spondylus shells were procured from Ecuador by the Lambayeque Valley peoples and then the Chimú, as well as emeralds from Colombia and even amber from as far away as Central America. With increasingly extreme social stratification the elites pushed their artists to create more and more lavish items, without the premium on individuality seen before. Mold-made items dominate the ceramic corpus and portraits no longer appear. Patterns reiterate small motifs often arrayed in continuous all-over designs or bands, repeated almost exactly across the various media. Multiplication of like elements is a key strategy, as in the 200 metal beakers piled high in a Lambayeque tomb. Though made up of diminutive units, overall scale is even grander than before, also showing elite values: palaces enclose areas the size of several football fields, tunics sport thousands of metal appliqués, and ceramic molds produce huge quantities of identical vessels. In the service of enhancing elite power,

122. The so-called Chimú litter, actually Lambayeque, built of wood sheathed in gold and originally studded with feathers. Figures of the Sicán Lord stand inside six portals or temples. This litter may well have been used to transport a ruler. Late Intermediate Period.

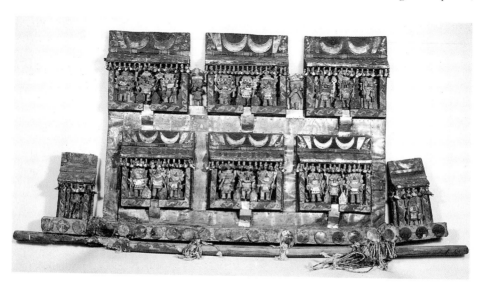

exclusivity was more rigidly enforced: among the Chimú, only royalty and nobility had the right to precious metals; royal compounds had only one entrance and were filled with maze-like labyrinths to deter free movement; most wells were controlled by the upper class; and so on. Even the scale relationships of earlier times could be reversed: at Chan Chan the sacred mound became 'furniture' inside exaggeratedly high security walls.

Because of the value placed on both quantity and exclusivity, these artistic objects often combine – almost paradoxically – extremely precious materials and arduous processes with a hurried assemblage and lack of attention to finishing, unusual in Andean art as a whole. Lambayeque weavers broke long-standing rules by sometimes cutting cloth or leaving tangles of floating threads on its reverse face. Chimú metallurgists added metal sheathings over baser materials, which may be practical but contrasts with, for instance, Moche metallurgical practices. 78–83 Some Chancay painters allowed the slip to drip down their clay effigies. This seeming carelessness may be attributed not only to haste induced by high demand, but also possibly to coercion. Increasingly propagandistic goals may have stressed artistic objects as power symbols to be clearly read from afar, so minute technical perfection and esoteric imagery were less important than impressive materials and design elaboration.

The delineation of a hierarchy according to quality of objects means that lesser objects created for the larger lower class outnumber better ones made for the elite. However, there are always a few superb examples in any medium. Southern products are generally more finely made than northern ones; Chancay tex- 141–43 tiles and Ica ceramics are almost universally technically superb, 145 implying that the hand of the expanding Chimú empire rested more heavily on the artists' shoulders. Social stratification also dictated that the exact same objects and images be made in clay 125–26 for the commoner, and in metal for the elite. 138

To help reconstruct the period, some ethnohistoric documents, Spanish Colonial administrative and judicial records, remain from the North Coast. These name historical figures and deeds, map out certain indigenous traditional social groupings and leadership roles, and one even describes a Chimú royal entourage. The latter gives us an important glimpse of the role of the Fonga Sigde, the Chimú official in charge of spondylus shells. Yet such sources are nevertheless limited, being written down from 150 to 500 years after the fact by the Spanish, who did not well understand their subjects. They too are propagandized,

often ambiguous and contradictory, and may revise events to favor certain factions. Therefore, the artistic evidence remains the primary source. Our discussion will proceed from north to south, with emphasis on the dominant Chimú.

The North Coast

Even after the Moche demise, its reverberations continued to be felt on the North Coast. In later North Coast architecture the Moche components of adobe constructions, platform mounds, and walls were variously chosen and recombined. In the Moche Valley itself, where Chan Chan would eventually share in the locale's prestige and practical advantages, the small, short-lived settlement at Galindo was built c. AD 550–700. Its rectangular compounds with interior courts may have set much of the subsequent pattern for constructions in the Moche and surrounding valleys. Farther north, the Moche stepped platform structures were more influential, at sites such as Batán Grande. Religious and funerary architecture continued to favor mountain-like masses, while secular administrative buildings emphasized enclosures to an unprecedented degree, focussing on controlled spaces and containment. In the Late Intermediate Period walls became dominant, suggesting an imperial sacralizing of the secular.

The Lambayeque style

A major North Coast style flourished before the Chimú in the Lambayeque Valley and hit its peak between AD 900 and 1100. The Chimú then conquered the valley, absorbing the Lambayeque style, technologies, iconography, and trade networks, probably even capturing the renowned Lambayeque artists for Chan Chan (just as the later Inca would capture Chimú artists for Cuzco). Although several important Lambayeque sites were built, the extensive Batán Grande ('Great Anvil') in the La Leche Valley was dominant. Its different sectors served various functions, including a major religious/funerary center with over a dozen huge mounds filled with sumptuous shaft tombs overflowing with metal offerings.

123. Gold mask assemblage excavated in its original, elaborate configuration from Tomb 1 at Huaca Loro, in the site of Batán Grande. With its dangles, earspools, and tall headdress representing feathers in gold, this burial mask rivals the Moche metalwork found at Sipán. Late Intermediate Period.

Lambayeque metalwork

Lambayeque metalwork has become much better known since recent archaeological discoveries have been made by Izumi Shimada in Batán Grande graves. One grave contained over 220 pounds (100 kg) of copper alloy objects, while even higher-status

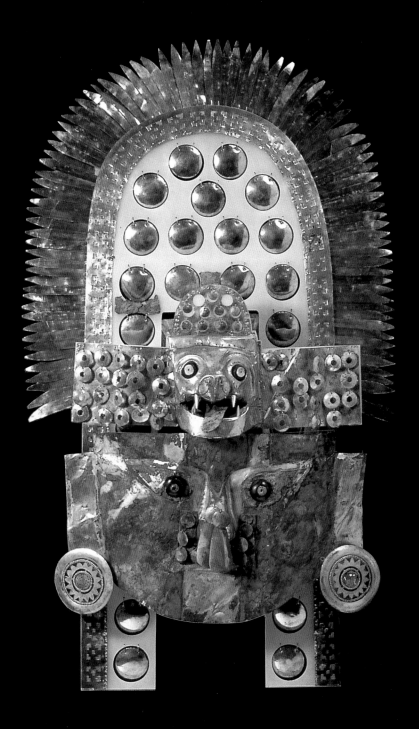

ones held hundreds of precious silver and gold ornamented beakers. All this metalwork came from Cerro Huaringa, a huge copper alloy industrial center. Shimada estimates that at least two workshops with many smelting furnaces were built there. The probable use of non-functional copper axes as a standardized medium of exchange suggests that the Lambayeque developed one of the few true currencies in the ancient Americas.

One of the structures at Batán Grande, called Huaca Loro, has been found to contain a breathtaking array of goldwork, including a group of about 2000 square gold plaques originally sewn on a ground cloth, golden feather ornaments, tall circular crowns, and the painstakingly reconstructed mask and headdress seen in ill 123. In the mask assemblage, the unique forehead ornament features a bat, its fangs probably marking it as a vampire bat. (Recall the Moche bat-ornamented man excavated at Dos Cabezas.) The magnificent headdress, with its trembling gold feathers and glittering disk dangles, was one of many similar ones found piled in this tomb. Some masks are over 23 inches (60 cm) wide. Originally the faces were very colorful, painted in red (cinnabar), white, and green, adorned with precious jewels (stones or circular emerald beads projecting from the irises). It is a measure of the conspicuous consumption of gold that it serves mostly as a vehicle here.

Because of the conquest of the Lambayeque culture by the Chimú, there is a sometimes confusing (and not yet completely understood) continuum between the two styles. However, Lambayeque art reliably features a being called the Sicán Deity or the Sicán Lord, a standing figure of a culture hero/supernatural that can be reduced to a bust (ill. 126, right) or just a head (ill. 127). Often with a crescent headdress and smaller attendants, he always has the eyes shaped like sideways commas that are diagnostic of this style. Vessels feature an exaggeratedly large double-spout-and-bridge, whether in ceramic or metal, but add a base not seen in Nasca or Wari versions. Lambayeque sculptural objects are more polychromatic than Chimú examples; beakers and *tumi* knives often feature turquoise and gold masks the red overlay.

Technically, Lambayeque metalwork is typically Andean, but introduces or modifies certain traditional methods. It emphasizes masterful repoussé and cut-out sheet metal techniques, but beakers were produced by hammering a circular sheet over a harder metal form. This approach achieves identical pieces, yet it is nevertheless extremely difficult to create a one-

124. Lambayeque-style beaten metal beaker with Sicán Lord repoussé figure. These were formed by beating metal around a three-dimensional form. Graves at Batán Grande contained as many as 200 of these stunning beakers. Middle Horizon-Late Intermediate Period.

125. Silver version of a Lambayeque double-spout-and-bridge vessel. Lambayeque style calls for a flaring base and an intricate, often cut-out bridge. Middle Horizon-Late Intermediate Period.

126. Lambayeque blackware vessel of the Sicán Lord (right) and a typical double-spout-and-bridge vessel (left). Influential to the later Chimú pottery (see ills. 139, 140), Lambayeque-style ceramics are more intricately detailed. Middle Horizon-Late Intermediate Period.

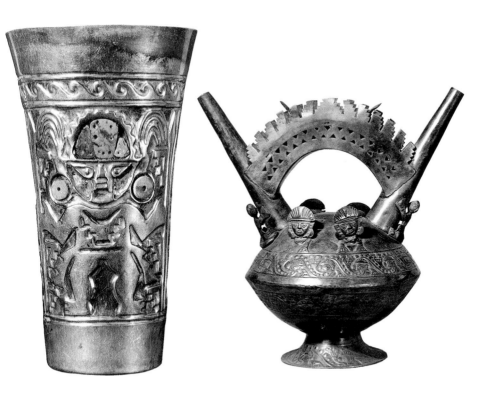

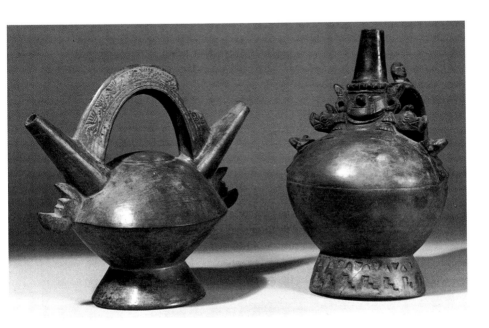

127. Gold, silver, and turquoise *tumi* knife in the Lambayeque style. A bust of the Sicán Lord (see ills. 124, 126) with elaborate headdress surmounts the bi-metal blade of this ceremonial knife. Middle Horizon-Late Intermediate Period.

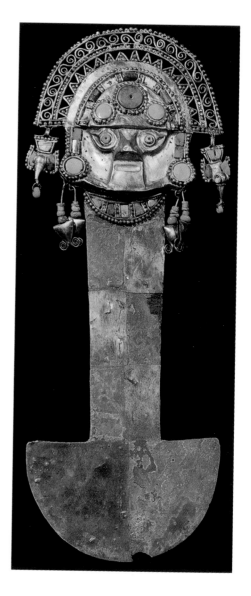

piece, three-dimensional, tall cup in this manner. Another innovation is the turquoise and spondylus shell inlay in which large chunks of stone or shell nestle into cavities hammered out of the object's surface. Silver and gold also occur in the same piece, but in addition to perpetuating Moche metallurgical techniques, silver sections may be simply applied as sheathing. In general, during this and later periods, precious metal sheets are widely overlaid on the human body, on textiles, ceramics, wood, and

even architecture, including the interiors of tombs. (The Spanish melted down almost half a ton of gold from a doorway sheathing at Chan Chan.) To make matters more difficult to reconstruct, some Lambayeque metalwork consciously revives Moche precedents, even spiders very like those from Sipán.

However, Lambayeque metalwork is nothing if not distinctive. The famous *tumi* knives have long shafts ending in semi-circular, non-functional blades. The gold openwork details of the head-dresses, bright blue-green stones, silver/gold checkerboard blade, and dangling birds make *tumis* sparkle and move dynamically. While the overall style is quite visually busy, there are simpler beakers, especially ones with large-eyed faces (that likely refer to less lordly persons). Finally, there are a few preserved Lambayeque litters, highly elaborate assemblages of luxury materials with repeated Sicán Lord figures. These carriers epitomize the opulence of the privileged nobility at this time. Imagine the dazzling gold-headdressed lords riding in these litters, wearing gold appliqué clothing! 122

Lambayeque ceramics and textiles

Lambayeque ceramics employed complex, two-part molds to create the entire vessel at once. Press-molded reliefs often adorned the surfaces. Lambayeque ceramics, usually blackwares, place little premium on variety, so the corpus appears repetitive. Distinguishing characteristics include: flaring pedestal-based, double-spout-and-bridge vessels with elaborately cut-out and modeled bridges; the head of the Sicán Lord in front of the spout, flanked by humans or animals lying on the chamber as if prostrate before him; and some strikingly Moche-like figures in red and white. Like the other arts, Lambayeque ceramic style is noticeably more intricate and delicate than the Chimú, its closest relative. 126

Textiles from the Lambayeque and neighboring valleys are scantily preserved, but very impressive. Found mostly at Pacatnamú and Pachacamac, they combine Moche, Wari, and local aspects to create a unique synthesis. Moche holdovers include an emphasis on complex narratives. One from Pacatnamú features architectural forms with projecting thatch roofs and numerous figures offering llamas. Reminiscent of Moche murals, other textiles display a white background and a varied color scheme of red-orange, olive green, gold, brown, white, and sometimes cochineal scarlet. Wari influence can be seen in images of staffbearers wearing fancy tunics, surrounded by bird heads, and 128

128. This North Coast tapestry likens elite crescent-headdressed figures to successful hunting sea birds (with fish in their talons). Human-bird analogies are common in this period (see ills. 134, 136, 139, 142, 143) and are basic to shamanic religious experience. Late Intermediate Period.

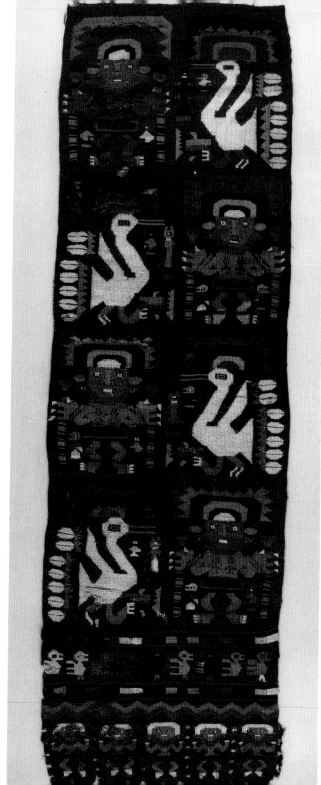

abstracted with nested rectangles. Yet, as in other media, local style is strong, with the telltale eyes and crescent headdresses on frontal figures, sea motifs such as birds and fish, and use of the typically coastal slit tapestry (long slits sometimes sewn up for strength). As in other Lambayeque media, the attention to detail is striking.

The kingdom of Chimor

Chimú is the name used for the general style of the kingdom of Chimor, the largest and most successful of the Late Intermediate Period regional organizations. Its capital city of Chan Chan, intrusive administrative centers in the North Coast valleys, canal system, and farflung portable arts, as well as the ethnohistoric record, document its spread from the Moche Valley up and down the coast for some 800 miles (1300 km). Because the North Coast is wider and better watered than elsewhere, the Chimú eventually controlled two-thirds of *all* the coastal land ever irrigated in the Central Andes. While exact dating of events in Chimú history still eludes us, a general sequence seems credible. Four rulers stand out, beginning with Taycanamo who is credited with founding the dynasty just north of the site of Moche. Under Guacricaur the first phase of expansion incorporated the Moche Valley and then the Santa to the Zaña. A major El Niño struck, but rather than being destroyed like the Moche before them, the Chimú apparently changed their strategy from one of canalization and incorporation to one of military conquest and tribute exaction. They conquered the rich 'breadbasket' valleys of Lambayeque and La Leche under the ruler Ñancinpinco. Chimor reached its height around AD 1400, under the final monarch Minchançaman, who was captured by the Incas *c.* 1470. This two-stage expansion, including a strategy change from direct, intensive control to indirect extensive management, can be traced in the architectural record of the mighty Chimú city.

Chan Chan

The vast metropolis of Chan Chan is a monument to the building potential of adobe, to status and craft specialization, to royal prerogative and succession, as well as to change over time. Its immense, high-walled *ciudadelas* ('citadels,' or combination royal palaces, administrative and storage spaces, and mausolea) encode the Chimú state image in their labyrinthine passages. As in the other arts of this time, the architectural approach was additive and surprisingly non-centralized. Chan Chan covers 8

129
130

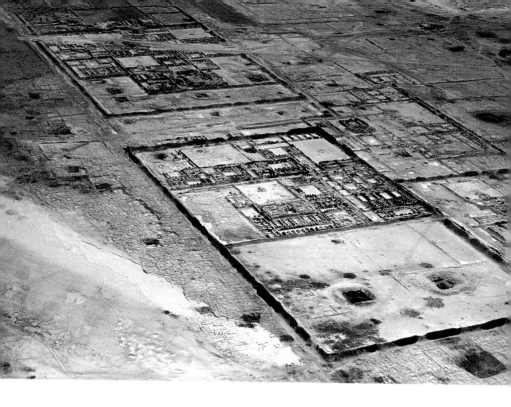

129. Aerial view of Chan Chan, the Chimú imperial capital city. Periodic El Niño rains and flooding over the centuries have eroded the tall adobe brick walls around the royal compounds and elite residences. Commoners, who were mostly artists, lived in the outskirts. Late Intermediate Period.

130. Plan of Chan Chan at its height, showing the royal compounds that were administrative centers, residences, storage depots, and mausolea. The Chimú controlled most of the North Coast from this capital city. Late Intermediate Period.

square miles (20 square km) in a series of nodes and filled spaces, but has no true center. The city was located very near the sea and so was automatically dependent on canals for its fresh water needs. According to Thomas Pozorski, the low water volume overall, the great lengths it had to travel on a perfectly calculated incline, plus the tendency for windblown sand repeatedly to clog the canals, made the Chimú multi-valley canalization a difficult, labor-intensive enterprise that was soon dropped in favor of easier, extortative approaches.

Nevertheless, an estimated 30,000 Chan Chan residents lived in commoner housing/artistic workshop neighborhoods mostly outside a central core of elite residences and ten (one of which was unfinished) grand royal compounds. Archaeologists have postulated several possible chronologies for the *ciudadelas* using a combination of adobe brick type seriation, ceramic associations (though few objects remain in Chan Chan as the clearing out began with the Inca takeover), absence or presence of damage from the major flood, and ethnohistoric reconstruction. While the royal compounds may have been built in pairs, and the exact sequence of *ciudadelas* varies from one interpretation

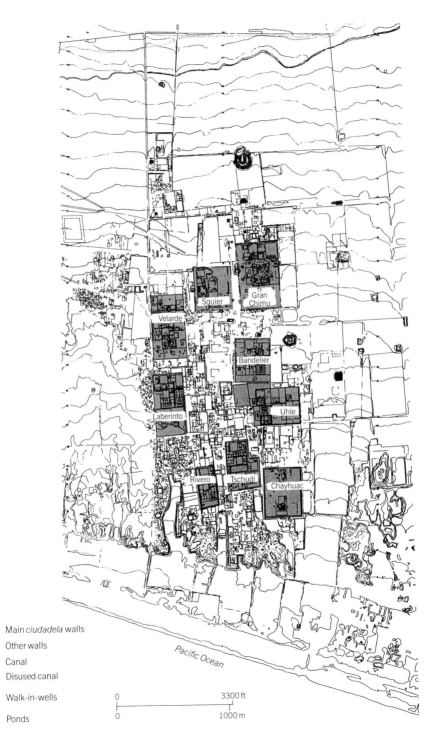

N

Main *ciudadela* walls

Other walls

Canal

Disused canal

Walk-in-wells

Ponds

Squier

Gran Chimu

Velarde

Bandelier

Laberinto

Uhle

Rivero

Tschudi

Chayhuac

Pacific Ocean

0 3300 ft

0 1000 m

to another, the following reconstruction introduces some of the major characteristics of the different ones.

Perhaps the earliest of the high-walled adobe-brick enclosures, known as Chayhuac, established many of the principal *ciudadela* features: massive high walls in a rectangular format, a single entrance, and a burial platform. The latter rectangular mounds with a T-shaped principal tomb and numerous offering/lesser burial spaces, are interpreted as royal interments. All are heavily looted (it was these that the Spanish 'mined'), which in itself betrays the riches placed within. Around the burial platform are small, restricted storage spaces, presumably to hold the offerings that were amassed before and at the ruler's death. There is relatively a smaller amount of space in Chayhuac than in later *ciudadelas*, reflecting the nascent stage of the empire. If the documents are correct, Chayhuac was Taycanamo's palace.

The next compounds, Uhle and Tello, seem contemporaneous but fulfilled different functions. A new element was added, the U-shaped structure called *audiencia* ('audience room'), probably an administrator's office. In the labyrinthine passages *audiencias* must be passed to gain access to the storerooms. In Uhle some storerooms are near the royal burial area, while others are in courts near *audiencias*; this can be interpreted as a new, expanded storage of goods, such as food and art objects, for state as well as kingly uses. Redistribution figures prominently in successful Andean state strategies and later Chan Chan architectural choices suggest that storage expanded beyond the ruler's direct control to reflect a wider administrative network operating outside the palace. Tello, as further demonstration of this pattern, has a great number of storerooms and no burial platform. It was most likely built expressly for administration and continued as a storage depot in later times, while the other palace/mausolea were sealed at the ruler's death. With the Moche and neighboring valleys now incorporated, new ways of organizing space and processing tribute seem to have prevailed. In this first phase a small amount of elite housing clustered near the commoners' housing, presumably to oversee art production. High-ranking administrators lived in more modest versions of *ciudadelas* with formidable walls, single entrances, and a few *audiencias* but no burial platforms.

Laberinto is also without a burial platform (a space set aside for it was never used, perhaps because the great flood interrupted). This compound may reflect another spurt of sudden wealth, corresponding to the second phase of expansion, as it

131

contains the highest percentage of storage space of all the *ciudadelas*. Atypically, it has two entrances, perhaps to subdivide goods by type and give somewhat more efficient access to them. Its mate, Gran Chimú, the largest of all the compounds (measuring an awesome 1310 by 1970 ft [400 by 600 m]), seems to be a kingly palace, possibly Ñancinpinco's. Gran Chimú has proportionately less royal and more administrative storage, but less total storage than other *ciudadelas*. It is an extraordinary monument to kingly might, a veritable city in its own right.

At this imperial mid-point, four times the number of elite houses were built than in the earliest phase, suggesting there was an explosion of administrators needed to manage the incoming wealth. The houses were increasingly constructed close to the royal compounds: overseeing by the elite was apparently now needed more for goods from afar than for those produced at home. Commoners continued to live in small, irregularly arranged home workshops, the remains of their hearths found near evidence of woodworking, metalworking, and weaving activities. Chan Chan was a city of state-supported artists, several thousand creating the fabulous objects for the burial platforms and for royal exchange. Imported from all over the kingdom, especially from Lambayeque, the last generation of artists were deported to Cuzco by the Incas – so rapidly that they

0 ———————— 100 ft
0 ———————— 25 m

131. Drawing of an elite residence at Chan Chan with smaller, less formalized elements such as *audiencias* (see ill. 134) found in the royal compounds (see ill. 133).

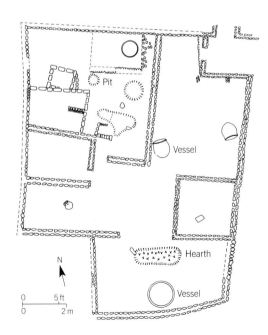

132. A typical commoner's house in Chan Chan made of cane. Thousands of artists lived and worked in such small spaces in and around the royal (see ill. 133) and elite (see ill. 131) residences. Late Intermediate Period.

N

0 ——— 5 ft
0 ——— 2 m

133. The *ciudadela* Rivero, one of the latest royal compounds at Chan Chan built at the time of the greatest standardization. The main entrance to the north restricts access and labyrinthine passageways control human movement, expressing the bureaucratic character of the late kingdom of Chimor. Late Intermediate Period.

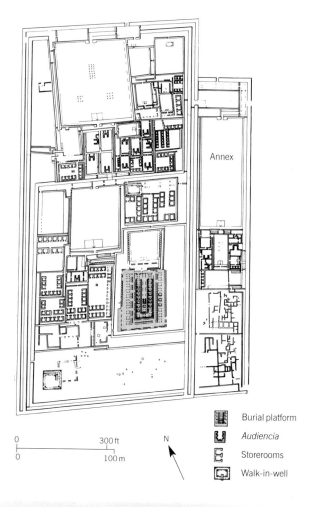

Annex

134. The surviving portion of a typical late Chimú *audiencia* in *ciudadela* Tschudi at Chan Chan, showing spectacular adobe reliefs of birds. These U-shaped offices of the nobility are usually found controlling access to storerooms for foodstuffs and royal luxury goods. Late Intermediate Period.

0 300 ft
0 100 m

N

Burial platform
Audiencia
Storerooms
Walk-in-well

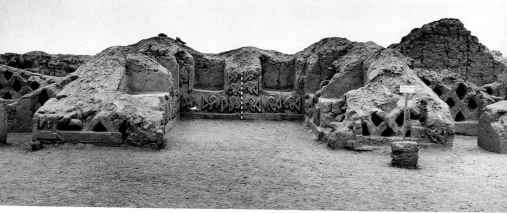

left pots on the fire and ingots on the ground. The premium placed on elite art objects in the late Andean empires is obvious. Wealth in difficult-to-reproduce forms drove, funded, and organized the state system. It rewarded and lured subjects, reinforced power, and occupied peoples' time peacefully. Art effectively communicated sacred and secular meanings, as well as providing a recognizable presence in a foreign territory and allowing a measure of self-expression and upward mobility in an otherwise rigid social framework.

Late-phase *ciudadelas* at Chan Chan, known as Bandelier, Velarde, Rivero, Tschudi (the likeliest candidate for Minchança- 133 man's headquarters), and the unfinished Squier, were built in rapid succession in increasingly standardized layout. These final *ciudadelas*, veritable mazes, show how important it was to exclude most people and run those allowed to enter through a gauntlet of administrators. The compounds point to an extreme, almost paranoid, royal hoarding of wealth, bearing out the records which claim that stealing was a capital offense to the Chimú. The *ciudadelas* may even be likened to museums, since *audiencias* have niches for object display, storerooms protect them while in transit, and their final destinations are royal burial platforms or other elites' 'collections.' Royal compounds were also works of art themselves, the courtyard and *audiencia* walls being covered with adobe reliefs in repeated geometric and 134 animal motifs. Openwork walls and diagonal patterns are deeply reminiscent of textiles; in a sense the friezes may be permanent wall-hangings for the highest-status people.

The personal, acquisitory attitude betrayed by the *ciudadelas* is played out in the overall arrangement of Chan Chan; each compound simply claims its own space with no easily determined relationship to the others. Geoffrey Conrad proposes that a documented rule governing royal succession, a system known as split inheritance, informs this format of independent kingly domains. Split inheritance is a system in which the heir to the throne receives the right to rule but none of his predecessor's wealth or land, which become a royal corporation administered by the other offspring. This ingenious arrangement ensures that the disgruntled non-heirs are materially satisfied and that the heir must conquer new areas and tribute sources, guaranteeing imperial expansion. While each *ciudadela* with a royal burial platform was sealed at the king's death, architectural additions included living spaces apparently used by members of a royal corporation for a number of generations. This strategy

apparently was taken up by the Incas as well. Its 'every man for himself' attitude can be seen played out in the unique non-unified form of Chan Chan.

Beyond Chan Chan

The Chimú were concerned not only with adding to their metropolis, but with establishing centers throughout their empire to proclaim their presence. Archaeological investigation has revealed three main levels of administrative Chimú architecture beyond Chan Chan: large provincial centers (earlier Farfán in the Jequetepeque Valley and later Manchan in the Casma Valley), smaller storage depots (such as El Milagro in the Moche Valley), and tiny compounds for the overseeing of agricultural land (for example, Quebrado Katuay near Chan Chan). Other pre-existing centers taken over by the Chimú, such as Pacatnamú near Farfán, have recognizable, intrusive walled compounds to announce Chimú control.

The walled compound with interior *audiencias* and patios, as well as storage capacity for higher-level centers, defined Chimú presence and level of authority outside the capital. Six compounds were built at Farfán, one of which has a burial platform. Over forty storage facilities were located there in order to act as depots in the transport of goods from the north to Chan Chan. Nine compounds at Manchan and separate, local-style elite burial structures show the even larger scale of second-phase Chimú expansion with its indirect control strategy. Nearly fifty large storage facilities served as shipment warehouses for tribute from the southern valleys. A large permanent population of artists at Manchan shows that art was high on the administrative agenda. Lower-level settlements administered agricultural products, with little storage or permanent housing capacity, but kept key Chimú features. El Milagro, located near fields and canals, had one main structure measuring only 180 by 148 ft (55 by 45 m) and containing five *audiencias* placed near storerooms.

Other Chimú arts

While architecture was perhaps the grandest Chimú achievement, their weaving and featherwork, metalwork and ceramics were all impressive artistically. Textiles often feature matched sets of brocaded lightweight garments, including wide shirts with sleeves, loincloths, and mantles. Most Chimú textiles feature white cotton; camelid fiber was used sparingly in super-structural techniques. Openwork, in which spaces are deliber-

ately left between worked areas, is characteristic here and for the Chancay. Textiles share certain qualities with the other Chimú arts: they are often woven on a large scale, some over 6 by 4 ft (2 by 1.3 m), and betray piecemeal construction (the one in ill. 135 is made up of four parts, for instance). The figural representations are also relatively simple versions of profile and frontal crescent headdressed figures. Textile patterns and those of wall reliefs are especially similar; the fiber arts again may have served as the influencing medium.

142

Even more prestigious than woven textiles to Chimú elites were feather-covered and appliqué gold garments. Brilliant tropical feathers acquired via the extensive trade network were sewn in rows to plain-weave cloth backings. Even more shimmering are the plain-weave tunics covered entirely in tiny gold squares, as many as 7000 on a single garment. Imagine the blinding effect of a wearer reflecting the sun at every step. Sheathing the nobility in precious metal extended to appliquéd bags and even shoes. The ethnohistoric records claim that Chimú noblemen were descended from a golden egg, noblewomen from a silver, and commoners from a copper one. In fact, the elite were associated with the various metals worked into many forms, such as huge earspools made in gold and silver repoussé technique. This pair, which measures over 4 in (10 cm) in diameter across the faces and 2 in (5 cm) across the posts, points up interesting cultural connections during the Late Intermediate Period. Relations with the all-important north are especially featured in the scene of divers retrieving the precious spondylus shell from Ecuadorian waters (the spiny oyster only lives in warmer waters above the reach of the Humboldt Current). The divers are shown giving the shells (which are jagged on the top) to two men standing back to back on a large raft with a sunshade or rolled sail. Earspools such as these might well have been worn by the Fonga Sigde, the high official in the Chimú hierarchy who was responsible for the spondylus trade (perhaps appropriated from the Lambayeque). Beautifully matched and reflective, gold captured an even more precious commodity in action.

136

137

Chimú metalwork that mimics ceramic forms, such as the traditional stirrup-spout, and depicts nobles in restricted-access architectural settings, also obviously differentiated the elites from others in their society. The precious metal version of the commoner's clay vessel is not only a statement of the political hierarchy, but also a metalworking tour-de-force, its sculptural complexity achieved solely in silver sheets. A figure holding

138

139

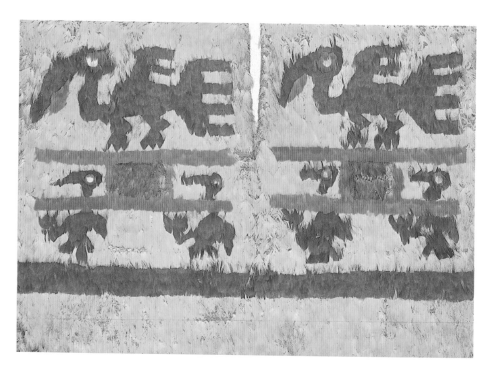

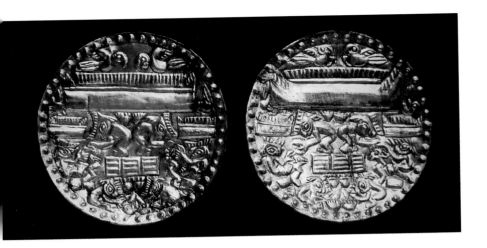

135. Chimú cotton textile in the discontinuous warp and weft technique. The blue color is obtained from indigo, a notoriously difficult dye to use. Late Intermediate Period.

136. Detail of Chimú featherwork tunic with pelicans borne on litters (see ill. 122). Feathers, laboriously obtained from the distant jungles, are sewn in rows to cotton backing, and represent perhaps the most prestigious medium in the Andes. Late Intermediate Period.

137. Back to back men on a rectangular raft receive spiny oyster shells from divers below. These earspools may have been worn by the Chimú official in charge of the spondylus shell trade with Ecuador. Late Intermediate Period.

138. Chimú silver version of a stirrup-spout vessel depicting an important person in an *audiencia* (see ill. 134). Repoussé patterns are almost identical to reliefs at Chan Chan. Late Intermediate Period.

court wears tiny but proportionately large earspools. The reliefs on the vessel walls match very closely the adobe reliefs on the walls of the Huaca el Dragon at Chan Chan, their projecting surfaces beautifully rendered in repoussé.

Adobe reliefs, silver repoussé, and the designs on ceramic vessels all reflect a similar aesthetic of shallow surface patterning. More boldly sculptural than those of the Lambayeque and featuring the stirrup-spout as in the earlier Chavín and Moche

traditions, Chimú ceramics were made in molds. Their seams, often hastily smoothed, can be seen on the sides where the two parts met. Chimú ceramics are also distinctive for the appliqué animal, often a monkey or bird, placed where the spouts meet. A typical subject, sea birds fishing, is also seen in Late Intermediate Period textiles and remains characteristic iconography of the Chimú even under Inca rule. Dominance in the food chain seems to be a code for elite power. Chimú blackwares also typically explored the possibilities of double-chambered whistling compositions. Imagery may again concern the prestigious spondylus shell, personified and with its jagged profile rendered in both two and three dimensions. Bumpy texture references water in both these pieces. The figure's almond eye is typical, yet the face is generic; portraiture in the sense of individualistic physiognomic rendering is not present as it was with the Moche.

Chimú arts, while diverse in media, work together to delineate the political hierarchy. We can only imagine the visual splendor of Chan Chan's colorful walls and nobles wearing gold earspools and feather tunics, provided by the thousands of artists dedicated to making quantities of these works of art.

139. Typical Chimú blackware vessel with a bird design and a monkey appliqué at the spout juncture. A final revival of the stirrup-spout form, these mold-made examples were created by the thousands. Late Intermediate Period.

140. A Chimú double-chambered whistling vessel of a personified spondylus shell. Water levels change the whistle tone which escapes from a hole behind the figure. Whistling pots and doubling of all kinds are time-honored Andean artistic choices. Late Intermediate Period.

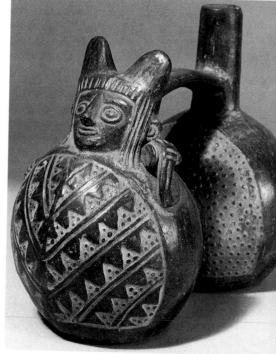

The Central Coast: the Chancay style

During roughly the same time as the Chimú hegemony to the north, the Chancay style held sway over four Central Coast valleys: Chillón, Huaura, Rimac, and the Chancay itself – but without a centralized state organization. Above-ground architecture made in tapia (clay mixture poured like concrete into wooden forms and allowed to dry) was erected, though the unbonded walls often separated. Next in skill of execution, the starkly black and white Chancay ceramics (see frontispiece) are quite distinctive and graphically appealing though sometimes casual in their finishing. By contrast, the often colorful textiles and fiber sculptures in this style are magnificent almost across the board.

Chancay ceramics

The boldest of the coastal styles of clay sculpture, Chancay Black-on-White ceramics, shared two-part mold technology with the north. The vessels were often quite large and several unusual shapes were preferred, especially tall ovoid jars and large female effigies with short, outstretched arms. The high-contrast pairing of black and white (sometimes with added red touches) was painted over terracotta clay in thin coats. Chancay ceramicists must have painted quickly with the watery slips, as obvious drips and colors showing through each other are common. Matte, unburnished surfaces appear dull and gritty due to the sand temper in the clay paste leaching out. Poor firing is often apparent in the warping of vessel shapes, fire-clouding, surface blisters, and glassy patches where the temper has overheated.

Despite the careless approach, there are well-painted examples and all are graphically powerful. Females have elaborate body painting on their frankly sexual nude bodies; in the frontispiece we know that the dark painting on her upper body does not represent a garment because the imprint of an actual textile remains on her chest. Outfitting effigies in real clothing represents another way in which Andean images were granted reality and vital energy. Her body art lends her a double reading as her shamanic animal counterpart; jagged teeth are painted along her jaw (her actual mouth is small and modeled), and spots on her torso suggest cat markings. There is even a line down her back like the one jaguars have along their spines. Double-chambered whistling pots with tall, thin spouts, appliqué animals, and strong geometric designs, as well as bulbous-bodied animals (perhaps representing camelids, whose hair was precious to the Chancay weavers) are also typical.

Chancay textiles

It is striking how very different Chancay textiles are from ceramics, although both may be white and feature shamanic animals. Chancay techniques in fiber are extraordinarily varied and are almost without exception executed in a virtuoso manner. From gauzes and openwork embroideries to painted plain weave and tapestry, as well as fully three-dimensional figural sculptures, the most challenging avenues were explored. Openwork, ultimately derived from the ancient coastal fishing tradition of netmaking, reached new heights of lacy intricacy. Women wore headcloths with complex patterns, such as felines (which can be read as snakes when the piece is inverted) and interlocked birds. Significantly, the motifs could not be seen except by the weaver during their creation because the overspun threads pull together when not under tension. When the weaver removed the finished headcloth from the loom its designs became illegible, especially if the piece were folded (as it is often shown on the fiber sculpture renditions of women). This again exemplifies the Andean value placed on the essence over the perceptible appearance and soundly displaces the viewer in favor of the weaver.

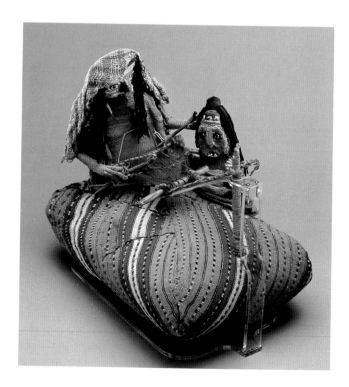

141. A fiber sculpture of a mother teaching her daughter the art of weaving. Notice the headcloth that is similar to ill. 142. This is one of the very few Andean images of the weaving process (see ill. 93). Late Intermediate Period.

142. A Chancay openwork woman's headcloth similar to that worn by the fiber effigy of a weaver (see ill. 141). Although the weaver could see the complex design of interlocking birds and felines that can also be read as snakes, when worn the threads contracted. Andean art often favors the intrinsic over the visually accessible. Late Intermediate Period.

Surviving images of weaving on a backstrap loom, such as a 12-inch-long (30 cm) fiber sculpture, underscore the handing down of the intricate textile techniques from mother to daughter. Literally thousands of Chancay textiles are preserved in museums all over the world; although the artistic output was staggering, there was little or no lowering of quality. One is reminded of the Paracas dedication to massive burial offerings laboriously woven and stitched. The Chancay palette features a softly harmonious combination of golds, browns, scarlet, white, and even lavender and olive green. Outlined, repeated figures, such as birds carrying fish, are assigned color with little regard to regular patterning and thus accomplish a lively, yet subtle effect. Painted textiles follow the geometric lead of the woven techniques with all-over designs, such as the familiar crescent headdress figures. Chancay textiles are among the most pleasing of the many incarnations of Andean fiber arts.

The South Coast: Pachacamac

The sacred city of Pachacamac, located some 19 miles (30 km) south of Lima, had long been a pre-eminent pilgrimage center

143

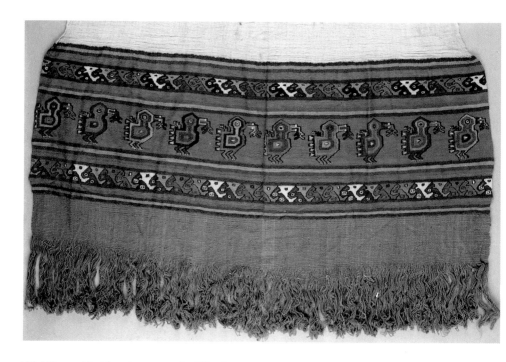

143. A Chancay loincloth end in tapestry. In the central band birds carry fish in their beaks, while in the flanking bands a fret pattern reveals abstracted birds in more shorthand form. Late Intermediate Period.

144. Detail of the wooden oracle sculpture at Pachacamac, a long-revered independent cult center on the Central Coast. Tragically when the Spanish arrived the oracle 'fell silent.' This inauspicious occurrence contributed to the European takeover. Late Intermediate Period.

145. The characteristic style of the South Coastal Ica (not to be confused with the later conquering Incas) featured textile-like repeated geometric patterns on well-made flaring vessels. Late Intermediate Period.

and still in the sixteenth century boasted the most revered oracle in the land. Objects in all styles were brought here as offerings to earth deities, primarily Pachamama (Mother Earth), as well as myriad lesser supernaturals. Two later Inca constructions remain in good condition, though the earlier shrines and courts do not. The principal terraced adobe mound, the Temple of Pachacamac, was originally covered in bright murals depicting plants and animals, a fitting claim to natural abundance. Repainted as many as sixteen times, with the reed and human hair brushes found near one of the terraces, these lost murals were of supreme importance. This spectacular temple and a unique colonnaded esplanade below, presumably to shelter masses of supplicants, form the ceremonial core of the city. Atop the Temple was the enclosure for the oracle, a carved wooden sculpture with figures superimposed rather like a totem pole. According to the Spanish accounts, only the select priesthood was allowed in its chamber and a High Priest spoke for it from another room (reminiscent of the Lanzón at Chavín de Huantar). Tragically, the shocking arrival of aliens in the form of the Spanish caused the oracle to fall silent, which was interpreted as abandonment by the earth itself and contributed to the success of the invasion (see Epilog).

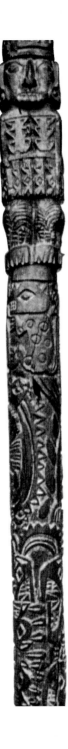

Ica

Well beyond the reach of the Chimú, the southern valleys of Ica, Chincha, Cañete, and Mala shared a degree of stylistic unity. Like the Chancay, this corporate style did not betray great political power – indeed, there are no cities to speak of – yet still commanded high prestige due to its obvious quality. Ica pottery is the only major Late Intermediate Period type to be handbuilt and uniformly well painted, so its relative status is understandable. Ica ceramic vessels are mostly flaring or globular, with everted rims and narrow necks. Polychromatic, featuring orange, red, black, white, maroon, purple, and a sparkly purple-black made from specular hematite, the patterns are almost entirely geometric, often interlocking in bands, or all-over arrangements. Determinedly rectilinear, they have the obvious look of textiles. The approach is meticulous, with thin, even walls and elegantly symmetrical elemental shapes, precise painting and burnishing; though repetitive in their own way, Ica vessels avoid the mass-produced look of those to the north. When conquered by the Incas, this aesthetic was applied to the new prescribed vessel shapes, but after the Spanish takeover the South Coast reverted to its own strong earlier aesthetic traditions. In fact, all the Andean cultures tenaciously maintained their sense of ethnic identity throughout the series of political upheavals that rocked the region in the fifteenth and sixteenth centuries.

With the advent of the last native conquerors, the Incas, coastal artistic and ethnic diversity prevalent during the Late Intermediate Period was suppressed. Yet the art and architecture of the coastal peoples still inspired their new overlords with its beauty, ingenuity, and variety.

Chapter 7: Inca Art and Architecture

On the heels of Late Intermediate Period diversity, the conquer-
ing Incas enforced a new level of uniformity, albeit not absolute,
on the entire Central Andes. Their meteoric rise to power in less
than a century spread their style from Quito in Ecuador to below
Santiago in Chile, a span of *c.* 3400 miles (5500 km). They con-
trolled the largest territory in the world by about AD 1500 and
developed one of the most elegant, subtle, and recognizable art
styles in history. The Inca genius was expressed mainly in stone-
work, from a network of roads more than 20,000 miles (33,000
km) long, to cities perched high in mountain saddles, to walls of
perfectly fitted monoliths. For the Incas art was not directed
principally toward the dissemination of a new or complex
iconography, as with earlier state styles. Instead, the presence
and look of stonework itself formed the bulk of the imperial
power message. Of the portable arts, textiles and ceramics were
more regularly geometric, while metalwork and sculpture,
almost all of which was destroyed by the invading Spanish, seem
to have been quite representational. Thus, the surviving Inca art
and architecture, abstract and seemingly minimalistic, must be
carefully analyzed to understand the communicative richness
that underlies a primarily non-iconographic artistic strategy.

The Incas approached politics and art by standardized units
and yet avoided rigidity, an extremely successful balancing act in
the practical and the aesthetic arenas. Standardization, though
powerfully unifying, did not necessarily lower the quality of art;
technically Inca tapestry thread count, large-scale ceramic vessel
production, mortarless masonry, and miniature metal sculpting
are unsurpassed. To an unexpected degree subject peoples con-
tinued or blended their own religious and artistic traditions with
the new order so that while Inca standard shapes and patterns
were imposed, aspects such as color scheme remained locally
interpreted. As long as the Incas received tribute in food, art, and
labor (for building and conquest) they were satisfied. All subjects
owed something in tax – even the most aged and infirm had to
give the tax collector the lice off their head! State control was
typically Andean: based on tribute, a network of centers, and
syncretism (the blending of local and imperial systems) rather

than blanket domination. In an empire of this size, absolute control would have been impossible anyway. It was the Incas' unique ability to organize and standardize that made their ruling presence palpable, especially through impressive and ubiquitous masonry reminders. Generally speaking, they also made their presence palatable by paying back the workers in redistributed food, support during labor tax projects, and improved lifestyle. At least in the ideal, the state performed these services; imperial reciprocity is, however, almost never symmetrical.

The Incas called their empire Tawantinsuyo, 'Land of the Four Quarters.' They capitalized on longheld traditions of verticality, reciprocity, and dualism to integrate more than ten million subjects into the largest-scale empire the Andes has ever

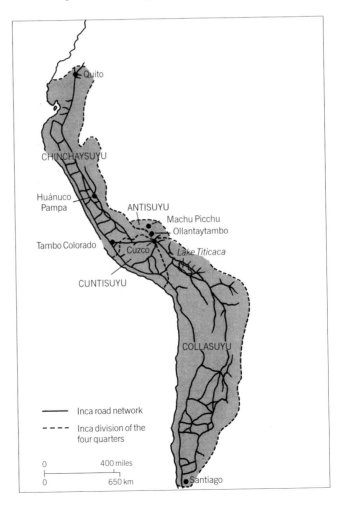

146. Map of the principal Inca roads and the four parts of Tawantinsuyo, The Land of the Four Quarters, showing the extent of the Inca empire (shaded area). Over 20,000 miles (33,000 km) of roads connected the coast and highlands like a giant ladder. The four quarters emanated from the capital city of Cuzco. Late Horizon.

known. They were neither, as sometimes portrayed, dull bureaucrats nor fascistic dictators. It is important to recognize their uniqueness, their complexity, and their aesthetically sensitive side. And despite the greater role Spanish documentation may play in our understanding, the artistic remains take precedence as grand and beautiful messages the Incas left about themselves.

Origins and history

Like the Mexica (Aztecs) of Mesoamerica, the Incas were a relatively lowly, unimportant group that nevertheless propelled themselves into political prominence during the fifteenth and early sixteenth centuries. As a result of both their humble beginnings and impressive accomplishments, they developed an elaborate, but rarely accurate, version of their origins. Scholars are still disentangling myth from reality; embedded in the myths, however, are values and beliefs held by actual personages linked to real events.

In brief, Inca propaganda claimed that they were born of Inti, the Sun God, at Tiwanaku, where the gods themselves had originated in the distant past. Miraculously traveling underground, the first eight Incas, four brother-sister pairs under Manco Capac and Mama Ocllo, emerged from Pacaritambo, a cave near the Cuzco Valley. Led by prophecy to a place where Mama Ocllo's golden staff would easily penetrate the rich earth, the group journeyed, losing some members. Along the way one of the brothers was turned to stone, becoming a particular outcrop on Huaynacauri, a Cuzco Valley peak. Finally she drove the staff into the ground, entered the valley, fought off the inhabitants, and took over easily. When they defeated the Chanca, a neighboring power to the west, the Incas claimed the rocks in the fields rose up and fought as humans to help. The rest, as they say, is history: conquests, success, power, wealth.

The reality of the Inca rise to power was of course rather different from this heroic tale. According to recent excavations by Brian Bauer, the Cuzco Valley was occupied at least as early as 4500 BC by simple hunter and gatherer peoples. However, it was not until the late Late Intermediate Period that the settlement of Cuzco began to emerge as a potential center of an expansionist state. Unification of the region occurred in the late fourteenth and early fifteenth centuries, after which the Incas began to spread their influence across the Central Andes as a whole. The war with the neighboring Chanca people in 1438 succeeded against all odds and a new Inca leader emerged, who renamed

himself Pachakuti ('Earthquake,' 'Reverser of the World'). Accounts vary as to whether he usurped the throne or saved the day, with the majority leaning toward the latter. He seemed to have a new imperialist attitude and further conquests followed in close succession. However, the Incas had to keep conquering and reconquering people throughout their reign. With their sudden prominence and the concomitant need for loyal administrators, the Incas expanded their noble class to include Quechua speakers in the heartland.

The king list contains eleven names, of which the first eight may be best understood as pre-imperial leaders, though Spanish accounts and modern scholars are divided on this matter. There may well have been two rulers at a time, which makes interpretation of the king list complicated. Cuzco we know was divided into two parts, a moiety system as we have seen before. The more prestigious upper half was called *hanan*, the lower *hurin*, and each seems to have had royal representation. Pachakuti is credited with redesigning the imperial capital (a claim that encapsulates the Inca penchant for architecture as an expression of royal will). His heir, Topa Inca, has been called South America's Alexander the Great. He expanded the kingdom an astonishing 2500 miles (4000 km) in extent. The final monarch was Huayna Capac, a consolidator who established a second capital in Quito since the extended empire had grown so unwieldly. He was residing there when European diseases preceded the invaders into South America and he died around 1528 without naming an heir. The epidemic, together with the ensuing civil war between two of Huayna Capac's sons, Huascar and Atahualpa, paved the way for the Spanish takeover (see Epilog).

Empire and art

Conquests and battles cannot fully explain the ideas and institutions of an empire, nor do they account for the art style chosen to represent the conquerors to their subjects. Yet Inca political aspirations had almost universal expression in art, architecture, and ritual life. An understanding of the organizational and religious aspects of the imperial vision form the necessary background to an appreciation of Inca stonework and the other arts.

The Incas divided up their world into interlocking parts, from the four quarters of Tawantinsuyo, to groups of taxpayers, to the walls they built. Units were the key to constructing such a complex hierarchy out of enormous ethnic diversity, ecological challenge, and sheer size. The ruler oversaw governors of the

147. The unique Inca fiber recording device, the *quipu*. Through knot type and position, cord color and placement the Incas could encode incredible amounts of information from the census to astronomy, and even history and poetry. Their mathematical system was virtually identical to our own. Late Horizon.

quarters, who in turn controlled regional and local administrators (who usually had been leaders before the Inca conquest). The population was divided into multiples of ten taxpayers (10, 100, 1000, 10,000, etc.); in fact, the Incas probably had a more accurate census than exists in modern times. This information, among many other types of data, was recorded on a unique writing device, the knotted string *quipu*. Taxes (*mit'a*) were owed in goods and labor, especially in textiles, food, and construction of roads, waystations, and centers throughout the realm. *Mit'a* laborers often had to travel long distances to reach their work-sites and were supported for the duration of the project. Subjects also received corn beer, redistributed food from other vertical zones (especially during times of hardship), and generalized state assistance. Thus, reciprocity, verticality, and nomadism – time-honored Andean survival strategies – were employed by the Incas on a new global scale and taken to extremes for political purposes. Certain groups of people (*mitimae*) were even forcibly relocated far from their homes as a means of preventing rebellion. Loyal subjects were also moved so as to promote cooperation in a newly-added region. *Mitimae* were required to maintain their native dress so as *not* to be integrated into the new area.

Conquest by the Incas brought with it gifts of sumptuous, imperial-style art, especially textiles. Such large-scale movements of people and products served to create identification with the conquerors, manifested by the use of standardized Inca artistic style by people all over the Central Andes. This style emphasized units, recognizability, and universality. It could not afford to rely on specific or detailed past associations, such as another Chavín revival, because these would have had a limited reception. As an exception, Tiwanaku was a favored, if generalized referent, familiar to more subjects than any other because the Wari and Tiwanaku states had spread over most of the same territory previously. Yet the staffbearer and other complex earlier imagery was not specifically revived; instead, the Incas constructed an elemental geometric vocabulary that drew on basic patterns from all regions but matched none. Without acknowledging the debt, they absorbed many elements from the Chimú, from split inheritance to bronze technology. In the recombination of pre-existing political and artistic elements and reduction to new essential forms, the Incas were quite innovative. They were also highly practical. Reiterated across architecture, textiles, and ceramics, their layouts and motifs were simple enough to be faithfully reproduced in any part of the kingdom and

recognizable enough to announce Inca presence at every turn. Standardization thus achieved the twin goals of unity and distinctiveness, yet was not absolute; local materials, techniques, color schemes, and figures coexisted with the Inca long-necked jar, checkerboard pattern arrangement, and trapezoidal city block.

Inca control was pronounced, however: they captured foreign leaders, artists, and religious icons (*huacas*) and held them hostage in Cuzco. King Minchançaman and his artists at Chan Chan were removed to the capital, along with all the best female weavers in the realm. State-supported, protected, and revered, the latter *acllacuna* (chosen women) wove for the ruler and the 170 Sun as prisoners. As with the Chimú, precious metals were reserved for Inca nobility, as were the finest silky vicuña textiles 173-75 (the ruler or Sapa Inca owned all vicuña herds). Atahualpa even commissioned a mantle of bat skins. Royalty ate and drank only from gold and silver, wore silver-soled sandals and feather garments, walked on the finest tapestries during wedding celebrations, in short, lived a stupendously opulent life. Upon death, the ruler was treated as if still alive, his mummy ritually fed, consulted, dressed, paraded, and all his wealth preserved in his palace, as with the Chimú. His non-ruling heirs maintained his estate intact and lived off its proceeds. The royal mummies (*mallquis*) survived until the late sixteenth century when the Spanish finally tracked them down and burned them as heretical. The Andean cyclical view of life and death reached an extreme in immortal kings as physical reminders of Inca power.

Ritualism of all sorts was fundamental to the state, from the daily sacrificing of a llama and periodic burning of the finest textiles as offerings to the Sun, to child sacrifices to ensure the king's health (known as *capac hucha*), to calendric, agricultural, 175 and cleansing ceremonies of all sorts. Complementary to the permanent forms of Inca cities and roads, the daily observances also solidified state control. Naturally much of this ceremonialism took place in Cuzco, the *axis mundi* or world center into which only the gift- or tribute-bearing elite were allowed. Its visible, and even invisible, parameters proclaimed the close Inca relationship to the natural world. Forty-one radiating invisible lines, known as *ceques*, subdivided space and ritual time from 153 Cuzco outward. A fascinating abstract conceptualization and manipulation of the landscape, this system of imaginary lines tells us much about the Incas' grandiose yet respectful sense of themselves in nature, spelled out in every working of stone from natural outcropping, to terrace, to town, to wall.

Inca religion was an important guiding force of the empire and combined Andean traditions with new twists. Royal mummies were an extreme extension of a broader ancestor cult, with roots in Andean consciousness long before the Incas. The mummies served to visually solidify Inca claims to rule (the actual conqueror of a given region could be produced for state occasions), reinforcing a sense of a long Inca past while connecting the living to the supernatural realms of the dead. Sacrifices of valued commodities such as camelids propitiated the spirits to aid Inca subjects in their struggle to survive in the harsh Andean environment. A mythic connection was made to the creator god Viracocha and the Sun God Inti through the belief that both these gods and the Inca people emerged from the impressive ruins at Tiwanaku, and/or from the Island of the Sun in Lake Titicaca. The Incas imported their stonemasons from this area (despite the gap in time between the two empires) and built a shrine on the island itself. Thus, ancestor veneration, an expanded pantheon that stressed the sun, direct connections to the gods, and to an impressive past, were the basis of Inca politicized religion. Diviners and other specialized shamans continued to practice; one was the Sapa Inca's constant companion, according to the Spanish chronicles.

The Incas deified natural forces and made their greatest politico-religious statements by sculpting nature: terracing the mountains, modifying stone outcrops, nestling cities into peaks and one stone into another. According to Spanish descriptions of the high altar in Cuzco's main temple, the sun, constellations, water, rainbow, and thunder were represented. In keeping with the Andean embeddedness in a hostile environment, they sought to control the uncontrollable flood, earthquake, drought, and frost by ritual and by redistribution. They held processions on important astronomical days, performed elaborate ceremonies for planting and harvesting the all-important maize, and tended *huacas* both within and beyond Cuzco. The Incas used sightlines to the mountains and other landmarks to locate key celestial movements and literally tell time by space. In a deeply Amerindian way, they coordinated their sacred duties to the rhythms of the cosmos itself.

Stonework
The profound Inca sense of identity with the earth, especially their rocky highland homeland, took to a new level the Andean identification with nature. The Incas felt a special interchange-

ability with stones, believing them to be alive and able to transform into people and vice versa (as illustrated in the Chanca war story). Quechua linguist Susan Malverde-Howard notes that the words for rocks are not only nouns, but also verbs; for instance, 'boulder' also signifies 'to begin.' What she calls 'lithification,' the active, transformational ability of stones, has obvious applicability to Inca architecture. The Observatory at Machu Picchu 163-65 literally begins with the boulder that forms the foundation, its temporal and spatial inception. The boulder is made to turn into the building almost seamlessly, in a virtuoso performance of masonry art. In general, Inca stonework seems alive as it dynamically responds to natural formations, creates active surfaces, and dances in the strong light of the high-altitude sun. At the same time, this dynamic Inca feeling of identity with stone led them to manipulate stones, mountains, and streams toward imperial expressive ends. Being one with the earth, they proclaimed themselves able to construct cultural statements with its materials and pre-existing forms. To geometricize, enhance, frame, and move people through the environment they subtly changed natural outlines. Theirs was a 'prepositional' attitude toward the landscape: vision and movement were directed over,

48. The Sacred Rock at the northern end of Machu Picchu, designed by the Incas to echo the form of the peak beyond. The subtle focussing of attention onto natural and manipulated shapes characterizes the Inca approach to architectural landscaping of their mountain homeland. Late Horizon.

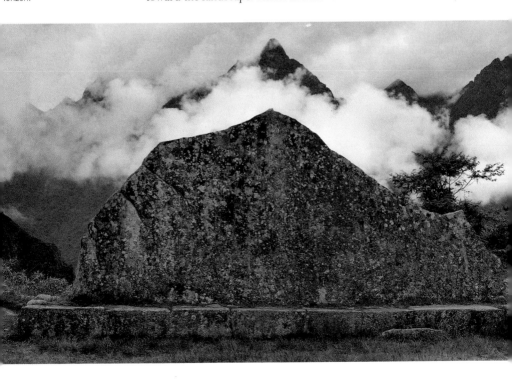

under, through, around, between, and among stones, walls, fountains, waterways, rooms, and clefts. The world was primarily to be experienced, rather than just viewed, as one would expect from a people for whom nomadism formed an abiding world-view.

The fascinating interplay of the organic and geometric achieved in Inca stonework seems also to have been calculated to alter their subjects' very perception of the world as one inevitably marked by their overlords. The lines between untouched and altered natural forms are blurred and the Inca hand can be seen or imagined everywhere. This was a conscious, and extremely effective, way to convey dominant power without a specific set of motifs or a complex pantheon, by controlling the elemental: vertical and horizontal, light and dark, scale, distance, similarity, interlockedness. We can follow a progression from the less- to the more-manipulated stonework by reviewing the treatment of rock outcroppings, terraces and waterways, roads, walls, and finally cities.

Previously we have seen rock drawings, artificial mountains, and all manner of natural subjects in Andean art and architecture. However, the Incas were the only ones to concentrate so much creative energy on modeling the Andes themselves. Rock outcroppings range from small boulders to those large enough to contain interior space in their clefts, from caves to entire hillsides. Especially in the heartland around the capital, but even as far away as Bolivia, outcrops were sculpted, some minimally and others more extensively. Rather than carving a stone into an image of something, such as an animal (although there are a few rather rudimentary felines), steps or stepped forms, rectangular shelves and niches, zigzag channels, and the occasional semi-circle were the preferred abstract forms. In the harsh high-altitude sun the lighter horizontal planes contrast with the darker vertical cuts. The play of light and shade unerringly draws attention to the freeform geometries that are at once like the hills and terraces around the outcrops and, upon closer inspection, significantly different. Thus, without a sense of artificiality or imposition, the Incas managed to suggest an elusive human hand at work modifying the living rock. As with all Inca stonework, each one is different, reflecting the characters of the living rocks themselves as well as the laborious contributions of the *mit'a* carvers.

One supremely important rock carving was the Inca 'throne' at Sacsahuaman, a series of sharp steps sliced into the curve of the stone hillside. From here the Sapa Inca (literally 'the unique

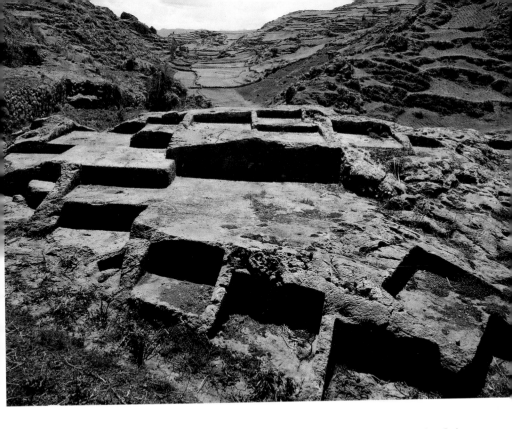

149. One of the many rock outcroppings that the Incas carved in their evocative, understated dual statement of embeddedness in nature and domination over the landscape. This one echoes the terraced fields in the valley near Chinchero. Late Horizon.

Inca') likely reviewed his troops and watched ceremonies. It is typical of the Inca aesthetic to extend to the highest monarch the same forms as elsewhere and to set him into the hill, rather than apart from his power base, nature itself. Yet one only has to think of the appearance of thrones in almost any other society to appreciate the singularity of this choice. On this and other carved outcrops food offerings were left on the flat planes, where ceremonies involving drinking and animal sacrifices, and even weddings also took place.

As practical people as well as aesthetes and dominators, the Incas developed the most extensive network of terraces that the highlands have ever known. On the Wari model yet on a scale much more vast, they converted mountainsides into stepped fields and sometimes even ornamental gardens. Terraces increased exponentially the amount of arable land available for growing maize, which can adapt to high-altitude conditions with considerable human tending. Retaining walls were built of fieldstone, the packed earth scooped out, a layer of stones laid at the bottom for water drainage, and the earth loosely repacked.

152

159

160

150. The triple zigzag walls of the fort-ritual center of Sacsahuaman, partially dismantled since Inca times. Characteristically, the shadows cast by the walls echo the shape of the peaks beyond. See the inset in ill. 153 for a plan of Sacsahuaman. Late Horizon.

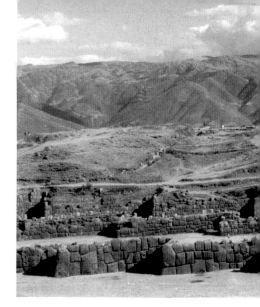

151. The Inca 'throne' carved into the living rock of Rodadero Hill across from the zigzag walls of Sacsahuaman. The sharp edges and precise planes of Inca landscape carving catch the high-altitude sun to create a bold play of light and shadow. Late Horizon.

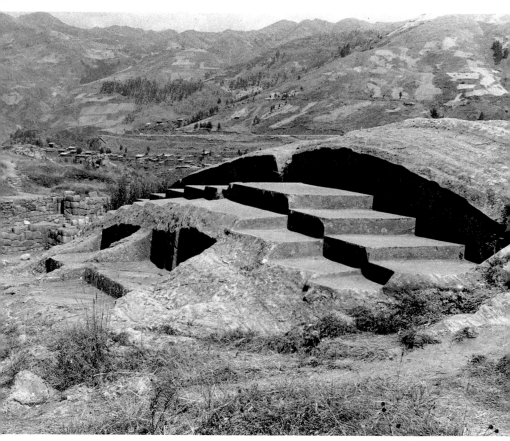

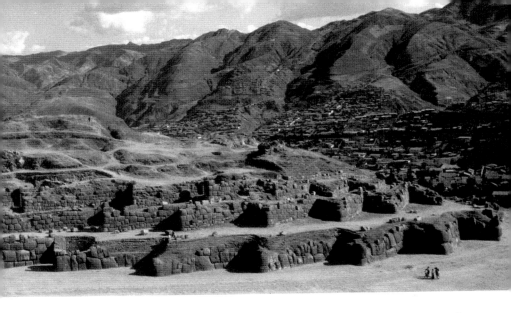

152. This dramatic cascade of agricultural terraces at the Inca site of Pisac epitomizes their vast geometric vision, equally practical and aesthetic. Terracing enabled maize to flourish above its normal altitude and also marked areas as under Inca dominance by its visual power. Late Horizon.

With looser soil and canals effectively keeping it moist, terraced maize crops had a better chance of flourishing and producing higher yields. (Maize, even more than before, was crucial as a portable protein source in a redistributive imperial economy.) Yet certain terraces appear to have been entirely decorative; according to the Spanish, those at Ollantaytambo displayed flowers, and at Moray, with no apparent water sources, the circular terrace patterns may have been principally a regularization of the earth's own contours. All Inca terraces followed the natural topography, but managed to stripe and step the mountains with

160

159

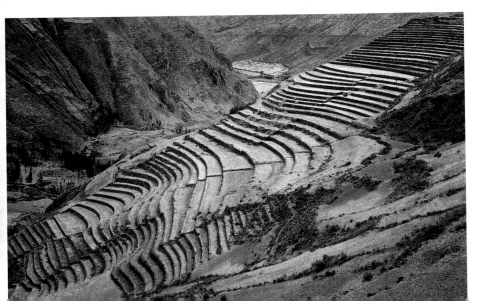

geometries not found in nature. As in the carved outcrops, the visual effect of terracing balances the subtle with the obvious. As a power statement, Inca terraces are unsurpassed because they announce control over the very edge of the earth itself.

The Incas also specialized in the practical/ritualistic movement of water. Canals teased the limited output of springs into snaking paths down the steep terraces, and fed baths and fountains. Even at tiny sites such as Tambo Machay the architects designed water to flow in one stream, then split, go underground, and re-emerge with a dramatic flourish. Rock outcrops were often carved with channels for liquids to be poured into during ceremonies. Watering and drinking vessels were also important portable art forms. Water, the life blood of the Andes, was considered as or more alive than stone; it vivified the earth itself.

Reflecting this preoccupation with controlled movement, the Incas also had their subjects build for them the most impressive system of roads in the pre-modern world. Like a giant ladder, over 20,000 miles (33,000 km) of roughly parallel highland and coastal roads were connected to each other across the mountain passes, according to a massive study by John Hyslop. The Inca road system constitutes the world's largest archaeological monument. In the highlands, the road was typically paved, edged with a low wall, and varied from 1 to 33 ft (0.4 to 10 m) across, depending on conditions. In particularly steep areas the road became a series of hundreds, even thousands, of steps. This underscores the fact that it was a road only for foot traffic and pack animals, the sure-footed llama in particular. With a system of runners (called *chasquis*), each sprinting a short distance, the Incas were able to send messages more swiftly than the Spanish on horseback, as an early Colonial experiment proved. Again the Incas proved themselves flexible in their approach to connecting up their vast territory, yielding to the exigencies of the terrain and relying on the millions of tribute-payers at their disposal.

The expenditure of labor on roads was matched by the investment of energy in wall-building. Terrace retaining walls and everyday housing were constructed from fieldstones laid in mud mortar (*pirka*). But the Incas' crowning achievement was the high-status, dressed-stone, mortarless wall built for royal, elite, and sacred structures by *mit'a* laborers. Some monolithic stones in these walls reached over 13 ft (4 m) high and weighed many tons. The effort expended in quarrying and transporting such stones was matched by the time-consuming fitting of the

stones. River-cobble hammerstones were literally bounced on the monoliths, pecking out round-edged natural shapes. The process of fitting stones to their neighbors' contours consisted of rough pecking, placing the stones together, moving them apart, gauging where the rock dust was not compressing (indicating a loose fit), pecking some more, and so on. Monoliths were lifted into place using the projecting knobs ('handling bosses') visible on the lower left corner of ill. 156. It is indeed true that even the thinnest coin does not fit between the stones in an Inca mortarless wall. The resulting interlocked polygonal shapes form calculatedly irregular but ultimately balanced freeform compositions. Protrusions punctuate the surface, left for aesthetic reasons and likely to demonstrate the process of building itself, referring to the time and skill appropriated by the Incas. The beveled edges where stones meet create a pattern of shadow lines picking out each dynamic intersection. Some rocks were modified to such a great extent that they sport as many as twelve angles. This extreme dovetailing not only holds walls together without mortar but means that they can withstand the frequent earthquakes that rock the Andes. Their remarkable stability also comes from the fact that each stone is bedded in another, the one below concave where it meets the convex base of the one above. Practical, beautiful, organic, geometric, standardized, individual, reproducible, elitist, technologically simple, and incomparably elegant, the wall epitomizes Inca aesthetics. It can also be seen as a social statement: divergent people were enjoined to interlock, adjust, and resettle into a dynamic whole by pooling their varying forms, smoothing their ethnic edges, and holding together with no visible means to face the hostile environment. The Incas were to engineer it.

Cuzco

The Inca capital of Cuzco was a city of the finest masonry buildings, made exclusively to house royalty, nobility, kidnapped provincial dignitaries, deities' images, and priests. Cuzco had been speedily promoted to royal center and *axis mundi* from being a relatively obscure village, located in a rich highland basin at an altitude of *c*. 10,170 ft (3100 m) and ringed with higher peaks. Its prime location was enhanced by the confluence of rivers, the Huatanay, the Tullumayo, and the Chunchul. Recall that the laudatory Quechua term *tinkuy* conveys the harmonious balancing of opposites where paths or rivers meet. The Incas straightened and canalized the first two rivers – the stone lining

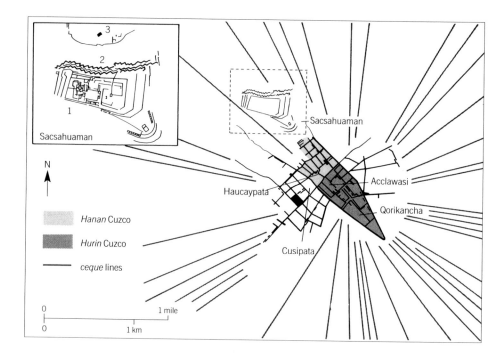

153. Plan of the Inca capital of Cuzco, which was conceived of as a puma with Sacsahuaman (ills. 150, 151) as the head and the canalized rivers' junction as the tail ('Pumac Chupan'). Two social divisions, *Hanan* and *Hurin*, as well as the roads to the four quarters of the empire, further differentiate the urban space. The *ceque* lines radiated outwards from Cuzco, the *axis mundi* of the Inca empire. Late Horizon. (Inset) Plan of Sacsahuaman, the fort–ritual center above Cuzco. Remains of a tall tower (1) and three tiers of defensive monolithic walls (2) lie across the parade ground from the Inca 'throne' (3). In its original form the tower reportedly could hold 1000 warriors, but ironically was used only by the Spanish against the Incas during the Conquest. Late Horizon.

still visible in places today – to create an acute angle. According to chronicler Juan de Betanzos, this point and the widening space between them was envisioned in the shape of a puma. The neighborhood near the rivers' union is still called Pumac Chupan, 'the puma's tail.' At the other end of the city, the shrine-fortress of Sacsahuaman topped a steep hill to define the puma's head, while in the center, the plazas formed the open space beneath the belly. As far as we can tell, this is the only Inca city, or Andean one for that matter, to be conceptualized as a mighty animal. Its corporate message contrasts markedly with the amorphous, individualized accretions of Huari or Chan Chan: Cuzco palaces and temples are wedged within the body like the stones in a wall, parts subsumed in the unified, royal image of the supreme mountain animal. Although the important buildings remained concentrated within the puma, the city outgrew its boundaries, spreading to the west and south between the Huatanay and the Chunchul Rivers.

The animal shape was not the only significant delineation of space in Cuzco. In the middle of the city a huge dual plaza, the larger one called Haucaypata and the smaller Cusipata, formed a great centripetal space for large-scale ritual gatherings. In the plaza was an *usnu*, a square masonry platform from which the

194

Sapa Inca could preside over these ceremonies. In a fascinating holistic gesture, and a striking aesthetic flourish, the plaza floor was covered in sand from the coast. The mountain's opposite, the sea, was appropriated for the *axis mundi*, thus proclaiming the full geographic extent of the empire.

Elevations, invisible radiating lines, and roads joined the capital to the entire empire both literally and symbolically. Relative elevation distinctions in Cuzco favored the front half of the puma, uphill to the temple-fortress Sacsahuaman, as the dominant *hanan* moiety. The downhill, subdominant *hurin* moiety nonetheless contained the most sacred religious structure, the Qorikancha. Thus, the dual subdivision of Cuzco reiterates that in the Andes two halves were always viewed as complementary, despite the understandable priority given by highlanders to the most highland areas.

The Qorikancha was in many ways the absolute center, not only as the house (*kancha*) for all the deity images and High Priests, but also as the point from which radiated the 328 *ceque* 153 lines. As the preeminent *huaca* in the land, this 'Golden House' invisibly subdivided all space and time. *Ceque* lines are not even really straight, but consisted of a connect-the-dots series of *huacas*, such as natural springs, caves, and outcrops, but also fountains, doorways, and other constructed shrines. Using lists

154. Interior view of the Qorikancha, the 'Golden House,' the Incas' main temple in Cuzco. Its elegantly simple trapezoidal doors, windows, and niches take the hallmark Inca shape. The structure visible beyond is the Santo Domingo church built over the Qorikancha by the Spanish. Late Horizon-Colonial.

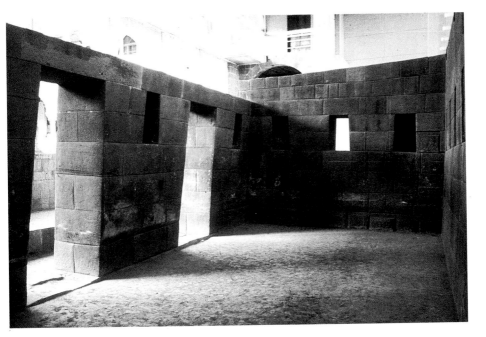

left by Spanish chroniclers, modern traditional placenames, and close observation of the landscape, Bauer and others have now located many of these *huacas* in the countryside around the imperial capital. According to our reconstructions, the Incas designated different groups of people to hold processions to that day's *huaca*, where they chanted, prayed, and left offerings and sacrifices. Through this daily worship and care of significant places, treated as if they were alive in typical Andean fashion, the Incas believed that the shrines' powers could be directed to positively affect the future. In addition, the complex sociopolitical organization of Cuzco, a microcosm of the empire, could be spelled out through the sequential actions of various social groups in this unique landscape calendar/cosmogram. Other rituals such as the *capac hucha* child sacrifices were organized along the extended trajectories of Cuzco's *ceques*. With a beginning at the Qorikancha but no conceptualized endpoints, their imaginary lines projected the Incas to the tops of the mountains, the farthest borders of the empire, and even off the continent itself (*capac hucha* burials have been found on Isla de la Plata off the shores of Ecuador). Yet the *ceque* lines around Cuzco, like other Inca inventions, were not only symbolic but also highly practical: scholars agree that they also subdivided the water rights of the capital's residents. Access to water, as we have seen, was a permanent preoccupation of highlanders, and nowhere more so than among those uncharacteristically living in a densely populated city where conflict over scanty resources would have been destructively divisive.

Finally, Cuzco's layout reflects the segmentation of all Tawantinsuyo into quarters. Again not a regular 90-degree division, the four *suyus* were accessed by roads leading from the royal city across the nearest passes in their general direction: Antisuyu to the northeast, Collasuyu to the east, Cuntisuyu to the southwest, and Chinchaysuyu to the northwest. People from or connected to each *suyu* lived in the corresponding sector of the city, so that Cuzco structurally mapped out the empire. The roads all led to and from the capital, thus connecting goods, troops, ideas, rulers, and subjects. Along these roads, more tangibly than the *ceques*, the Incas strung their settlements. In sum, the city was an all-inclusive image of authority, unity, duality, hierarchy, cosmic confluence, and time-space itself.

All of Cuzco's monumental constructions suffered in the burning of the city during the Spanish invasion, and subsequent dismantling by the colonizers, recurrent earthquakes, and

modern modifications. Yet Sacsahuaman, the Qorikancha, some walls, and the Acllawasi (House of the Chosen Women) retain clues to their former glory. High above, on a naturally defensible jut of land, Sacsahuaman presides in semi-dismantled state. Its main feature is a trio of monolithic zigzag walls that barred access to the fortified temple complex originally containing three tall towers, of which only foundations remain. Across the parade ground is the rock outcrop known as Rodadero Hill into which the 'throne' is carved. The zigzag walls are some of the most impressive made by the Incas, with individual stones – up to 13 ft (4 m) tall – laid in asymmetrical but dynamically balanced patterns. The undulating walls capture dark triangular shadows, not coincidentally echoing the chevron shadows in the peaks beyond. The result is a complex orchestration of environment, sculptural form, and surface patterning that defines the richly abstract sensibility of its makers.

The Qorikancha features a different version of Inca design principles, with more regularized stonework courses in its stunning curved wall and a large courtyard with surrounding

155. The curved Inca wall of the Qorikancha, the main temple, surmounted by the Santo Domingo church built over it by the Spanish. The Qorikancha got its name 'Golden House' from its sheathing in gold, 700 loads of which the Europeans removed after the fall of the Inca empire. Late Horizon-Colonial.

156. The famous 12-angle monolith in the wall of Cuzco's Hatun Rumiyoc Street. Its complex form resulted from being modified by all the surrounding stones. Elaborate Inca stonework does not use mortar; these interlocked stones hold together without it. Late Horizon.

enclosures for the holy shrines. (The Colonial monastery of Santo Domingo was built around and over the Inca temple, hence the juxtaposition of conflicting architectural styles.) The Spanish carted away 700 loads of gold sheathing from the upper walls, its crowning glory. Interior walls were also sheathed to create a truly 'Golden House.' The Qorikancha was also 'planted' with a gold and silver garden, mimetic of nature down to the tiniest details of earthen lumps, animals, and plants (see below). An underground channel connected the temple directly with the main plazas, so that sanctified liquids could run magically between the two points of power. Doorways were double-jambed, and these and all windows and niches were trapezoidal, the preferred Inca shape. The simple trapezoid is not only visually powerful, but also eminently practical, as the narrower lintel across the top survives well in earthquakes. Again, the elegant, repetitive Inca solution fulfills functional requirements as well as aesthetic and political goals. In fact, the Qorikancha is only a larger, plated, holy version of the basic architectural form used for housing throughout the empire. Thus, a standardized image of equality can nonetheless be elaborated so as to reinforce hierarchy.

Only walls and the city blocks remain of the many royal palaces and other buildings that filled the capital. These vary from the irregular polygonal stonework type, epitomized by the

twelve-angle stone on Hatun Rumiyoc Street, to the very recti-
linear, bricklike courses of the Acllawasi. It is tempting to see in
the choice of building method messages about levels of control –
the more regimented Acllawasi perhaps reflecting the restric-
tions placed upon the *acllacuna* women weavers within, who
spent their lives there in the service of the Sapa Inca. As we shall
see, the provincial center of Huánuco Pampa has a well pre-
served Acllawasi that demonstrates architecturally the physical
containment such high-status slaves endured. All the enclosures
in Cuzco seemed to have had high walls, limited entrances, and
interiors most probably based on the *kancha* form.

Beyond Cuzco
The environs of Cuzco are filled with small Inca sites and carved
outcrops, *huacas* along the *ceque* lines. Of these, Tambo Machay 157
and Qenqo, just north of Sacsahuaman, display important 158
characteristics of Inca stonework and ritualized space. Tambo
Machay is semi-dismantled but retains a picturesque quality in
its elegant siting. Nestled into the hillside, it has three shallow
terraces with fine dressed-stone masonry walls marked with tall
trapezoidal niches. On the second terrace a natural spring

157 The site of Tambo Machay,
above Cuzco, near Qenqo.
Elaborately embracing a natural
spring, its polygonal stonework
juxtaposed with unworked
boulders, Tambo Machay
summarizes many central Inca
aesthetic choices. Late Horizon.

emerges from below a plain wall. The spring is undoubtedly the reason for the stonework, which is less a building than an architectural frame. The Incas designed the water to run in one stream, fall down the lower terrace, disappear into the ground, and reappear in two streams cascading down the last terrace. Another important feature of the *tambo* (Quechua for waystation, used to denote any small outpost along the road) is how rocks from the hillside are periodically incorporated into the built structure. The dressed walls merge into the rocks and out again as one scans the walls. In particular, one doorway frames a boulder whose edges are somewhat modified to accommodate the polygonal dressed stones nestled around it but whose rough, natural surface seems unaltered. Thus, Tambo Machay uses fine masonry to draw attention to the 'untouched' pre-existing water flow and rock formation, both of which the Incas have actually geometricized and brought under their dominion.

158. View of the 'seated puma' stone at Qenqo just north of Cuzco. A semi-circular courtyard creates a ritual space around this framed, untouched tall boulder reminiscent of a seated cat. Nearby is a huge outcrop, subtly geometricized with steps and channels, underneath which a natural cleft has been transformed into a special room, as at Machu Picchu (see ills. 163, 165). Late Horizon.

While Tambo Machay expresses itself simply and subtly, Qenqo makes more visually radical statements. This very large outcrop is carved all over its bulbous surface with steps, shelves, indentations, and a striking zigzag channel for liquids that also branches and rejoins. It is so heavily modified that it re-approaches natural irregularity, yet the sun catching a completely flat area periodically shocks the viewer out of such an inattentive assumption. Underneath, the boulder has a large cleft which has been worked into a small room, a common Inca choice for ritual purposes. The 'heart' of a cleft stone was considered a very spiritual place, alive, isolated from the secular world, and one with the earth. In fact, one meaning of *huaca* is 'double' or 'split.' On one side of the outcrop, a separate jutting triangular monolith is doubly framed by its small square wall and the enclosing curve-walled courtyard. This stone has been left to its own evocative shape (perhaps a seated puma) suitable for veneration.

In the heartland, within three days walk of Cuzco, more extensive sites were built to feed and supply the capital: to the east Rumicolca, to the north Pisac and Chinchero, to the northwest Ollantaytambo and the famous Machu Picchu. Myriad mid-size *tambos*, terraces, and clusters of buildings dot the countryside, among them the spectacular circles of Moray. Moray represents the quintessentially Inca geometric organicism, a topographic exercise in molding the earth according to its own essential shapes and Inca essentializing vision. Pisac demonstrates the principles adopted in most Inca settlements: leave the rich bottomland uncovered, terrace the hills, place the elites in a

159

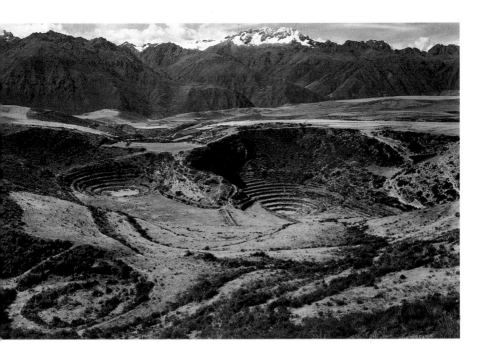

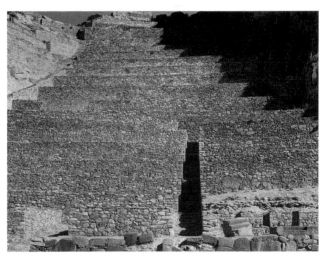

159. The concentric terraces of Moray follow, yet regularize, the terrain in a typically Inca manner. Without any known canals to irrigate them, these terraces may have been primarily aesthetic statements. Late Horizon.

160. The seventeen terraces of Ollantaytambo. To reach the temple on top, one is led up the center then over to the left, then up again in a typical zigzag movement pattern. Spanish accounts claim that these terraces were planted with colorful flowers. Late Horizon.

well-defended outlook, and provide minimally for the *mit'a* laborers. This small outpost was built of stone high above the Vilcanota River in the saddle of a mountain spur, with workers' housing clinging to the unusable slopes. 152

The site of Ollantaytambo has a flight of seventeen terraces that span the dip between two promontories; according to the 160

Spanish, these were planted exclusively in colorful flowers. Not only an extravagant gesture, these ornamental terraces again frame and focus the natural in relation to the constructed. One is made to walk straight up steps through the center of this juxtaposed world, before the path turns abruptly left then right again. The path exemplifies the Inca 'prepositional' use of architectural space by not only calling attention to natural forms but by necessitating and controlling movement. Zigzag and stepped movements in particular are favored, probably as they echo the switchbacks necessary to climb the Andes and the terraces geometricizing their outlines. Paths, doors, steps, clefts, passes, all are used to effect; free exploration is not allowed (nor was it on the Inca roads either). On the summit of Ollantaytambo is an unfinished temple, whose crowning illusion is a vertical series of three barely visible, carved diamond outlines that emerge via shadows only to retreat into the temple face when concentration wavers or the sun goes behind a cloud. They are, at once, the

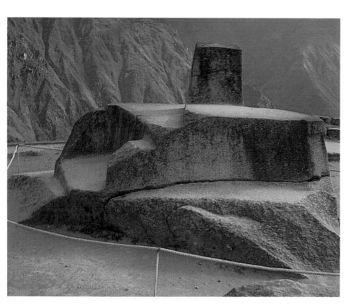

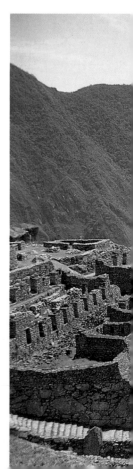

161. The Intihuatana Stone ('Hitching Post of the Sun') at Machu Picchu's highest point. In many Inca cities these elegant, enigmatic carved outcrops seem to connect earth and sky, and possibly were used for astronomical rituals. Late Horizon.

steps one has just mounted, the carved diamonds at Puma Punku, and an optical trick designed to reveal and withhold geometry at the wave of the Inca hand. A final important feature of Ollantaytambo is the town, located across from the sanctuary, which is laid out in a large trapezoid shape. This standardized form was used routinely not only for stones and openings, but also for *kanchas*, plazas, and towns themselves. It is probable that the Incas recognized how the trapezoid optically exaggerates scale (converging sides trick the eye into perceiving greater depth). Inca community spaces, already enormous, seem even larger.

Machu Picchu, the most famous monument of ancient South America, was rediscovered (it was known to the local peoples) in 1911 by Hiram Bingham. Its dramatic setting, on the top of a high mountain spur overlooking the Urubamba River as it makes a hairpin turn, has made it justifiably admired over the years. Machu Picchu is both a very special Inca settlement and a

162. General view of the famous Inca city of Machu Picchu, which follows the topography of a steep mountain saddle above the Urubamba River. Known to be Pachakuti's royal retreat, Machu Picchu lies about a three-day walk from Cuzco. Late Horizon.

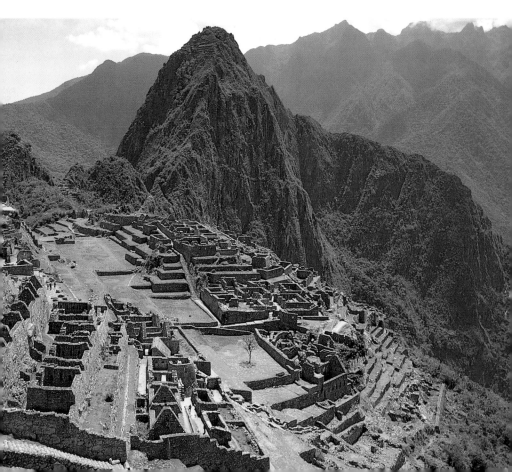

typical one. Bingham wrote of the area: 'Not only has it great snow peaks looming above the clouds more than two miles overhead; gigantic precipices of many-colored granite rising sheer for thousands of feet above the foaming, glistening, roaring rapids; it has also, in striking contrast, orchids and tree ferns, the delectable beauty of luxurious vegetation, and the mysterious witchery of the jungle.' Like Pisac and other sites, it was built in an easily defensible position over an important river, set into a saddle with agricultural and living terraces hugging the steep hillside. The top was partly flattened for a main plaza. Clusters of buildings, over 200 residences in all, are arrayed in no clear format, unlike the Cuzco puma or the Ollantaytambo trapezoid. At its highest point is a carved boulder (found in other Inca settlements as well) known as the Intihuatana Stone, 'Hitching Post of the Sun.' The projecting trapezoidal portion elegantly thrusting upward may have held offerings to the sun, especially on solstices when the sun, frighteningly, seems to stop moving through the sky.

16

Another important boulder is encased in the building now known as the Torreón, the 'Observatory.' The building's rounded wall was almost seamlessly joined to this tall outcrop whose top inside the room has been somewhat modified. Indeed the boulder

163. The Observatory at Machu Picchu as seen from below. The curved wall, a rare form also found at the main temple in Cuzco (see ill. 155), embraces the top of a two-story outcrop with an elaborate room carved into its natural cleft below (ill. 164). Late Horizon.

164. View of the Observatory at Machu Picchu from above. Walls enclose the top of the outcrop, onto which the sun shines on 21 June, the summer solstice. The window was carefully placed to capture the sunlight only on the important day in which the sun seems to stop its movement. Late Horizon.

is the building's beginning. Sets of niches alternate with windows, the central one of which is oriented toward the rising sun on the 21 June solstice. As at Qenqo, the outcrop was split below with a large cleft, recarved and set with masonry to create a small room with a stepped diagonal entrance. This is an especially diagnostic Inca treatment, combining all levels of interference and accommodation of the natural forms. The far left remains untouched mottled stone; the left side of the slanting cleft was smoothed, but not completely straightened; the right side was stepped, but not altogether regularly; and the odd-shaped interstices to the far right were filled with stonework that fits like liquid poured into a crack despite its courses and accentuated beveled edges. Stones are even inserted into the rightmost grey stone so that the vertical wall might progress more smoothly. To devote such extraordinary care and skill to the stone's inner space bespeaks the Incas' great refinement of the Andean notion of essence.

The various Inca rulers are associated with particular places constructed along the Urubamba River north of Cuzco: Pachakuti commissioned Machu Picchu, Ollantaytambo, and Pisac; Topa Inca constructed Chinchero; and Huayna Capac claimed a large tract of land at Yucay. Huayna Capac's royal estate at Yucay, where he came to rest from his campaigns and hunt deer in a nearby canyon, features the now-ruined palace of

165

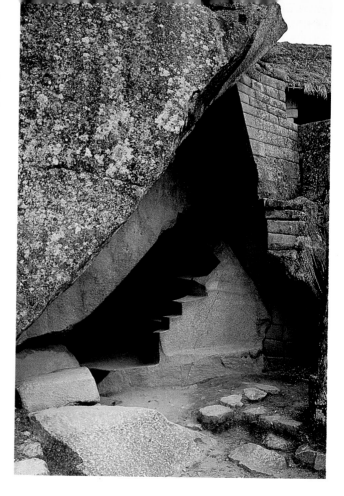

165. The cleft room beneath the Observatory at Machu Picchu. Subtle sculpting of the rock edges combined with in-filling of dressed stonework show the Inca fluency in organic geometry. Late Horizon.

Quispiguanca. This unusual palace has been recently reconstructed by Susan Niles and provides us a glimpse into a distinctive late Inca architectural expression which recombines familiar elements in startling new ways. The palace was built on a raised terrace so that it had to be approached by a ramp, signaling the importance of its royal occupant. On the eastern side of the palace a massive and unusual mud-plastered wall imbedded two tall gatehouses on either side of a central two-story tower with an enormous triple-jamb doorway. This grand entrance leads to an unworked white boulder just north of the center of a large plaza, a typical Inca gesture of the cultural construction framing a noteworthy natural entity. Water was drawn into the courtyard from the north, past the rock, and made to cascade off the southern end of the platform into an artificial lake that reflected the mountains (both an act of reverence and one of visual

capture, like the Observatory window). On the northern side of the plaza long *kalanka* halls faced the canal, orienting their short sides with the plaza (whereas elsewhere long sides parallel plazas, for instance at Huánuco Pampa). Quispiguanca is as idiosyncratic as the white boulder it embraces, and demonstrates how creatively an architect could express authority, the framing of nature, and royal individuality in the later years of the empire. 166

While the heartland is dotted with a huge variety of constructions, the Incas also lavished their architectural skills on administrative nodes in the periphery. The best-studied site of the highland hinterland is Huánuco Pampa located along the northern road to Quito. This sprawling city was oriented so that the road passed diagonally through its central plaza, which measured an enormous 1800 by 1200 ft (540 by 370 m). Fanning out from the sides of the plaza were heavily-populated sectors, over 4000 structures in all, and above the plain lay over 700 storehouses for tribute, rations for the army, and provisions for the laborers housed here temporarily. Barracks have been identified to the north, and commoners' housing made of *pirka* are found outside the city on all sides except the east, where fine gateways led through courtyards to an elite residence complete with a bath. This building was reserved for the ruler on royal visits, and perhaps also for the highest local administrator. The eastern sector

166. Plan of the provincial Inca administrative center of Huánuco Pampa, on the road from Cuzco to Quito. Over 4000 buildings and 700 storehouses were built primarily for temporary state workers' housing and food storage for redistribution. Late Horizon.

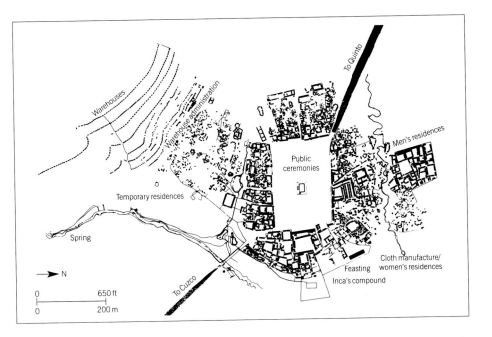

To Quinto
Warehouses
Warehouse administration
Men's residences
Public ceremonies
Temporary residences
Spring
N
0 650 ft
0 200 m
To Cuzco
Cloth manufacture/ women's residences
Feasting
Inca's compound

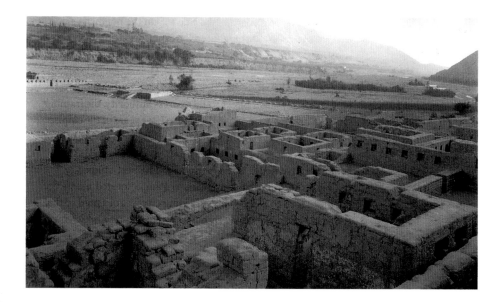

167. The coastal Inca waystation, Tambo Colorado, shows a typical combination of Inca elements, although built entirely in adobe: a large trapezoidal plaza, adjoining *kanchas* (walled enclosures of rooms around courtyards), and trapezoidal niches, windows, and doors.

was aligned with the massive *usnu* in the center of the plaza and oriented toward the sunrise to equate explicitly royalty and Inti. On the north side of the plaza lay the city's Acllawasi, as at Cuzco an enclosed structure with only one entrance built to house the local chosen women (ill. 170) who wove for the elites and made beer for the workers. Their own self-contained world, emphatically walled off, had a central courtyard set with long halls for group activity and rows of identical workshop/rooms. Finally at Huánuco Pampa there were long halls (*kalanka*) all around the main plaza used as ritual drinking places for the *mit'a* laborers. The various architectural contexts – for royalty, male workers, and female artists – show the contrasts of control and regimentation possible within a very limited vocabulary of forms. Massive, permanent settlements such as Huánuco Pampa dedicated primarily to temporary, shifting populations, helped inculcate thousands of subjects over the years with Inca style, reciprocity, and power.

The Incas were also concerned with their coastal conquests and could adapt their designs to wholly different environments and materials. Tambo Colorado in the Pisco Valley, a distinctly modest waystation, nevertheless evinces values similar to the highland centers. Set so that the coastal road likewise travels through the plaza diagonally, it has an *usnu* for rituals, and surrounding buildings with trapezoidal niches. All are made in adobe, but retain the characteristic Inca proportions, shapes, and simplicity.

167

A quite different culture area, and one that seemingly inter-
acted with the Incas as equals, lies along the northeastern side of
the Andes. Exciting recent discoveries by Warren Church add
the Chachapoyas to the cultural mix in Inca times, and include
impressive cities of up to 400 round buildings characterized by
intricate stone mosaics. Round burial structures at the site of Los 168
Pinchudos retain traces of their original yellow, white, and red
paint and rare wooden sculptures of ithyphallic males hang from
the exteriors. Offerings of spondylus shell inside their buildings
show that the Chachapoyas people were successful traders of
nearby lowland Amazonian luxury goods such as gold, feathers,
and dyes, as well as possibly hallucinogenic and medicinal plants
(reminiscent of Chavín times). Shamanic assemblages including
quartz crystals again reinforce the idea that this spiritual empha-
sis characterized all Andean regions. The Incas seems to have

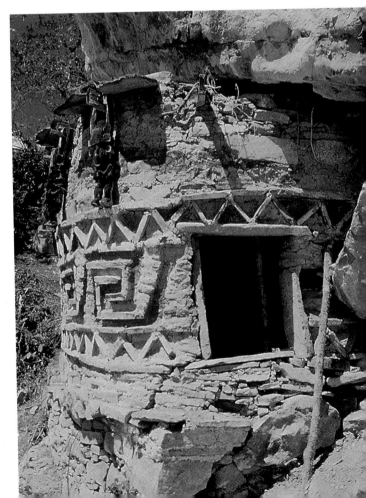

168. Newly-discovered cylindrical
tombs at the Chachapoyas site of
Los Pinchudos in northeastern
Peru. Wooden male figures hang
above the geometric wall mosaics
characteristic of this powerful
non-Inca people of the late pre-
Hispanic times. Late Horizon.

been forced to trade with the Chachapoyas peoples, not conquer them, as the only Inca influence is seen in a few Cuzco-style trade ceramics and a shadowy incorporation of trapezoidal niches in a few mosaiced buildings.

Inca textiles, metalwork, and ceramics
The Incas may have been consummate architects, but their artistic imprint extended into other media as well, notably textiles, metalwork, and ceramics. The same general approach can be traced – technical excellence, standardization, geometric organicism – although different media had noticeably different roles to play and imperial styles to project. Textiles were the most highly valued (they were the first gifts offered to the Spanish, not goldwork) as well as the most colorful and abstract, metalwork the most restricted and mimetic, and ceramics the most standardized and practical. Portability was a key issue in this farflung kingdom, and so textiles circulated extensively as gifts to cement political relationships, reward, indoctrinate, and brand subjects as ethnically identified with their conquerors. The textile recording device, the *quipu*, also played a key role in the administration of the empire. Metalwork was more exclusive to the nobility and so helps us understand elite value systems and sacred practices, such as sacrifice. Tragically very few actual Inca gold and silver pieces survived the Colonial meltdown of works of art into ingots; however, ironically also because of the European mania for gold, Spanish chronicles preserve descriptions of lost precious metal sculptures. By contrast, ceramics were more widespread and functional; for example, a new shape of jar, the *urpu*, was used to transport maize over long distances. Such ceramics document clearly how new Inca forms were inserted into pre-existing local color schemes and iconographic traditions. Given the grand scale on which the Inca fed their *mit'a* laborers, huge numbers of serving dishes, maize beer brewing and serving containers, and other feasting wares were produced. Ceramic was also one of the options for *qeros* (along with wood and precious metals) and for a few very revealing higher-status ritual items, such as *pacchas*.

Weaving, an occupation of all Andeans, was organized and regulated by the Incas at several levels. Therefore, children, the sick, and the elderly were all required to spin fiber into thread, if not weave to the best of their ability. Everyday cloth was called *awaska* and sufficed for household use. The Incas cared most about the fine cloth they called *qompi* (in fact, when recording

169. An Inca royal tunic covered with *tocapus* (geometric patterns). Colonial drawings show this type only being worn by rulers (see ill. 171). One pattern is that of the army uniform (see ill. 172), showing the ruler's absolute power over conquest forces. Late Horizon.

numbers of items in the census, the Inca first listed human subjects, then camelids [whose fur made most cloth], then textiles themselves, before foodstuffs or gold). There were two levels of *qompi*, good cloth woven by male *qompicamayocs* (keepers of the fine cloth) as tribute, and the best cloth made by the *acllacuna* for royal and religious use. Control over the finest textiles was an obvious priority as they served to adorn the ruler, grease the most important political wheels, and even to propitiate the sun

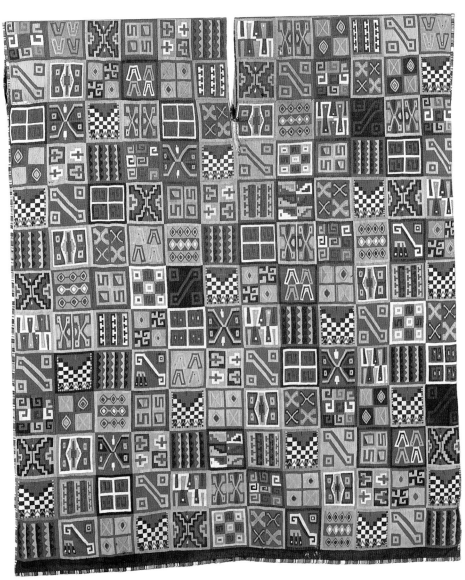

(*qompi* were burned as sacrificial offerings). One offers only the most prized possessions to the highest spiritual powers. At its best, Inca weaving is unsurpassed technically in the pre-industrial era, with thread counts reaching several hundred per centimeter.

The highest-status Inca textile that survives today is a royal tapestry tunic we know was made for a king because of the sixteenth-century illustrations by Guaman Poma de Ayala of Inca rulers. In addition, the tunic bears as its motifs the images, patterns, and colors in other tunics. Notice the tiny black-and-white checkerboard with red stepped yoke that is the Inca army uniform in miniature. The square geometric designs known as *tocapus*, reserved for elites and usually only seen in small bands, broadcast the message that the ruler controls more diversity, more ethnicity, almost the totality of possible patterns in his clothing. By contrast, lower-status tunics are limited to a single motif. The ruler is above the rule of regularity as well, since these motifs and their coloration do not repeat in any order, while those of lesser tunics follow strict checkerboard and stripe patterns. Standardization applies to lower status textiles even in the number of squares per row. Non-royal clothing was an instrument of conformity, unmistakably signaling imperial power. Imagine 10,000 warriors in checkerboard tunics advancing over the hill! The graphic boldness of simple, high-contrast geometry is thus both aesthetically pleasing and politically effective. Motifs make only rare, tangential reference to pre-Inca styles (stepped diamonds come the closest to a Wari model) and so proclaim the universal, elemental quality of Inca rule.

Special note must be taken of the unique Inca recording device, the *quipu*. Around 500 of these are preserved, giving a good, if tantalizing, sense of Inca mathematics and thought. As mnemonic devices (memory aids) there was a code – unfortunately not written down in Colonial times – that told the reader the subject and date of the information recorded. According to the Spanish, *quipus* recorded the census, tribute, labor, astronomy, history, even poetry, in short all types of information necessary to organize an empire of ten million people. Interestingly, this 'fiber computer' proves that the Incas used the same base-10 mathematical system as the Arabic-European world, complete with zero, the four operations, and fractions. The *quipu* coded all information into numbers, represented by rows of knots for the 1s, 10s, 100s and so on, but also used knot types, subsidiary cords, sum cords, cord colors, and even the direction the cords were spun and plied (according to new research by Gary Urton)

16

17

17a

147

PRIMER·CAPITVLO·DE·LASMŌIAS
ACLLA·COIRAS
auasesa · mamaiona

EL·DECÍMOÍNGA
TOPAINGA·IV
PANQVI

Reyno torma·djī
to atopi Clo ni vos
hme (uay llai —

hay rochā uaro chiri ian
chas chij cap concyoco —
uaram ga uuno lo allauca ydyoca un

170. Guaman Poma's Colonial drawing of the Acllawasi, or House of the Chosen Women who wove for the ruler (see ill. 169) and Inti as virtual slaves. Early Colonial representing Late Horizon times.

171. Guaman Poma's Colonial drawing of ruler Topa Inca Yupanqui, the 'Alexander the Great' of the Inca empire. He is shown as an old man – he ruled for many years – and wears an all-*tocapu* tunic (see ill. 169). Early Colonial representing Late Horizon times.

172. The standardized Inca checkerboard tunic, in black and white with a red yoke, apparently was the army uniform. It epitomizes the Inca graphic, bold, and often minimalistic style. Late Horizon.

to convey different aspects of complex data. Perfectly portable when rolled up, knot writing was uniquely adapted to the Andean environment. It is also very culturally revealing that the Incas successfully reduced reality into codified units only understandable in relation to one another (the 10's position is only readable as such if there is a knot in the 1's position below it, for example). Just as they maneuvered people, crops, stones, and

173. This fragmentary silver and gold corn stalk shows the degree to which Inca sculpture could be mimetic. Gardens of precious metal plants, animals, and even lumps of earth were created for the nobility. Late Horizon.

174. A gilded bronze llama effigy ceremonial knife. Visible on the left side of the blade are the remains of the wrapping textile, converted into metal. This Andean tradition of encasing precious objects in fiber goes back at least 10,000 years. Late Horizon.

motifs into position, so their form of writing was one of abstract placement.

Late Horizon metalwork was largely appropriated from the Chimú, but with changes in scale and quality of execution. Metal was worked both on a grander scale (for instance the enormous sheathing of the Qorikancha) and on a more minute one (some figures only a few centimeters in height were painstakingly constructed from as many as eighteen sheets). Large-scale sculptures of the gods, rulers, and camelids are mentioned in Spanish documentary sources, as is the remarkable golden garden in the main temple. Garcilaso de la Vega gives a description of these gardens, of which there were many in the kingdom: 'they made fields of maize, with their leaves, cobs, canes, roots and flowers all exactly imitated. The beard of the cob was of gold, and all the rest of silver. . . . They did the same thing with other plants, making the flowers, or any other part that became yellow, of gold and the rest of silver. In addition to all this, there were all kinds of gold and silver animals in these gardens, such as rabbits, mice, lizards, snakes, butterflies, foxes, and wildcats. . . . Then there were birds set in the trees, as though they were about to sing, and others bent over the flowers, breathing in their nectar.' Tantalizing glimpses of these wonders survive in a partial maize stalk (its oxidized silver cob aptly evokes the black maizes typical of the Cuzco area and its gold husks the color of real dry husks).

A growing number of metal figurines are being found buried with the child sacrifices recently excavated on high mountain tops throughout the empire. Male and female figurines are elaborately dressed in miniature finery that often directly echoes that of the child (the textiles and featherwork being as or more important than the metal, in typical Andean fashion). Camelid images are also found, often in silver to represent the white fur, a famous one with a red blanket is interpreted as the white llama sacrificed daily to the Sun in the plaza at Cuzco. Distinctions are made between types of camelids, long-haired varieties shown with striated sheets hanging off their sides. Charmingly mimetic, diminutive metal sculptures demonstrate a less-abstract side of the Inca aesthetic and help us envision the life-sized pieces whose metal now graces European churches.

Mass-produced ceramics reflect the characteristic Inca concern for identifiable shape and geometric surface patterning. One of the new, imperial forms was the *urpu*, a long-necked jar with low-set handles (see ill. 176; called an *aryballo* in Spanish, from the very similar Greek *aryballus*). Its pointed tip was made

175. A cast silver figure dressed in a miniature feather headdress and woven mantle, found with a child sacrifice at Cerro del Plomo in Chile. In the *capac hucha* ritual, a few special children gave their life force in the belief that it would strengthen that of the ruler. Other nude silver and gold figures were originally dressed in this way, as were Andean effigies from other eras (see frontispiece). Late Horizon.

to rest in the ground, allow for easier pouring – some stood over a meter high – and ergonomically fit the small of the back while being carried on a tump line. Graduated sizes were actually standardized as to internal volume, so that the Incas could calculate how many maize kernels or how much beer they had at a glance. The imperial Cuzco-style *urpu* was recognizably elongated and usually painted in black on a red background, while local versions were squatter, interpreted in black on the North Coast and buff on the Central, reflecting those ongoing traditions. Inca power was strong over the many ethnicities and art styles they

176. Three provincial Inca *urpus*, the standardized maize beer storage vessel, reinterpreted by the Chimú in blackwares and by the Chancay in buff. Late Horizon.

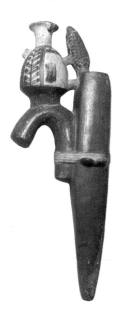

177. An Inca *paccha* or watering device, that encapsulates the entire cycle of growing maize. Wear on its pointed tip shows it was 'planted' in the earth so that maize beer could ritually water the field. Late Horizon.

conquered, but it was also politically expedient to allow local peoples to maintain their own political structures, deities, and decorative habits to a surprising degree. Chimú-Inca *urpus* are distinctive for the sculptural relief on the surface, either bowing to Inca geometry or keeping the familiar coastal bird motif. Chancay-Inca ones retain a diagnostic black-on-white aesthetic, though abstractly render maize plant designs.

This particular light-colored *urpu* is key to interpreting a ceramic *paccha* that new research by the author has shown to be an Inca watering device used almost certainly in a Chancay Valley planting ritual. The pointed and hooked element represents the man's foot plow used to punch holes in the earth for seeding. The miniature vessel perched on the top left nearly matches the center one in ill. 176, while the black cob on the top right is molded from an actual ear of 'proto-Chancayano' maize (as its name suggests, a type found in the Chancay Valley, and, tellingly, imported from the Cuzco region). Together the three elements represent the cycle of successfully growing maize, from planting to harvesting to producing beer (stored in the *urpu*). Not only does the vessel style and maize type point to its use on the Central Coast, but sand found in a residue trapped in the end of the hook matched a sample taken from that particular valley. However, the most important finding of recent scientific analysis of the residue is that maize beer was the liquid poured through this *paccha*. Wear on the tip suggests it was symbolically planted so that maize beer could be shared with Pachamama, Mother Earth, reciprocally asking her to grant success to the crop of Inca-style maize being grown locally. Thus, in a small-scale clay object a

particularly cogent symbolic combination nevertheless elegantly conveyed both political dominance and reverence for nature, as did monumental Inca terraces and architecture. A sense of local Inca rituals – not recorded by the Spanish – can be gained by careful artistic and scientific probing of such works of art.

Epilog

In the early sixteenth century a turn of world events shook the Americas and brought entirely foreign elements into the Andean artistic milieu. The Inca empire fell after the European-introduced plague killed the last Inca king, Huayna Capac, and set into motion a fateful civil war between competing heirs, worsened by Spanish divide-and-conquer tactics. It was not, as is so often portrayed, the simple or miraculous dominance of a few hundred Europeans swiftly toppling the Incas. The Conquest in South America took at least a generation, if not nearly fifty years before the new order was truly established. Disease played a pivotal role in devastating the population and undermining their religious faith. Certainly many reluctant Inca subjects were eager to believe Spanish promises that they were liberators rather than the next dominators. With no clear ruler, the army divided, two capitals, and a ritualized version of warfare that did not involve ambush and deceit, the Incas were not in a position to unify against the invaders. Finally, rupturing the delicate balance of reciprocity meant that sustenance, communication, and overall organization broke down rapidly. Given the challenges of the Andean environment, the traditional system could not be altered substantially, as the Spanish swiftly found out for themselves.

The early Colonial era was one of upheaval, depopulation, resistance, and tragedy. During the sixteenth century in the Americas as a whole, an estimated *ninety million* or more indigenous people died, making this the greatest holocaust in world history. When the coastal Andean populations declined precipitously the Spanish then began the further holocaust of African slavery. Highland peoples fared a little better than their more accessible coastal neighbors, being able to fade into the mountains and return to herding and farming to survive. A neo-Inca state was formed near Cuzco and continued to defy the Europeans for a generation.

There are some politically-charged and culturally mixed works of art that seem to document this conflicting time. In particular a spectacular child's mantle and burial shroud combines

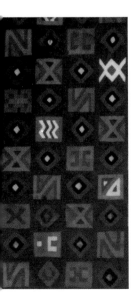

178. Detail of a neo-Inca prince's mantle and burial shroud. This unique tapestry seems to date from just after the Spanish invasion, its Inca affinities signaling a rebellious political statement. Early Colonial.

178

Inca technology (with over 78 threads per cm) and overall *tocapus* (geometric designs) with a Colonial flavor; the simplified geometric units uncharacteristically seem to float on the dark brown background. Inca control, signified by the grid which held *tocapus* before, is no longer absolute, yet poignant references to it continue under siege. It is hypothesized that during the first generations after the invasions a would-have-been Inca prince wore this as a mantle and then as a burial shroud. The use of other Inca objects, such as *qeros*, was allowed to continue in the Colonial era, in some cases because they could not be stamped out. When the Spanish tried to ban drinking they did not receive their tribute, so quickly rescinded the prohibition. Colonial wooden *qeros* were painted with European-style figures, sometimes Inca royalty, in combination with modified *tocapus* and plant motifs, in deeply hybrid compositions. Social status could thus be proclaimed in both the imposed and the indigenous aesthetic systems simultaneously.

The most informative Colonial works for the reconstruction of the ancient past are a few manuscripts composed and illustrated in the late sixteenth and early seventeenth centuries. Most notably the 1000-some page letter from Guaman Poma de Ayala 170-7 to the Spanish monarch, with hundreds of line drawings, gives insight into the history, rituals, practices, and values of the pre-Hispanic and Colonial eras. Incisive analysis by such scholars as Rolena Adorno has shown the many layers of political messages embedded in its text and illustrations. Cautious use of this information, keeping in mind the Colonial context of the work, can help us determine that overall *tocapu* arrangements were reserved for Inca royals in their time, but that the child's shroud was likely Colonial since Poma's post-Conquest illustrations match the exact patterns of the latter more closely.

Despite the profound changes of the last 500 years, the Andean people have maintained a strong, vital continuity with their independent past. Herds of camelids still constitute wealth and walk the Inca roads, the Humboldt Current still yields fish by the billions to the coastal fisherfolk in reed boats (and to large companies), textiles are still woven and exchanged (albeit to tourists too). Without overemphasizing continuity or seeking to prevent 'picturesque' cultures from inevitable and rightful change, one can recognize that the deeply-held values of duality, reciprocity, hierarchy, and embeddedness in nature are still fundamentally Andean today. And art still holds a pre-eminent place in the expression of a unique world and worldview.

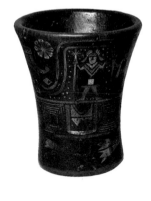

179. An Early Colonial wooden *qero* (drinking cup), typically Inca in its shape and incised geometric patterns, but painted with figures and flowers in a Spanish-influenced manner. Such hybrids show how indigenous forms of ritual communal celebration survived, with some alterations, the upheavals of European conquest. Early Colonial.

Select Bibliography

1 Introduction

Recent general treatments of the Andes include Karen Olsen Bruhns, *Ancient South America* (Cambridge Univ. Press, 1994), Craig Morris and Adriana von Hagen, *The Inka Empire and its Andean Origins* (Abbeville Press, 1993), Michael E. Moseley, *The Incas and their Ancestors* (Thames & Hudson, 1992, rev. edn 2001), and Luís Lumbreras, *The Peoples and Cultures of Ancient Peru* (Smithsonian Institution Press, 1989). A key resource is *Andean Art at Dumbarton Oaks* (2 vols.), ed. Elizabeth Hill Boone (Trustees for Harvard Univ. and Nuova Arti Grafiche Ricordi, 1996). The sections on the Andes in Rebecca Stone-Miller, *Seeing with New Eyes: Highlights of the Michael C. Carlos Museum Collection of Art of the Ancient Americas* (Michael C. Carlos Museum, 2002), and in *The Ancient Americas: Art from Sacred Landscapes*, ed. Richard F. Townsend (The Art Institute of Chicago & Prestel, 1992), are relevant as well.

For specific media, see Adriana von Hagen and Craig Morris, *The Cities of the Ancient Andes* (Thames & Hudson, 1998), Christopher Donnan, *Ceramics of Ancient Peru* (Fowler Museum of Cultural History, UCLA, 1992), Rebecca Stone-Miller, *To Weave for the Sun: Ancient Andean Textiles* (Thames & Hudson, 1994), Duccio Bonavia, *Mural Painting in Ancient Peru* (Univ. of Indiana Press, 1985), *Precolumbian Gold: Technology, Style and Iconography*, ed. Colin McEwan (British Museum Press, 2000), Heidi King, *Rain of the Moon: Silver in Ancient Peru* (The Metropolitan Museum of Art and Yale Univ. Press, 2000), and portions of *The Art of Pre-Columbian Gold: the Jan Mitchell Collection*, ed. Julie Jones (The Metropolitan Museum of Art, 1985).

Colonial chroniclers, such as Pedro Cieza de León, *La Crónica del Peru* (Historia 16, Madrid, 1984 [1550]), Bernabe Cobo, *History of the Inca Empire*, 4th printing, 1993 (Univ. of Texas Press, 1979 [1653]), and Felipe Guaman Poma de Ayala, *El Primer Nueva Corónica y Buen Gobierno*, eds. John V. Murra and Rolena Adorno, (Siglo Veintiuno, Mexico, 1980 [1613]), add greatly to our understanding of the pre-Hispanic past. See also Rolena Adorno, *Guaman Poma: Writing and Resistance in Colonial Peru*, Latin American Monographs no. 68, (Univ. of Texas Press, 1986).

2 Early and Chavín Art

On the world's first artificial mummification, see Bernardo Arriaza, 'Chile's Chinchorro Mummies,' in *National Geographic* 187, 3, March 1995. The single most important source on the Initial Period precursors and Early Horizon Chavín style is Richard Burger, *Chavín and the Origins of Andean Civilization* (Thames & Hudson, 1995). For a distinctive perspective, see Alana Cordy-Collins 'The Cerro Sechín Massacre: Did It Happen?' in *San Diego Museum of Man Ethnic Technology Notes* No. 18 (San Diego Museum of Man, 1983). John Rowe's classic, *Chavín Art: an Inquiry into its Form and Meaning* (The Museum of Primitive Art, 1962), introduced the important idea of kennings (visual metaphoric substitutions).

On textiles see Alana Cordy-Collins, 'Cotton and the Staff God: Analysis of an Ancient Chavín Textile,' in *Junius B. Bird Pre-Columbian Textile Conference*, ed. Ann P. Rowe, (Textile Museum, Washington D. C., 1973), and Rebecca Stone, 'Possible Uses, Roles and Meanings of Chavín-style Painted Textiles of South Coast Peru,' in *Investigations of the Andean Past*, ed. Daniel Sandweiss, (Latin American Studies Program, Cornell Univ., 1983). For articles on individual sites of interest, see the bibliography in Burger and *Early Ceremonial Architecture in the Andes*, ed. Christopher Donnan (Dumbarton Oaks, 1985).

3 Paracas and Nasca

A recent noteworthy publication on textiles of this period is Alan Sawyer, *Early Nasca Needlework* (Laurence King, London, 1997). Anne Paul has written extensively on Paracas textiles, including *Paracas Ritual Attire: Symbols of Authority in Ancient Peru* (Univ. of Oklahoma Press, 1990), ed. *Paracas Art and Architecture: Object and Context in South Coastal Peru* (Univ. of Iowa Press, 1991), 'Procedures, Patterns and Deviations in Paracas Embroidered Textiles,' in Rebecca Stone-Miller, *To Weave for the Sun: Ancient Andean Textiles* (Thames & Hudson, 1994), and Paul and Susan Niles, 'Identifying Hands at Work on a Paracas Mantle,' *The Textile Museum Journal* 23, 1985.

On Nasca art, see Helaine Silverman and Donald A. Proulx, *The Nasca* (Blackwell Publishers, 2002). Anthony Aveni has written extensively on the Nasca Lines, the most recent publication being *Between the Lines: the Mystery of the Giant Ground Drawings of Ancient Nasca, Peru* (Univ. of Texas Press,

2000). On Cahuachi see Helaine Silverman, *Cahuachi in the Ancient Nasca World*, (Univ. of Iowa Press, 1993). See also Johan Reinhard, 'Interpreting the Nazca Lines,' in *The Ancient Americas*, ed. Richard F. Townsend (The Art Institute of Chicago & Prestel, 1992).

4 Moche Art

Two recent general books presenting new research on the Moche are *Moche Art and Archaeology in Ancient Peru*, Joanne Pillsbury, ed. (National Gallery of Art, Studies in the History of Art 63, Center for Advanced Study in the Visual Arts, Symposium Papers XL, and Yale Univ. Press, 2001), and Garth Bawden, *The Moche* (Blackwell Publishers, 1996). One of the leading Moche scholars, Christopher Donnan has written 'Moche Burials Uncovered,' in *National Geographic* 199, March 2001, with Donna McClelland, *Moche Fineline Painting: Its Evolution and Its Artists* (Fowler Museum of Cultural History, UCLA , 1999), with Walter Alva, *The Royal Tombs of Sipán* (Fowler Museum of Cultural History, UCLA, 1993), and with Luís J. Castillo, 'Finding the Tomb of a Moche Priestess,' *Archaeology* 45, 6, 1992. Izumi Shimada presents the archaeology of the northern sphere in his *Pampa Grande and the Mochica Culture* (Univ. of Texas Press, 1994). See Elizabeth Benson, 'The World of Moche,' in *The Ancient Americas*, ed. Richard F. Townsend (The Art Institute of Chicago and Prestel, 1992), for a clear overview.

Specific treatments such as Jeffrey Quilter, 'The Narrative Approach to Moche Iconography,' in *Latin American Antiquity* 8, 2, June 1997, and Santiago Uceda and José Armas, 'An Urban Pottery Workshop at the Site of Moche, North Coast of Peru,' in *Andean Ceramics: Technology, Organization and Approaches*, ed. Izumi Shimada (Univ. of Pennsylvania Museum of Archaeology and Anthropology, 1998), are also key.

5 Wari and Tiwanaku

New publications on Tiwanaku include Jean-Pierre Protzen and Stella E. Nair, 'On Reconstructing Tiwanaku Architecture,' *Journal of the Society of Architectural Historians* 59, 3, September 2000, and two works by Alan L. Kolata, *Valley of the Spirits: A Journey into the Lost Realm of the Aymara* (John Wiley & Sons, Inc., 1996), and *The Tiwanaku: Portrait of an Andean Civilization* (Blackwell Publishers, 1993).

219

Recent archaeological discoveries on Huari and Conchopata have been presented by William H. Isbell, 'Reconstructing Huari: A Cultural Chronology for the Capital City,' in *Emergence and Change in Early Urban Societies*, ed. Linda Manzanilla (Plenum Press, 1997), and with Anita G. Cook, 'Reinterpreting the Middle Horizon: Implications of Recent Excavations at Conchopata, Ayacucho, Peru,' in *Andean Archaeology*, vol. 2, eds. Helaine Silverman and William H. Isbell (Kluwer Academic/Plenum Publishers, 2002). See also *Huari Administrative Structure: Prehistoric Monumental Architecture and State Government*, eds. William H. Isbell and Gordon McEwan (Dumbarton Oaks, 1991).
On textiles see Rebecca Stone-Miller, 'Camelids and Chaos in Huari and Tiwanaku Textiles,' in *The Ancient Americas*, ed. Richard F. Townsend (The Art Institute of Chicago & Prestel, 1992); Rebecca Stone, 'Color Patterning and the Huari Artist: the "Lima Tapestry" Revisited,' in *Junius B. Bird Pre-Columbian Textile Conference*, ed. Ann P. Rowe (Textile Museum, Washington D. C., 1986). For cross-media comparisons, see Rebecca Stone-Miller and Gordon McEwan, 'The Representation of the Wari State in Stone and Thread: A Comparison of Architecture and Tapestry Tunics,' *RES: Anthropology and Aesthetics* 19, 1990.

6 Late Intermediate Period
On the Lambayeque culture, see Izumi Shimada, *Cultura Sicán* (Fundacion del Banco Continental para el Fomento de la Educacion y la Cultura, EDUBANCO, Lima, 1995), 'Behind the Golden Mask: Sicán Gold Artifacts from Batán Grande, Peru,' in *The Art of Pre-Columbian Gold: the Jan Mitchell Collection*, ed. Julie Jones (The Metropolitan Museum of Art, 1985), and with Jo Ann Griffin, 'Precious Metal Objects of the Middle Sicán,'

Scientific American 270, 4, 1994: 62–68. An important comprehensive work is *The Northern Dynasties: Kingship and Statecraft in Chimor*, eds. Michael E. Moseley and Alana Cordy-Collins (Dumbarton Oaks, 1990). *Chan Chan: Andean Desert City*, eds. Michael E. Moseley and Kent C. Day (Univ. of New Mexico Press, 1982), remains seminal. On Chimú textiles see Ann P. Rowe, *Costumes and Featherwork of the Lords of Chimor: Textiles from Peru's North Coast* (The Textile Museum, Washington D. C., 1984), and on the period more generally see Margaret Young-Sanchez, 'Textile Traditions of the Late Intermediate Period,' in Rebecca Stone-Miller, *To Weave for the Sun: Ancient Andean Textiles* (Thames & Hudson, 1994).

7 Inca Art and Architecture
Relatively speaking, the most work in the Andes has been done on the Inca empire, although the majority remains from an archaeological point of view. Julie Jones, *Art of Empire: the Inca of Peru* (The Museum of Primitive Art, New York Graphic Society, 1964), although spare, is still a good resource, as is John Rowe, 'Inca Culture at the Time of the Spanish Conquest,' in the *Handbook of South American Indians*, ed. Julian H. Steward (Smithsonian Institution, Bureau of American Ethnology, Bulletin no. 143, vol. 2, 1946).
New work on Inca architecture includes Susan Niles, *The Shape of Inca History: Narrative and Architecture in an Andean Empire* (Univ. of Iowa Press, 1999). Architecture can be best appreciated by the art photographs of Edward Ranney in John Hemming, *Monuments of the Incas* (Univ. of New Mexico Press, 1990), and by an overview, Graziano Gasparini and Luise Margolies, *Inca Architecture* (Indiana Univ. Press, 1980). Reconstruction of Inca methods of working stone is found in Jean-Pierre

Protzen, 'Inca Stonemasonry,' *Scientific American* 254, 2, 1986, and *Inca Architecture and Construction at Ollantaytambo* (Oxford Univ. Press, 1993). John Hyslop has contributed greatly to our understanding of *Inka Settlement Planning* (Univ. of Texas Press, 1990), and *The Inka Road System* (Academic Press, 1984). A comprehensive study of the best-known provincial Inca center is Craig Morris and Donald Thompson, *Huánuco Pampa: An Inca City and its Hinterland* (Thames & Hudson, 1985). On the Chachapoyas culture, see Warren Church, 'Opening Hidden Gateways,' in *Américas* 51, January/February 1999, and Adriana von Hagen and Sonia Guillén, 'Tombs with a View,' in *Archaeology* 51, March/April 1998. On the *quipu* see Gary Urton, 'From Knots to Narratives: Reconstructing the Art of Historical Record Keeping in the Andes from Spanish Transcriptions of Inka *Khipus*,' *Ethnohistory* 45, 3, Summer 1998, and Marcia and Robert Ascher, *The Code of the Quipu: A Study in Media, Mathematics, and Culture* (Univ. of Michigan Press, 1981).
On Inca textiles see Ann P. Rowe, 'Technical Features of Inca Tapestry Tunics,' *The Textile Museum Journal* 17, 1978, and John Rowe, 'Standardization in Inca Tapestry Tunics,' in *Junius B. Bird Pre-Columbian Textile Conference*, ed. Ann P. Rowe et al. (Textile Museum, Washington D. C., 1986). For a consideration of Inca and post-Inca Peruvian textiles, see Susan Niles, 'Artist and Empire in Inca and Colonial Textiles,' in Rebecca Stone-Miller, *To Weave for the Sun: Ancient Andean Textiles* (Thames & Hudson, 1994).
On Colonial Peruvian art see sections of Diana Fane, *Converging Cultures: Art and Identity in Spanish America* (Harry N. Abrams, 1996).

Sources of Illustrations

Unless otherwise stated, measurements are given in inches followed by centimeters, height before width; a third measurement indicates depth.

Abbreviations

AMNH courtesy Department Library Services, American Museum of Natural History, New York

AMUT Archaeological Mission of the University of Tokyo

FMCH © UCLA Fowler Museum of Cultural History

MCCM Michael C. Carlos Museum, Emory University

MFA Museum of Fine Arts, Boston

MNAA Museo Nacional de Arqueología, Antropología e Historia del Perú, Lima

NMAI Photo courtesy National Museum of the American Indian, Smithsonian Institution

RSM Rebecca Stone-Miller

SAN Servicio Aereofotográfico Nacional de Peru

UMAE University Museum of Archaeology and Ethnology, Cambridge

Frontispiece 13H x 11I (34.3 x 29.9), MCCM, photo Jamie Squire; **1** Philip Winton; **2** David Drew; **3** © Edward Ranney; **4** David Drew; **5** M. Allison et al. 'Chinchorro, momias de preparacion complicada...,' Chungara 13 (1984); **6** length 8½ (21.5), AMNH, neg. #328612; **7** Ferdinand Anton, *Ancient Peruvian Textiles*, Thames & Hudson, London, 1987; **8, 9** Yoshio Onuki, AMUT; **10** After T.C. Patterson, The Huaca La Florida, Rimac Valley, Peru, in *Early Ceremonial Architecture in the Andes*, ed. C. Donnan, pp. 59–69, Dumbarton Oaks Research Library and Collections, Washington D.C., 1985; **11** Redrawn after J.C. Tello, *Arqueología del Valle de Casma: Cultural Chavín, Santa o Huaylas, Yunga y Sub-Chimu*, Publicación Antropológica del Archivo 'Julio C. Tello' de la Universidad Nacional Mayor de San Marcos, I.UNMSM, Lima, 1956; **12** George Kubler, *The Art and Architecture of Ancient America*, Penguin, Harmondsworth and New York, 1962 (drawing by K.F. Rowland); **13** Chan Chan-Moche Valley Project; **14** Drawing by Richard Burger; **15** Kubler, *op.cit.*; **16** Michael E. Moseley; **17** G. H. S. Bushnell, *Peru*, Thames & Hudson, London, 1956; **18** After Richard L.

Burger; **19** Annick Peterson; **20** Pauline Stringfellow; **21** Richard L. Burger; **22** Richard L. Burger; **23** Richard L. Burger and Luis Caballero; **24** Cornelius Roosevelt; **25, 26** Wilfredo Loayza; **27** Richard L. Burger; **28** John Rowe; **29** Ferdinand Anton, *Ancient Peruvian Textiles*, Thames & Hudson, London, 1987; **30** 4¾ (12.2), former Bliss Collection, Dumbarton Oaks Research Library and Collections, Washington, D.C.; **31** 9¼ x 5½ (23.3 x 14), NMAI; **32** RSM after A. Cordy Collins; **33** Ferdinand Anton *Ancient Peruvian Textiles*, Thames & Hudson, London, 1987; **34** height 34.0 (13 ⅜). FMCH, Gift of Mr and Mrs Herbert L. Lucas, Jr.; **35** height 9⅝ (24.8) x depth 5¼ (13.2), MCCM, photo Jamie Squire; **36** height 15.5 (6⅛). FMCH, Gift of Mr and Mrs Herbert L. Lucas, Jr.; **37** height 11¼ (28.4), width 10¼ (25.9), depth 7⅝ (19.5), The Brooklyn Museum (64.94) Frank L. Babbott Fund and Dick S. Ramsay Fund; **38** Michael E. Moseley; **39** Archivio Museo De America, photograph by Joaquín Otero; **40–42** Anne Paul, *Paracas Ritual Attire: Symbols of Authority in Ancient Peru*, University of Oklahoma Press, 1990; **43, 44** J.H. and E.A. Payne Fund, courtesy MFA; **45** Denman Waldo Ross Collection, courtesy MFA; **46, 47** 55⅞ x 94⅞ (142 x 241), William A. Paine Fund, courtesy MFA; **48** Edwin F. Jack Fund, courtesy MFA; **49** MCCM, photo Michael McKelvey; **50** height 17.6 (6⅞). FMCH, Gift of Mr and Mrs Herbert L. Lucas, Jr.; **51** 6⅞ x 6 (17.5 x 15.2), Art Institute of Chicago, Buckingham Fund (1955.2137), photo Colin McEwan; **52** Museo Amano, Lima; **53** height 9.8 (3⅞). FMCH, Gift of Mr and Mrs Herbert L. Lucas, Jr.; **54** MCCM, photo Michael McKelvey; **55** 15⅞ x 7½ (40.3 x 18.9), MCCM, photo Jamie Squire; **56** height 7⅝ (20), UMAE; **57** 7⅞ x 20½ (20 x 52), The Textile Museum, Washington, D.C., 1966.46.1; **58** The Textile Museum, Washington, D.C., 1964.31.2 detail; **59** 35⅞ x 44⅞ (91 x 114), Private Collection, New York, photo Lyle Wachowsky; **60** Hans Mann; **61** Photo David Drew; **62** height 7⅜ (18.8), Staatliches Museum für Völkerkunde, Munich; **63, 64** © The Field Museum, Chicago, IL., negs. #72303, 72301, 72300, 72302; **65** FMCH, drawing by Donna McClelland; **66** Rafael Larco Hoyle; **67** 11¾ x 12⅝ (30 x 32), Museo de América, Madrid; **68** Chan Chan-Moche Valley Project; **69** 8¼ x 8 (21 x 20.3), MCCM, photo Jamie Squire; **70** Drawing by Carlos Ayesta; **71** height 9½ (24), AMNH,

trans. #5053(3), photo John Bigelow Taylor; **72** Chan Chan-Moche Valley Project; **73** Shippee-Johnson Expedition, AMNH; **74** Painting by Jorge Solórzano, © Proyecto Huaca de la Luna; **75** © Julian Comrie FRPS ABIPP; **76** Félix Caycho Q; **77** Carlos Angel/Katz Pictures Limited; **78** height 4⅝ (11), FMCH, photo Christopher Donnan and Donald McClelland; **79** diameter 3¼ (8.3), FMCH, photo Susan Einstein; **80** average height 2¼ (5.8), FMCH, photo Christopher Donnan; **81** diameter 3¾ (9.4), FMCH, photo Susan Einstein; **82** diameter 3¼ (8.4), FMCH, photo Susan Einstein; **83** length of largest 3½ (9), FMCH, photo Susan Einstein; **84** MNAA; **85** From Gallardo et al., *Moche Senores de la Muerte*, Museo Chilenu de Arte Precolombino, Santiago, 1990, drawing by Donna McClelland and Christopher Donnan; **86** height 11⅝ (29.5), Staatliches Museum für Völkerkunde, Munich; **87** MNAA; **88** height 7½ (19.1), photo © 1994 The Art Institute of Chicago, All Rights Reserved, Gift of Nathan Cummings, 1957.611; **89** height 6¼ (16), Peabody Museum, Harvard University, photo Hillel Burger; **90** (above, left) 8¾ x 7½ x 13¾ (22.2 x 19.1 x 34.9), (above, right) height 7¼ (18.4) x depth 2¼ (5.7), (below, left) height 9¾ (24.8) x depth 4⅝ (11.8), (below, right) 8½ x 5½ (21.6 x 13.8), MCCM, photo Edward M. Pio Roda; **91** 26.5 x 13.8 (10¼ x 5½). Museo Arqueológico Rafael Larco Herrera; **92** Staatliches Museum für Völkerkunde, Berlin; **93** diameter 13½ (34.3), copyright British Museum, London; **94** Abraham Guillén; **95** UMAE; **96** Richard Townsend, *The Ancient Americas: Art from Sacred Landscapes*, The Art Institute of Chicago, 1992 (drawing by Carlos Fuentes Sanchez); **97** Philip Winton; **98** Nick Saunders; **99** Colin McEwan; **100** RSM; **101** Drawing courtesy of Javier Escalante, National Institute of Archaeology, La Paz, Bolivia; **102** Bunny Stafford; **103** Abraham Guillén; **104** Ferdinand Anton, *The Art of Ancient Peru*, Thames & Hudson, London, 1972; **105** 14 x 9⅞ x 6 (35.5 x 25 x 15.2), Instituto Nacional de Arqueología de Bolivia, La Paz, photo Dirk Bakker; **106** height 4½ (11.4), The Metropolitan Museum of Art, The Michael C. Rockefeller Memorial Collection, Purchase, Nelson A. Rockefeller, Gift (1978.412.214); **107** William H. Isbell and Gordon F. McEwan, *Huari Administrative Structure*, Dumbarton Oaks Research Library and Collections, Washington D.C., 1991; **108** Alan Kolata; **109** 8¾ x 12¼ (22.1 x

31), The Brooklyn Museum (71.180) Gift of Mr and Mrs Alastair Bradley Martin; **110, 111** William H. Isbell and Gordon F. McEwan, *Huari Administrative Structure*, Dumbarton Oaks Research Library and Collections, Washington D.C., 1991; **112** Gordon F. McEwan; **113** Gordon F. McEwan; **114** SAN; **115** Robert Feldman; **116** 41⅞ x 77⅛ (106.5 x 196), Staatliches Museum für Völkerkunde, Munich, photo Marietta Weidner; **117** 43¼ x 47¼ (109.8 x 119.9), The Art Institute of Chicago, Kate S. Buckingham Endowment, 1955.1784, photo © 1994, The Art Institute of Chicago, All Rights Reserved, photo Nancy Finn; **118** Alan R. Sawyer, *Tiahuanaco Tapestry Design*, 1963 (drawing Milton Franklin Sonday, Jr., courtesy the Museum of Primitive Art, New York; **119** 39⅜ x 36⅜ (100 x 92.3), MNAA, photo Dirk Bakker; **120** 26.0 x 18.7 (10¼ x 7⅜). The Glassell Collection; **121** height 6 (15.2), copyright British Museum, London; **122** backrest 22⅞ x 44¾ (58 x 113.5), Fundaciòn Miguel Mujica Gallo, Lima, Peru, photo courtesy Royal Ontario Museum, Toronto; **123** approx. 41 x 26¼ (104 x 66.6), Sicán Archaeological Project, photo Y. Yoshii; **124, 125** height 7⅞

(20), Fundaciòn Miguel Mujica Gallo; **126** (left) 7⅞ x 5⅛ (20 x 13), (right) 7¾ x 5⅛ (18.5 x 13), MCCM, photo Jamie Squire; **127** 10⅞ x 4 (27.7 x 10.3), Fundaciòn Miguel Mujica Gallo, Lima, photo courtesy Royal Ontario Museum, Toronto; **128** 29⅞ x 9⅜ (76 x 23.7), Denman Waldo Ross Collection, courtesy MFA; **129** AMNH; **130–34** Chan Chan-Moche Valley Project; **135** 57⅞ x 84¼ (147 x 214), Textile Income Purchase Fund, courtesy MFA; **136** 38⅝ x 26¾ (98 x 68), Textile Museum, Washington D.C.; **137** MCCM, photo Michael McKelvey; **138** 23.5 x 16.5 x 10.6 (9¼ x 6½ x 4⅛). The Metropolitan Museum of Art, The Michael C. Rockefeller Memorial Collection, Gift of Nelson A. Rockefeller, 1969 (1978.412.170). Photograph © The Metropolitan Museum of Art; **139** UMAE; **140** 9⅛ x 5⅛ (23.2 x 13), MCCM, photo Jamie Squire; **141** 12⅝ x 14 x 9 (32 x 35.5 x 23), AMNH, photo John Bigelow Taylor; **142** 29 x 29 (73.7 x 73.7), MCCM, photo Jamie Squire; **143** 24 x 26 (61 x 66), Gift of Landon T. Clay, courtesy MFA; **144** RSM; **145** 3¼ x 6½ (8.1 x 16.5), MCCM, photo Jamie Squire; **146** Philip Winton; **147** Peabody Museum, Harvard University,

photo Hillel Burger; **148, 149** © Edward Ranney; **150** Patricia A. Essenpreis; **151** Susan A. Niles; **152** © Edward Ranney; **153** Philip Winton; **154** Nicholas Saunders; **155** © Martín Chambi; **156** Paul Bahn; **157** Heinrich Ubbelohde-Doering; **158** © Edward Ranney; **159, 160** © Edward Ranney; **161, 162** David Drew; **163, 164** © Martín Chambi; **165** Nick Saunders; **166** After Craig Morris; **167** © Edward Ranney; **168** Rio Abiseo National Park Project. Photograph courtesy of Warren B. Church; **169** 35⅞ x 30⅛ (91 x 76.5), Dumbarton Oaks Research Library and Collections, Washington D.C.; **170, 171** Felipe Guaman Poma de Ayala, *Nueva cronica y buen gobierno*; **172** 33¼ x 30¾ (84.5 x 78), William Francis Warden Fund, courtesy MFA; **173** RSM; **174** 5¼ x 5½ (13.5 x 13.8), MCCM, photo Jamie Squire; **175** 5½ x 4½ (14 x 11.5), Museo Regional de Atacama, Chile, photo Johan Reinhard; **176** MCCM, photo Michael McKelvey; **177** 12 x 5 (30.5 x 12.7), MCCM, photo Michael McKelvey; **178** 46⅞ x 67⅜ (119 x 171), Charles Potter Kling Fund, courtesy MFA; **179** UMAE.

Index

Numerals in *italics* are illustration numbers

abstraction 13, 15, 27, 45, 46, 58, 60, 64,
 69, 72, 77, 91, 118, 120, 144–148, 163,
 180, 185, 188, 197, 210, 214, 216; *35,
 118, 119, 143*
access 21, 24–25, 30, 137, 142, 143, 155,
 166, 169, 171, 196, 197
adobe 22, 24–25, 78, 82, 85–91, 96, 116,
 122, 125, 156, 163, 164, 166, 169, 173,
 178, 208; *8, 9, 11–14, 71–74, 129–134,
 167*
agriculture 9, 12, 23, 35, 40, 65, 74–76,
 78, 103, 107, 120, 122, 123, 170, 185,
 191, 204, 216; *57, 85, 152*
Andes Mountains 10, 12, 29, 123, 130,
 186, 188, 191–193, 202, 206–207; *2,
 148–152, 159, 162*
Arena Blanca 49
Asia (site) 20
Aspero 20
astronomy 15–16, 78, 80, 129, 184, 186,
 187, 202, 204–206, 212; *147, 161,
 163–165*
Atahualpa 183, 185
audiencia 166–170, 173; *131, 133, 134,
 138*
axis mundi: Chavín de Huantar as, 30,
 35; Cuzco as 185, 193–195; *153*

Batán Grande 156–158; *123*
birds 11, 16, 17, 19–21, 38, 53, 55, 58,
 60, 61, 66, 68, 69, 71, 76, 78–81, 83,
 85, 86, 88, 96, 99, 103, 105–107,
 109–113, 116, 119, 132–134, 136, 146,
 151, 161–163, 168, 172–174, 176–178,
 214, 216; *6, 28, 41, 45, 50, 52, 61, 68,
 85, 88, 89, 103, 104, 106, 118, 119, 121,
 128, 134–136, 139, 142, 143, 176*
Block Color style 57–61; *45–47*
boats 11, 84, 103, 152, 171, 173, 218; *137*
burials 13, 43, 48, 49, 52–54, 77, 93,
 95–102, 105, 116, 129, 140, 150, 161,
 166, 168–170, 196, 209; *38–41, 73,
 77–83, 133, 168*

Caballo Muerto 25, 26, 87; *13*
Cahuachi 65, 71, 76–78
camelids (llamas, alpacas, guanacos,
 vicuñas; camelid fiber) 11, 13, 15, 49,
 54, 106, 113, 121–123, 129, 132, 133,
 144, 151, 161, 170, 175, 185, 186, 192,
 211, 214, 218; *4*
Caral 21
Cavernas 49, 57
ceques 185, 195, 196, 199; *153*
ceramics 17, 23, 45–52, 64–73, 81, 82,
 86, 88–90, 103–117, 122, 136, 144,
 149–151, 152, 154, 155, 158–161, 170,
 171, 173, 174, 176, 179, 180, 184, 210,
 214–217; *34, 35–37, 49–56, 62, 65, 66,
 69, 71, 84–93, 107, 108, 121, 125, 126,
 139, 140, 145, 176, 177*

Cerro Arena 88
Cerro Baúl 143; *115*
Cerro Colorado 49
Cerro Mayal 106
Cerro Sechín 26–28, 30, 32; *15–17*
Chachapoyas 209, 210; *168*
Chancay 7, 16, 153, 155, 171, 175–179,
 216; *frontispiece, 141–143*
Chan Chan 153, 155, 156, 163–170, 173,
 174, 185, 194; *129–134*
Chavín (Chavín de Huantar) 7, 16, 21,
 23, 26, 28–47, 49, 50, 58, 64, 87, 89,
 104, 111, 119, 130, 173, 178, 184,
 209; *18–36*
Chimú 7, 12, 117, 153–156, 158, 161,
 163–175, 184, 185, 214, 216;
 129–140
Chinchorros 17, 18; *5*
Chongoyape 41–43; *31*
ciudadelas 163–169; *129, 130, 133*
complementarity (duality) 22, 24, 33,
 38, 99, 117, 195, 218
Conchopata 130, 150–152
contour rivalry 36, 39, 40, 46; *7, 29*
cotton 11, 19, 26, 43, 44, 52, 76, 109,
 170, 173, 177; *see also* textiles
Cotton Pre-Ceramic 7, 18–23
creative process 57–63, 69, 102, 103,
 105, 116, 117, 128, 144, 152, 154,
 175, 178, 193; *45, 93*
Cupisnique 41, 46, 47; *34*
Cuzco 156, 167, 181, 185, 186, 193–199,
 203–205, 214, 215; *153–156*

deer 54, 83, 96, 104, 109, 205; *82, 84*
Dos Cabezas 102, 158
dyes 14, 43, 76, 148, 161, 173, 209

Early Horizon 7, 28–49
Early Intermediate Period 7, 47–128
El Milagro 170
El Paraíso 21
environment 9–14, 18, 29, 49, 65, 80,
 86, 117, 118, 120, 122, 123, 125, 142,
 147, 149, 163, 164, 166, 171, 183,
 185–193, 195–210, 216–218; *1–3,
 150*
essence 15, 16, 20, 36, 42, 59, 69, 83,
 102, 176, 184, 200, 205

Farfán 170
feathers 11, 14, 20, 21, 49, 52, 55, 105,
 116, 122, 154, 158, 170–172, 174,
 185, 209, 214, 215; *41, 136, 175*
felines (pumas, jaguars) 26, 30, 32, 33,
 38, 44, 45, 50, 56, 58, 59, 76, 83, 85,
 96, 111, 113, 119, 122, 129, 133–137,
 175–177, 188, 194, 197, 200, 214; *21,
 32, 36, 43, 44, 57, 65, 90, 105, 109, 142,
 158*
females 20, 38, 43–45, 54, 68, 83, 95, 96,
 101, 106, 111–117, 176, 177, 185, 199,
 208, 211, 213, 214; *28, 33, 49, 76, 141,
 170*
finishing works of art 35, 54, 57, 58, 61,
 69; *45*

fish (fishing) 11, 18, 19, 23, 49, 66, 68,
 123, 162, 163, 174, 176–178, 218; *51,
 128, 139, 143*
food 11–13, 23, 45, 49, 54, 67–69, 74–76,
 110, 123, 135, 151, 166, 170, 174;
 see also maize, peanuts

Galindo 106
Gallinazo 87, 88
Garagay 26, 27, 37; *14*
Guaman Poma de Ayala, Felipe 212,
 213, 218; *170, 171*
Guitarrero Cave 17

hallucinogens 14, 27, 28, 32, 36, 41, 44,
 111, 113, 132, 133, 135, 209; *20, 89,*
 see also shamanism, transformation,
 visions
huaca 77, 185, 186, 195, 196, 199, 200
Huaca Cao Viejo 94
Huaca la Florida 23, 24; *10*
Huaca Prieta 17–20, 36; *6, 7*
Huánuco Pampa 199, 207, 208; *166*
Huari (city) 118, 137–140, 144, 151,
 194; *110–114*
Huarpa 121, 122
Huascar 183
Huayna Capac 183, 205, 217
hunting 107, 109, 110, 113, 205; *85, 88*

Ica 8, 153, 155, 178, 179; *145*
Incas 9, 12, 15, 16, 27, 29, 121, 125,
 127–129, 133, 135, 153, 156, 163, 167,
 170, 174, 179, 180–218; *146–179*
Initial Period 7, 23–28

Karwa 41, 43–45; *32, 33*
Kotosh 21–22; *8, 9*

La Galgada 21
Lambayeque (Sicán) 82, 117, 153–163,
 167, 171, 173; *122–128*
Late Horizon 7, 180–218
Late Intermediate Period 7, 8, 153–179,
 182
Linear Style 57–60; *43, 44*
Lithic Period 7, 17, 18
litter 96, 97, 154, 161, 173; *122, 136*
Loma Negra 102
Los Pinchudos 209; *168*
Lukurmata 134

Machu Picchu 187, 200, 202–207; *148,
 161–165*
maize 12, 76, 78, 104, 110, 117, 135,
 151, 184, 186, 191, 208, 210,
 214–216; *51, 57, 106, 107, 173, 176,
 177, 179*
maker's marks 85, 86, 91, 92, 102; *72*
Manchan 170
metal 20, 25, 26, 41–43, 48, 52, 73, 76,
 78, 82, 86, 89, 96–102, 121, 135, 149,
 150, 154–161, 167, 169, 171, 174,
 180, 184, 185, 197, 198, 209, 210,
 214, 215; *30, 31, 39, 77–83, 120, 122,
 123, 137, 138, 173–175*

Middle Horizon 7, 118–152
Mina Perdida 25, 26
Moche 7, 12, 26, 47, 48, 65, 69, 73,
 82–117, 119, 123, 156, 160, 161, 163,
 173, 174; 62–93
monkey 14, 60, 70, 73, 78, 87, 174; 54,
 66, 139
Moray 191, 200, 201; 159
Moxeke 24, 25; 11, 12
multiple readings 19, 20, 36, 38–40,
 175
mummification 11, 12, 17, 18, 52–57,
 129, 185, 186; 5, 38–41
murals 26, 82, 84, 88, 89, 93–95, 97,
 178; 63, 64, 68, 75, 76
music (musical instrument, musicians)
 64, 65, 71, 72, 83, 86, 97, 101, 107,
 110, 111, 113, 117, 148, 174, 175;
 55, 90, 140

Nasca 7, 12, 16, 48, 64–81, 90, 118, 122,
 123, 142, 158; 49–61

Ollantaytambo 191, 200–205; 160
Omo 134–136; 107
oracle 34, 35, 178, 179; 23, 144

Pacatnamú 161
paccha 210, 216, 217; 177
Pachacamac 43, 153, 161, 177, 178
Pachakuti 183, 203, 205
Pampa Grande 82, 102, 116
Pañamarca 95, 96; 76
Paracas 7, 47–65, 71, 73, 76, 177;
 36–48
Paredones 88
peanut 54, 83, 96, 97, 101, 110, 111; 83,
 90
Pikillacta 130, 137, 140–143, 149, 151;
 112–114
Pisac 191, 200, 201, 204, 205; 152
plants 12, 45, 54, 78, 105, 123, 178,
 198, 201, 202, 204, 214; see also food,
 maize, peanuts
portrait 15, 86, 106, 107, 135, 136, 154,
 174; 86, 87, 108
Pukará 121, 122; 94, 95

Qenqo 199, 200, 205; 158

qero 122, 129, 132, 135, 136, 151, 210,
 218; 106, 124, 179
Quebrado Katuay 170
quipu 91, 184, 210, 212–214; 147

reciprocity 9, 15, 16, 181, 218; see also
 complementarity
Recuay 87–89, 95; 67, 69
ritual killing of art/architecture 21,
 129, 130, 139, 152

Sacrifice Ceremony 85, 95, 96; 65, 76
Sacsahuaman 188–191, 194, 197; 150,
 151, 153
Salinar 87, 88; 66
Salinas de Chao 21
San José de Moro 96
San Pedro de Atacama 134
Santa Ana 41, 46, 47; 35
sea 11, 18, 20, 90, 153, 195
shamanism 16, 25–28, 32, 33, 51, 52,
 58, 61, 64, 65, 69, 71, 80, 83–85,
 87–89, 94, 102, 106, 107, 109–111,
 113, 115, 117–119, 123, 129, 146, 147,
 151, 162, 175, 186, 209; 12, 14, 16, 17,
 20, 22, 24–26, 37, 45–47, 52, 53, 68, 75,
 89, 90, 103, 104, 118, 121
shell 20, 32, 41, 49, 132; spondylus
 (spiny oyster) 21, 52, 54, 96, 154, 155,
 160, 171, 174, 209; 39, 137, 140
Sipán 82, 85, 96–102, 105, 109, 110, 117,
 161; 77–83
snakes 19, 26, 36–38, 40, 45, 52, 58, 113,
 147, 176, 177, 214; 7, 12, 20, 22, 23,
 27–31, 34, 35, 37, 75, 76, 90, 142
Spanish 7, 8, 153, 155, 166, 178–180,
 182, 183, 185, 186, 191, 195–198, 201,
 202, 210, 212, 217, 218
spider 26, 27, 86, 97, 98, 161; 14, 79
standardization 14, 85, 103, 153, 168,
 169, 180, 184, 185, 193, 203, 212,
 213, 215

Tambo Colorado 208; 167
Tambo Machay 192, 199, 200; 157
textiles, Colonial 217, 218; 178;
 Chancay 155, 171, 175–177; 141–143;
 Chavín 41–45, 119; 32, 33; Chimú
 167, 169–174; 135; Cotton

Pre-Ceramic 18–20; 6, 7; Inca 180,
 184, 185, 210–215, 218; 147, 169,
 172, 174, 175; Initial Period 26;
 Lambayeque 155, 158, 161–163; 128;
 Late Intermediate Period 153–155,
 160, 174, 179; Lithic Period 17; 5;
 Moche 86, 94, 96, 103, 116, 117; 93;
 Nasca 66, 68, 71, 74–78; 57–59;
 Paracas 48, 49, 52–64; 38–48; Recuay
 88, 93; 67; Tiwanaku 135–137; 109;
 Wari 113, 118, 130, 133, 137, 139,
 140, 144–149; 116–119; see also cotton,
 dyes
tinkuy 29, 193
Tiwanaku 7, 47, 95, 118–141, 144,
 151–153, 182, 184, 186, 203; 96–109,
 118
tocapu 212, 213, 218; 169, 171, 178
Topa Inca 183, 205, 213; 171
transformation 15, 16, 26, 29, 36–38,
 40, 60, 84, 87, 151; 14, 24–26, see also
 shamanism, visions
tumi 158, 160, 161, 214; 127, 174
turquoise 96, 135, 158–161; 124, 127

urpu 210, 214–216; 176, 177

verticality 12, 181, 184
visions 26, 37, 52, 71, 113–115, 132,
 133; 91, see also shamanism,
 transformation
visualization 19, 20, 69

war (warrior, army) 27, 28, 68, 69,
 82–85, 90, 94, 96–98, 100, 101, 105,
 107, 109, 110, 113, 118, 119, 139, 143,
 151, 152, 207, 211, 212, 213, 217; 52,
 62, 78, 81, 172
Wari (state) 7, 12, 47, 64, 72, 73, 76, 82,
 95, 113, 117–123, 130, 137–153, 158,
 161, 184, 189, 212; 110–121
withholding the work of art from
 visibility 35, 37, 39, 41, 58, 105, 106,
 144–148, 176, 177; see also essence
wood 11, 20, 135, 136, 154, 160, 167,
 209; 106, 122, 144, 179
worldview 15, 16, 188, 218

Yucay 205, 206